If you would like to receive a complete list
of titles in print please write to:

THAMES & HUDSON
181A High Holborn
London WC1V 7QX

In the United States please write to:

THAMES & HUDSON INC.
500 Fifth Avenue
New York, New York 10110

Printed in Singapore

1. Claude Monet,
The Gare Saint-Lazare, Exterior,
1877

Belinda Thomson

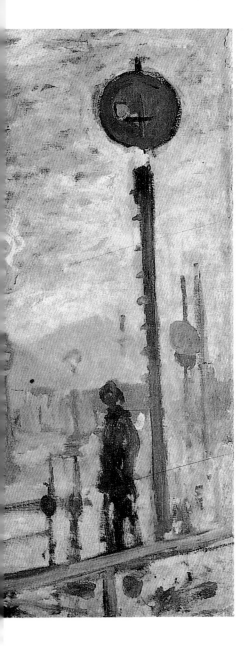

Impressionism

Origins
Practice
Reception

With 256 illustrations, 201 in colour

 Thames & Hudson world of art

Acknowledgments

To Rupert and George

I should like to thank Kathy Adler and Richard Thomson for persuading me at the outset to take up the daunting challenge this title presented. For my conception and realization of the book, I owe much to the scholars whose lectures, books, articles and exhibitions have made Impressionism such a rich and stimulating field over the last thirty years. At different stages, I received encouragement from Richard Kendall, Ann Dumas and from many new-found art-historical colleagues in Scotland, in particular, Michael Clarke, Elizabeth Cowling, Frances Fowle, Vivien Hamilton and Clare Wilsden. The staff of the Education department in the National Galleries of Scotland and of the Fine Art and Continuing Education departments at the University of Edinburgh have offered me valuable teaching and research opportunities which have contributed to the writing. I am indebted to Shannon Hurtado and to Richard Thomson for reading the manuscript and sharing ideas. The latter, as ever, has given me his unstinting support and sound practical advice, not always heeded. I am immensely grateful to the skilled team at Thames & Hudson who have steered the project through with a light but firm hand and to Derek Birdsall, whose inspired and finely tuned design has greatly enhanced the book's coherence.

First published in the United Kingdom in 2000 by
Thames & Hudson Ltd, 181A High Holborn, London WC1V 7QX

www.thamesandhudson.com

British Library Cataloguing-in-Publication Data
A catalogue record for this book is available from the British Library

ISBN 0-500-20335-0

Designed by Derek Birdsall
Typeset by Omnific
Printed and bound in Singapore by C.S. Graphics

Contents

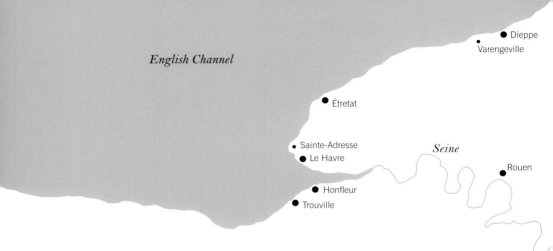

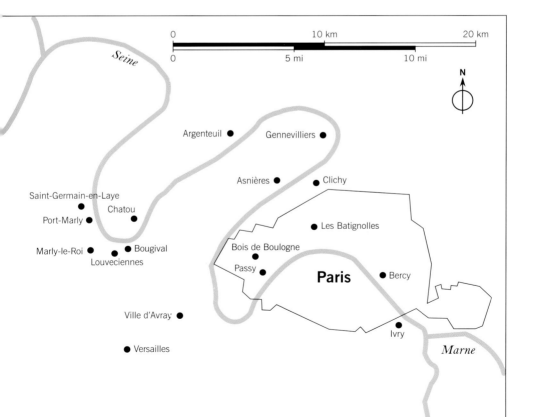

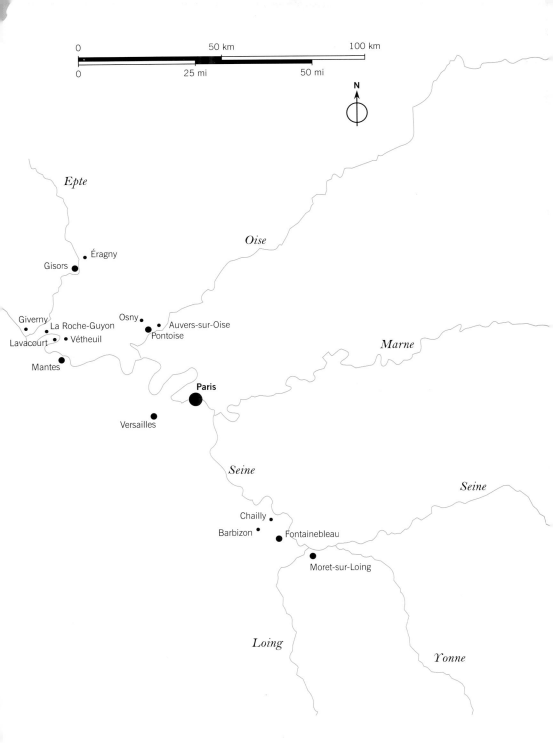

0 50 km 100 km
0 25 mi 50 mi

N

Epte

Oise

Éragny

Gisors

Osny
Giverny
La Roche-Guyon Auvers-sur-Oise
Lavacourt Pontoise
Vétheuil

Marne

Mantes

Paris

Versailles

Seine

Seine

Chailly

Barbizon Fontainebleau

Moret-sur-Loing

Loing

Yonne

Introduction

In the interval of over thirty years since the publication of Phoebe Pool's *Impressionism* in the World of Art series, an enormous body of scholarly material has appeared that has a direct bearing on the history of this fascinating art movement. One by one the careers of each of the key participating artists have been examined and reassessed in major retrospective exhibitions. Aspects of the Impressionists' collective and individual thinking and details of their personal lives have been illuminated by the publication of new documents and correspondence. Single pictures and groups of works in all media have been subjected to analyses from new perspectives. Meanwhile Impressionist art's popularity remains high. Its images are ubiquitous, mechanically reproduced in direct and indirect, tasteful and tasteless ways, most of which offer a visual experience which is far removed from that of the original painting. For all these reasons it seems apt 125 years after its inception to look again at Impressionism and present a synthetic account accessible to the general reader.

Phoebe Pool's balanced and lively book provided a valuable introduction to Impressionism in the 1970s. John Rewald's more detailed chronological and essentially biographical survey was the standard authoritative account. Since that time, there has been a proliferation of new approaches to the subject and the field has grown to such an extent that the project of assimilation and synthesis has become daunting to student and specialist alike. In the later 1970s and 1980s, in reaction to the limited purview of formalist modernism and its exclusive preoccupation with avant-garde innovation, a new mapping of the field of modern art studies began. Much important new work was done, particularly under the aegis of the social history of art. In Britain and America, a number of prominent university professors – among them, Timothy Clark, Francis Haskell, Robert Herbert, Linda Nochlin, Griselda Pollock and Theodore Reff – not only made scholarly contributions which continue to provide key signposts in the field (see Bibliography), but also provided influential models of art historical methodology. Diffused and disseminated through the work of their former students, some of their ideas have filtered down in modified form into the public consciousness, via textbooks, via exhibitions and their catalogues, and via the popular media.

The study of Paris, its sights and its social patterns (see Clark, Herbert, Reff) has advanced in tandem with the study of suburban

and rural France, where the exploration of the cultural resonance of landscape has deepened our understanding of the relationship between artist, society and motif (see Tucker, Brettell, Thomson). Psychoanalytic theory has urged us to reject the notion of a unitary, consistent creative personality and to regard with suspicion explanations predicated upon authorial intentionality. Thus the emphasis has drawn away from monographic studies and given rise to issue-based historical approaches addressing questions of gender, the place of women, the role of the spectator and notions of difference. Part of that process has been the theoretical problematization of art's reception, involving the close reading of criticism and critical language (see Clark, Shiff). But the biographical approach is still deeply entrenched; when sensitively handled and informed by psychological awareness, it continues to hold its own. Recent studies have thrown new light on some of the more complex and marginal figures associated with Impressionism, such as Édouard Manet (1832–83), Paul Cézanne (1839–1906), and Henri Fantin-Latour (1836–1904) as well as on central figures, such as Berthe Morisot (1841–95), Auguste Renoir (1841–1917) and Edgar Degas (1834–1917) (see Druick, Loyrette). Artistic interrelationships have been studied and reinterpreted not simply in terms of stylistic affinity and mutual influence but with an awareness of less obvious psychological interdependences.

A further important area of revisionist work has filled out our picture of the competing directions art took at the time of the Impressionists. Now, thanks to the reevaluation of many forgotten reputations, instead of seeing the Impressionists' position in simple dualistic terms – as the radical avant-garde heroes who bravely dissented from the norms laid down by stultifying academic convention – we are able to map a more detailed and nuanced picture, taking account of subtle gradations of artistic practice and congruences within the search for modern imagery. Thanks to recent work on art institutions, we can see that the Salon was a broad umbrella organization that evolved throughout the period (see Mainardi, Roos). Artists of varying positions, from the conservative to the *plein-airist*, and from the modern-life naturalist to the documentary realist all found a place there. Increasing numbers of independent artists, and not just the Impressionists, vacillated between the Salon and a range of independent exhibiting and selling options.

Thus our concept of Impressionism itself has undergone a number of metamorphoses in the last three decades. We have revised our attitudes to several formerly neglected figures. The

proto-Impressionist Frédéric Bazille (1841–70), the politically engaged Camille Pissarro (1830–1903) – a regular exhibitor and supportive teacher at the heart of the group – and the independently wealthy late recruits to the movement, Gustave Caillebotte (1848–94) and Mary Cassatt (1844–1926), have all benefited from this development. Particular kinds of scholarly attention have been paid to the rich and complex oeuvre of Degas. In many ways, he is Impressionism's odd man out, with his relative lack of interest in analysing effects of light and atmosphere in nature. But for all his irony at the expense of *plein-air* painters, he has been revealed as a highly inventive landscapist in his own right (see Kendall). His predilection, on the other hand, for exploring modern figurative themes drawn from the lives of working women – ballet dancers, milliners, laundresses, prostitutes – has made him a target for the unflinching and sometimes humourless scrutiny of a generation of feminist scholars.

All of us who work in the Impressionist field are conscious of being implicated in a commercial as well as an educational enterprise. Mounting an Impressionist exhibition has become a sure-fire route to profitability, with blockbuster Monet shows pulling huge crowds. From the world's artistic centres to its smaller cultural outposts, playing the Impressionist card has become a well-known gambit.

At the same time, more detailed and open-minded research is going on into the practices of dealers, the art market and collecting (see Distel), producing new data that moves our picture of Impressionism on. There used to be a notion that the rare individuals who supported the Impressionists did so as an act of selfless faith in their genius. Now we are more willing to acknowledge the speculative games that were played. Whereas the cruel but predictable laws of supply and demand produced the sudden surge in value of Alfred Sisley's (1839–99) work after his death, the leading Impressionists – Claude Monet (1840–1926), Degas and Renoir – knew something of commercial success in their lifetimes. Their works sold for good reason, and partly because the artists and their dealers kept a watchful eye on their market position and established identifiable niches.

While my own thinking has been modified, consciously or unconsciously, by different contemporary avenues of research, my own methods are intuitive and empirical. Like many art historians, I find merits in different approaches and am disinclined to endorse an exclusive system or overarching theory. My appetite for research is often stimulated by puzzling, easily overlooked details

which come to light in primary documents or in faulty translations which misconstrue the original; it is the teasing out of their meaning or meanings and place in the scheme of things that constitutes, for me, the pleasure of historical work.

My aim in this book is to offer some fresh and up-to-date insights into a well-worn field. In terms of organization, although the chapters follow a broadly chronological pattern, I have sometimes departed from this in order to explore more general themes. Beginnings and endings are in themselves problematic. To say that Impressionism existed by the year 1874 is an uncontroversial statement. That was the year when the artists whom the critics would dub 'the Impressionists' first exhibited as an independent group. Nor is it difficult to find evidence in 1900 that Impressionism, despite some eager pronouncements of its demise after the last group show held in 1886, continued to have a living identity. But during the quarter century that had elapsed, that identity had aged and evolved almost beyond recognition. Its status had changed too. By the turn of the twentieth century, Impressionism, always a loosely defined term, had developed from being the much-contested artistic style associated with a distinct group of individuals and was becoming, on an international scale, the new orthodoxy whose insidious influence the younger generation felt the need to overthrow. Apart from a glance forwards into the twentieth century in the final chapter, the year 1900 will serve as a convenient terminus for this book's historical enquiry. What is more problematic is settling on a date when Impressionism first emerged, either as a cohesive set of artistic aims or indeed as a definable concept. For the artists who exhibited in 1874 were by no means at the start of their careers; an assorted and loosely connected bunch, they were mostly in their thirties and had a measure of success behind them.

Before addressing the question of origins in more detail, it is worth asking simply, and in the broadest possible terms, why the Impressionist phenomenon occurred when it did. If one considers Impressionism as an artistic style which involved the representation of visual effects observed in the immediate, contemporary world through the application of light-hued surface touches of oil paint to small-scale canvases, what factors and experiences produced this style and allowed it to develop at this time? With one or two exceptions, in the realm of subject matter, Impressionist painting entailed a rejection of previously accepted themes drawn from religion, mythology and history. Instead, it focused on the

much more immediate and restricted goal of conveying the artist's passing, fragmentary perceptions. In practice, Impressionism involved discarding traditional, painstaking methods of building a composition from dark to light using tonal gradation and glazes, replacing them with emphatic brushwork and colouring of great freedom and subtlety.

And if one moves beyond the sphere of painting, what prompted the parallel, if slightly later, developments of Impressionism in music and literature? In these fields, one finds a comparable questioning of existing forms and an emphasis upon the subtle, sensory sensations of the creative subject. How can one characterize the Impressionist moment within the broader sweep of nineteenth-century French history? It is far from obvious where to start looking for an explanation of what amounts to a concerted rejection of conventional artistic objectives, resolved forms, structured designs and traditional subject matter, in favour of informal representations of direct sensory experiences from the modern world.

The explanation for this aesthetic revolution lies partly in the considerable changes in outlook that characterized this empirical, optimistic age, an age of increasing religious scepticism, but of important industrial and scientific discoveries. Chemical developments in the dyeing and paint industries were also affecting the ways people conceived of their world, no longer in terms of solids but of gaseous vapours and fragmenting molecules. In optics, particularly in the analysis of colour vision, new discoveries about visual perception were being made that would prove pertinent to painting.

Of course the new ways of perceiving and representing the world seemed perverse and threatening to the older generation. Were we to examine the phenomenon of Impressionism through the eyes of the elderly Jean-Auguste-Dominique Ingres (1780–1867), whose career was ending just as Monet and Renoir were embarking upon their daring youthful experiments, how would it look? What could this master of the meticulous portrait, the history subject and the classical nude possibly have understood by the neglect of preparatory drawing procedures and the scornful refusal of teaching methods which prescribed long hours of studying and meditating upon the Old Masters? For him, undoubtedly, Monet and Renoir's rejection of an intellectual aspiration towards idealism and perfection – replacing it instead with a commitment to an art of the everyday and to improvisatory techniques honed to capture momentary, ephemeral observation –

would have sounded the death knell of art. And yet among the future Impressionists we encounter the young Degas, a loyal devotee of the standards Ingres had set, struggling to come to terms with the apparent obsolescence of the lessons he had so painstakingly learnt in Italy. Are we right in fact to see Impressionism, as the elderly Ingres might have done and as we are often encouraged to do by conventional histories of art, as an out-and-out artistic revolution, a complete break with the past, the beginning of the modern movement? Are we not in danger of overlooking the strong elements of tradition that also lay at its heart?

As well as asking why Impressionism happened when it did, we also need to account for its enduring popularity. Certainly for many people there is a distinctive and abiding freshness and approachability about Impressionist art, which they do not find in the art of earlier periods. Perhaps it is no more than that the Impressionists' interests appear relevant to our own and that they operate unpretentiously by stimulating our visual pleasure. They address us from a position to which we can relate. Who can quarrel with their celebration of the sensory delights of daily life and their validation of the pleasures of food, landscape, physical beauty and health? To be sure, artists such as Pissarro and Degas often represented work rather than leisure, but while they invite us to look at such themes in new ways, they do not seek to preach at, instruct or amaze us with shows of superior learning, or to elevate our thoughts through arcane references. Instead they declare the private, domestic realm worthy of artistic consideration. They may disconcert us with superficially blurred or ambiguously structured compositions or arrest our attention with stark, unaccustomed viewpoints, but the brutal shock tactics we see deployed by artists of the late twentieth century were totally alien to the Impressionists' purpose. At the same time they are intellectually respectable because they appeal to our disinterested aesthetic sensibility rather than to our baser wish to empathize. This is what differentiates them from so many of their contemporary genre painters, who tried to stir the sentimental emotions of the viewer. Finally, Impressionist art is soothing because, on the whole, it avoids the painful realities of the world, of violence, war, heartache, illness and death. Indeed, it has a reassuring air of confidence and, unlike much conceptually based art of our own day, it does not constantly raise the question of its own legitimacy and seek to redefine its place in culture.

2. **Alfred Sisley**, *Avenue of Chestnut Trees at La Celle-Saint-Cloud*, 1865
In his early landscapes of the forests around Paris, Sisley demonstrates a
crisp boldness of touch and an ambition of scale, which are comparable
with Monet and Bazille. This large work, in which the importance of
Courbet and Rousseau is paramount, may be identifiable as Sisley's
rejected Salon submission for 1867. La Celle-Saint-Cloud, whose grove
of chestnuts was noted by Baedeker in 1900, lies to the west of Paris.

Part I

Chapter One: Setting the Scene

When? The Historical and Political Background
Clearly late nineteenth-century France offered the necessary conditions for an art form to flourish that was domestic in scale, devoted to sensual pleasure and addressed to the private collector. France's economic climate was favourable to commerce, self-advancement and conspicuous consumption. It was in the main a peaceful era which saw a marked increase in industrial output leading to greater bourgeois prosperity and leisure. Many kinds of new, highly sophisticated and complex capitalist phenomena emerged or were refined, catering to the new and existing demands of the urban bourgeoisie. Among these, we should count the railway network, the department store, the fashion house with its seasonal collections of ready-to-wear garments, the illustrated press, the café and café-concert, the theatre, the race course and the seaside resort. It was during this era of bankers and stockbrokers that Paris's reputation as the capital for culture, luxury goods and pleasure was enshrined and acknowledged around the globe.

Part and parcel of the new consumerism was an increase in activity in the art world. Collecting and dealing enjoyed a boom, a phenomenon which the de Goncourt brothers' diary noted in 1865. Whereas other commodities might rise and fall and represented risky investments, 'the art object embodies the most positive and realizable value. Collectables [*la curiosité*] have become more secure than rents, land, property.' Visiting art exhibitions – primarily the annual Salon held on the Champs-Elysées – was hugely popular. As Jane Mayo Roos has recently shown, whereas the early nineteenth-century Salons typically comprised fewer than five hundred works, by the mid-1860s, between four and five thousand works were on view. Attendance was high at the opening day of the 1866 Salon and overall visitors were estimated at 300,000.

Broadly speaking, under the Second Empire (1851–70), and to a slightly lesser extent after 1871 under the Third Republic, France was a self-confident nation, which offered artists a moderate degree of status, security and aesthetic freedom, providing its

official painters with considerable rewards. War-torn or politically troubled periods have a tendency to dislocate artists from their audiences and to elicit from them more extreme, hectoring or propagandist positions, as happened in the wake of the Revolution and during the Napoleonic wars. The history of the twentieth century tells us that autocratic régimes fear and usually try to stifle creative individualism and that artists comply timidly or are forced into exile. By comparison with its recent turbulent past, French society after 1850 was more liberal and enjoyed long periods of peace and prosperity as it started to assimilate – in Paris, in particular – the immense social and material upheavals of the earlier part of the century.

However, when one looks at the situation more closely one discovers anomalies. The greater spread of prosperity did not necessarily engender a more tolerant or receptive climate for artistic innovation. The Second Empire was characterized by extravagant displays of wealth, harsh institutional and media control, moral laxity and hypocrisy. Moreover, the precise moment when Impressionism was coalescing as a style, 1870–71, coincided with a war and a change of political régime. The bourgeoisie, increasingly the dominant force in cultural life, seized the occasion of the Franco-Prussian War to bring to an end Napoleon III's Second Empire, restore the Republic and reassert its democratic power. Doing so in the face of a national emergency when France was capitulating to the military might of Prussia did not undermine the significance of the power shift. Hitherto the political importance of the middle classes had been eclipsed, although their undoubted commercial and economic power was increasingly evident. The progress towards modern political democracy, which France's thinkers had long been urging, was anything but straightforward, characterized instead by interruptions and confusing false starts.

The biggest hiccup was in 1815, when the defeat of Napoleon Bonaparte at Waterloo had definitively brought about the restoration of the monarchy. The reigns of the Bourbon kings Louis XVIII and Charles X, brothers of the guillotined Louis XVI, seemed to indicate a return to the bad old days of the *ancien régime*, with all the promises and political advancement made since 1789 being swept under the carpet. It left the artists of the 1820 generation – the romantics – looking back in amazement on the Revolution's brave ideals of social justice and on Napoleon's vainglorious escapades on behalf of the French nation. In such a climate of retrospective nostalgia, artists tended to turn away from,

or openly renounce, the shameful, shabby times they lived in. Instead they sought inspiration further afield, in glamorous and exotic scenes from the past or the Orient, or in nature, which became the new deity in a world increasingly sceptical of its old spiritual beliefs. Louis-Philippe, the so-called bourgeois king who introduced a more constitutional form of monarchy between 1830 and 1848, is credited with more enlightened attitudes, but he lacked the vision or stature to carry them through. His era, as characterized by one of its best-known novelists, Honoré de Balzac, and by the brilliant caricaturist Honoré Daumier, was one of social uncertainties and rapacious obsession with money. The Revolution of 1848 and return to republicanism proved to have been a false dawn when, in December 1851, Louis-Napoleon Bonaparte, the opportunist nephew of Napoleon I, who had been waiting in the wings in exile in Britain, finally succeeded in seizing power.

As France's new self-appointed emperor, Napoleon III instated an authoritarian regime, but was also a modernizer and recognized the need to restore French national pride. He revived a number of his uncle's progressive schemes, notably to improve the fabric of Paris. However, the combination of his grimly tenacious hold on power, the corruption and moral laxity of his court and administration and his foolish handling of foreign affairs eventually disenchanted his subjects. In July 1870, provoked by Bismarck's diplomatic machinations designed to unify Germany under Prussian leadership, Napoleon declared war on Prussia. He was forced to abdicate in September, humiliated by his army's failure to hold back the Prussian advance. The painful siege of Paris ensued until France capitulated in January 1871. The end of hostilities was followed in April by the establishment of the Commune – brief days of power and glory for the urban working classes, desperate to vent their frustration and at last influence the course of public events. This first socialist-inspired uprising was quickly stifled when the Versailles-based government, under the leadership of Adolphe Thiers, launched a bloody campaign to restore order. In short, the Third Republic, which was to become France's longest-standing republican régime and form the background to the consolidation of the Impressionist group, was established amid the national humiliation of a military defeat and internecine civil bloodshed. However, at least it restored to the French electorate the hope of building their own republican society upon the idealistic foundations of Liberty, Equality, Fraternity, proclaimed at the time of the 1789 Revolution and emphatically incised into

Paris's public buildings. From this date on, as the writer Émile Zola wrily observed in 1875, the French could put their military ambitions behind them and concentrate their offensive on a more secure arena, one in which they would be sure to triumph, namely that of culture.

Since the Impressionists, on the whole, cultivated an upbeat, positive view of the world, it would be tempting to suppose that their experience of that world must have been less troubled than our own. Tempting, but false. While we may legitimately seek broad historical explanations for the aesthetic tide that Impressionism represents, and even ask what Impressionist pictures can tell us about late nineteenth-century France, we should never consider these artists' works (or any others) as simple, straightforward reflections of their historical times. Artists select those aspects of their experience which they consider challenging, worth exploring and perpetuating. Even the most determined naturalists of the late nineteenth century never offered transparent, unmediated replicas of the reality of their times, any more than did the photographers, on whose example such artists frequently leaned and whose grainy, sombre, black-and-white images were an increasingly dominant feature of contemporary life. Nineteenth-century photographers, many of whom received a conventional art training, selected and framed their images and worked by reference to visual traditions.

We find the Impressionists responding to and acting on their world in innovative but recognizable ways, exploring new technologies, adapting for the canvas recently available pictorial languages – not just the photograph, but the fashion plate, the comic illustration and the Japanese print – in an effort to create an art appropriate to the new age. Yet, at the same time, as generations of artists had done before them, they complicitly catered to market forces, responding to their buyers' requirements, which might include portraying the sitter in a flattering light. Alternatively, they might assist the buyer to project a status-enhancing image of advanced taste, which, at that period, could encompass paintings of hedonistic eighteenth-century-style rural arcadias, or urban scenes of daring modernity.

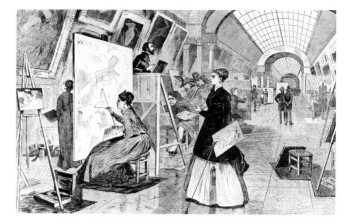

3. **Winslow Homer,** *Art Students and Copyists in the Louvre Gallery,* 1868

Where? The Importance of Paris

A consideration of Impressionism's origins also necessitates an examination of its place of birth (Paris and northern France), of French artistic traditions, techniques and practices in the 1860s and of intellectual currents and critical language. If the time was right, the place was undeniably conducive to the emergence of Impressionism. For many reasons, it was always likely that Paris, rather than London or Rome, would play host to the most exciting artistic innovations of the nineteenth century. There was wide recognition by mid-century of the importance of Paris as the cultural capital of Europe, indeed of the world. Not only could it offer the unparalleled riches of the Louvre, whose collections had been greatly amplified by Napoleon I's war booty, but it had a high reputation for its art teaching establishments. Whereas the ambition of the aspiring artist in the seventeenth and eighteenth centuries had been to visit Rome, just as in the mid-twentieth century it would be to work in New York, for the ambitious artist around 1860, Paris was the Mecca. As evidence one has only to look at the annual influx of hopeful art students arriving from the French provinces, from neighbouring European countries and from America. Most of them enrolled first at one of the private teaching academies and then moved on, if they were successful or lucky, to the École des Beaux-Arts. This was the pattern that most of the artists who went on to form the Impressionist group expected to follow.

But the measures of success that had been set in place by the Académie Française early in the previous century were being seriously questioned. In the past, the ultimate accolade for an École

3

4. **Louis-Auguste Bisson**, *Road and Rail Bridges*, c. 1860

des Beaux-Arts student anxious to make a career as a history painter was winning the annual academic prize, the Prix de Rome. This awarded the successful candidate a bursary to study the glories of classical and Renaissance culture at the heart of the ancient world. He was expected to master the techniques of complex figure compositions on lofty themes. It was required that prizewinners remained single for the duration of their stay in Rome, a practical rule perhaps but a clear indication of the monkish dedication that was, by tradition, attached to the idea of the artistic vocation. By the mid-nineteenth century, however, increasingly few artists were prepared to postpone family life in this way (Paul-Albert Besnard [1849–1934] for one absconded early in order to get married) and Rome was increasingly seen as an irrelevance. The Prix de Rome for landscape, for instance, was abolished as part of a series of academic reforms in 1864. In this respect, the young Degas was the exception in adopting the aspirations of an earlier generation. Even for native Italian artists the great ambition was now to go to the French capital. It is telling that some of the most successful Italian painters of this period – among them, Giuseppe de Nittis (1846–84) and Giovanni Boldini (1842–1931), as well as the less celebrated Vittorio Corcos (1859–1933) and Federico Zandomeneghi (1841–1917) – established their careers in Paris, working alongside and occasionally exhibiting with the Impressionists. Truly the tide had turned.

If the Paris institutions for art training were attractive to provincial and foreign students, so too was the opulent and modern image of the city itself. For all the faults of Napoleon III's Second Empire, it succeeded in giving Paris an extraordinary new look. Unprecedented levels of splendour were achieved not just in fashion and manufactured goods, but in architectural construction. Under the able administration of Baron Georges Haussmann, whom Napoleon III nominated Prefect of the Seine in 1853, a massive and far-sighted project of urban renewal was set in train. The new Paris left behind its previously divided character – partly medieval, partly classical. Envisaged first on paper, a modern city was gradually revealed to its citizens from behind the rubble, fencing and scaffolding. Paris emerged as a gleaming, visually harmonious European capital adapted to the demands of modern commercial life. The contrast with London at the period never failed to arouse comment. London, so contemporary visitors from France observed, was crowded and dirty, a confusing Babylon of a city, kept in perpetual motion by industry and trade. Its commercial possibilities were of considerable interest not only to

Alphonse Legros (1837–1911) and James-Jacques Tissot (1836–1902), who settled in London, but also to the dealer Paul Durand-Ruel and the artists Édouard Manet and Degas. As a source of motifs, however, it lacked the elegance and style of Paris and offered more to the artist of social realism than to the landscapist. Some of the most oppressive images of Victorian London life were drawn by the Frenchman Gustave Doré (1832–83), while London society and its docklands, the hub of the thriving Victorian Empire, were captured as acutely by Tissot, as by any of its home-grown painters. The Thames fogs had their own beauty, as the American painter James Whistler (1834–1903) discovered, closely followed by Monet and Pissarro, refugees in London during the Franco-Prussian War. Sisley, too, four years later, made the most of the motifs provided by London's urban parks and leafy suburbs.

Thanks to the latest transport technology, the railway, Paris in the 1860s could be reached with greater comfort and speed than ever before. A series of handsome new stations – the Gare Saint-Lazare, Gare du Nord, Gare de l'Est and Gare de Lyon – formed strategic features of the redrawn urban map. For large numbers of France's provincial population, a first experience of both Paris and rail travel coincided with visiting one of the Universal Exhibitions held at intervals throughout the period: the first was in 1855 and they recurred in 1867, 1878, 1889 and 1900. These grand staged events, inspired by Britain's Great Exhibition held at the Crystal Palace in London in 1851 and visited by Napoleon III, turned

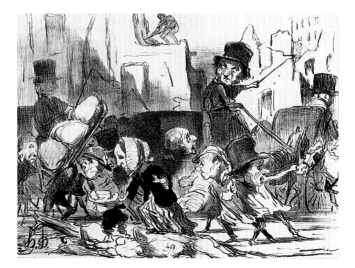

5. **Honoré Daumier,**
Scene Observed in the New Rue de Rivoli, 1852

Paris for months at a time into a showcase for French achievements in science, technology, manufacturing and the arts. A system of medals and prizes was set in place to encourage the raising of standards across the gamut of these fields. Through these exhibitions, France aimed to outdo her chief trade rivals and, in terms of tourism and visitor numbers, Paris could clearly outstrip London, Berlin, Vienna and Rome.

A consistent message was conveyed by the burgeoning fashion and travel literature of the period which spawned the familiar image of a frivolous, party-loving young woman as the symbol of Paris. Not even war could trouble this image for long. In the 1870s, after the destruction of the Prussian Siege of Paris and the Commune – during which the Hôtel de Ville, the Tuileries Palace and parts of the Rue de Rivoli had been virtually razed to the ground by the retreating insurgents – well-to-do Parisians were quick to regain their composure, social life resumed and Haussmannization continued apace. In fact it was not long before the travel writer George Sala, in his gossipy chronicle of 1878–79, was proclaiming 'Paris Herself Again', that is to say ready to cater to the needs of the (implicitly male) *bon viveur*. Somewhat more neutrally, the 1881 edition of Baedeker's guide describes Paris as a 'gay, splendour-loving, pleasure-seeking city', made up of 'spacious squares, noble avenues, and palatial edifices'.

The metamorphosis came about not through a series of piecemeal developments, as tended to happen in London, but through

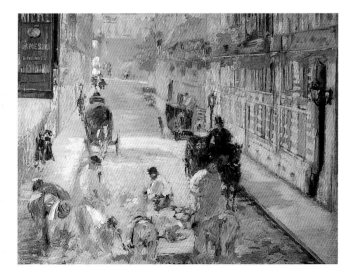

6. **Édouard Manet**, *Rue Mosnier with Pavers*, 1878
This was the first of three views Manet painted, using a light, Impressionist touch, of the newly laid-out street opposite his studio. Rue Mosnier ran parallel to the railway lines leaving the Gare Saint-Lazare and, according to Zola's *Nana*, published that same year, had already acquired a somewhat dubious reputation. This may explain the various stationary carriages parked at the kerb, awaiting gentlemen callers.

the implementation of a grand and logical plan involving large-scale repossessions of property. Enough of the old city's landmarks remained for most inhabitants not to feel alienated; even Victor Hugo, the great lover and champion of medieval Paris, was sufficiently converted to write in glowing terms of the changes. However, as in any such massive scheme, there were those who felt dispossessed, the etcher Charles Meryon (1821–68) for one, Renoir for another. They hankered after the old familiar Paris of narrow streets and class mixing, where ramshackle workers' housing cluttered up the courtyards of the Louvre and the Tuileries Palace. One of the chief aims of Haussmann's improvements was to rid Paris of such insalubrious accretions and facilitate the policing of troublesome workers' districts.

Together with the urban facelift, the newly laid-out avenues, boulevards, parks and open spaces, and the modern sewage and lighting systems, which gave the sense of a city opened to the sky, various factors helped to give Paris its superficial appearance of homogeneity and visual harmony. First, the building materials, the whitish limestone and its stucco imitation, lent the city a special quality of luminosity. Secondly, the continuation of the eighteenth-century policy of building apartments to a restricted height and roads to a regulation width maximized the amount of light received by individual dwellings. As a result, the new quarters, whether in the predominantly working-class east and north or the more middle-class and affluent west of the city, had a

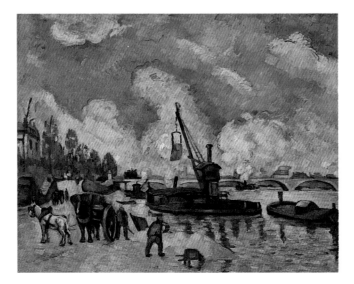

7. **Paul Cézanne**, *The Seine at Bercy* (after Guillaumin), 1873–75

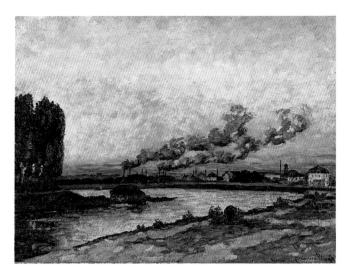

uniform look. (Nevertheless, there were clearly understood, if largely invisible, social distinctions between the various arrondissements; certain quarters were rarely penetrated by the affluent who tended to lead circumscribed lives centring around the Right Bank institutions.) Thirdly, there was the River Seine, an important cohesive factor ensuring for both newcomers and older residents of Paris a commonality of urban experience, whatever their social level. An integral feature of the city's history and her longest-standing link with the rest of France, the River Seine, after Haussmannization, assumed greater visual importance. No longer hidden from view or difficult to access, it was opened up to all through a series of embankments, quays and elegant bridges. These bridges were no longer cluttered by boutiques and houses but followed the model of the noble seventeenth-century Pont Neuf, still today Paris's focal point and the key link, via the Île de la Cité, between the Right and Left Banks.

The new generation of writers – naturalists such as Alphonse Daudet, Émile Zola, Guy de Maupassant, provincials who had moved to the capital – were fond of describing this age-old natural artery. In their short stories and novels, the Seine is, by turns, a glinting silvery ribbon, a stately parade of noble buildings, a bustle of laden barges, dredgers, cranes and laundry boats, a site for rural dalliance and a swirl of muddy eddies inviting the desperate to suicide. Not surprisingly, for the future Impressionists too, alert to the visual appeal of the city, the Seine became a central, recurrent motif. The landscape views of the eastern working quarters and of

7, 8

the western suburban villages such as Asnières, Bougival, Argenteuil or Chatou, which multiplied in the 1870s, usually have the Seine at their heart. And some of the Impressionists' earliest topographical views were painted in the summer of 1867 when Paris was thronged with crowds attending the Universal Exhibition. That summer Manet, Monet and Renoir each took possession of the city and painted bold, crisp views of central Paris from viewpoints adjacent to the river.

In *The Pont des Arts*, Renoir looked up from the quayside to the early nineteenth-century iron-built pedestrian bridge, so-named because it was the regular route taken to the Louvre by the members of the Institut de France, whose dome we see to the right, and by the students of the École des Beaux-Arts, just out of view.

9. **Édouard Manet**, *View of the Universal Exhibition*, 1867

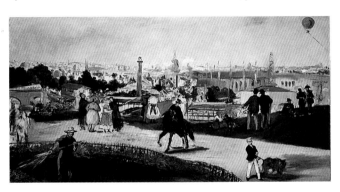

10. **Auguste Renoir**, *The Pont des Arts*, 1867

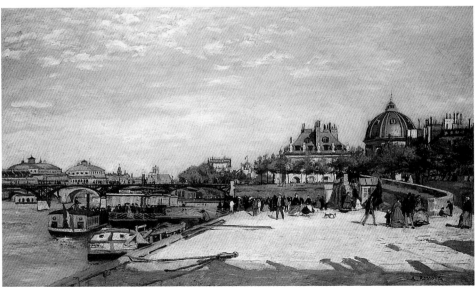

Despite the fact that the foreground is an empty vista, the overriding impression is of bustle and crowds. Brightly coloured crinolined ladies and top-hatted gentlemen cram on to a jetty where a steam ferry disgorges its passengers and prepares to depart again. Clearly Renoir chose his vantage point and time of day carefully, for it allowed him to incorporate the sihouetted shadows of people crossing the Pont du Carrousel behind him. Monet meanwhile stationed himself at the east end of the Louvre, intent on painting a view of the old church of Saint Germain l'Auxerrois but cutting out the newly completed town hall of the first arrondissement, a pastiche Gothic construction, which flanked it to the left. In another view from the same vantage point, *Garden of the Princess*, he looked south-eastwards towards the Panthéon, the vertical format allowing him to cut a visual and historic swathe through the city. At the top we see pearly grey luminous clouds and a venerable seventeenth- and eighteenth-century skyline; in the central band, heavily foliated trees, a fluttering tricolour and crowded quaysides; and in the lower foreground, ostentatiously gilded railings and trim newly laid lawns and flower beds. Here was evidence of Haussmann's improvements, for it was only a few years since the untidy lean-tos that used to encumber the east facade of the Louvre had been cleared to make way for this elegant urban space. In choosing such motifs, the artists were acting in tandem with a number of photographers, who recorded almost identical views of Paris *en fête* at the same date.

11. **Claude Monet**, *Saint Germain l'Auxerrois Church*, 1867

12. **Claude Monet**, *Garden of the Princess*, 1867

13. *The Tuileries Palace Burning, Paris 23 May 1871*

These 1867 paintings amount to a considered campaign of panoramic views of the city which rehearse topography – rather as Canaletto (1697–1768) had done for Venice – without engaging too closely with the city's population. Five years later, with the ravages of the Commune still a recent memory, Monet and Renoir returned to observe the Pont Neuf. While Monet relied on rapid execution to capture the effect of rain, this time Renoir allowed his interest to engage with the varied social types to be found crossing this famous bridge on a sunny day. He was surely aware of the saying that one could establish whether someone was in residence in Paris by watching the Pont Neuf closely for three or four days, for they were bound to cross at least once – an indication of the city's cohesive character. In Renoir's view we see a socially mixed crowd: tradesmen carrying or trundling their wares; soldiers; gentlemen with or without female companions; bustle-skirted ladies holding parasols, alone or with children in tow; and, at the heart of the animated scene, an amiable-looking police sergeant. To help him capture these unwitting models, Renoir's brother Edmond engaged passers-by in conversation, making inane requests for directions.

By 1873, Monet's focus of attention had shifted northwards, away from the picturesque riverside with its historic associations, to the new Haussmannized quarter around Charles Garnier's opera house, itself still under construction. From the third-floor vantage point of Nadar's photographic studio (where the First Impressionist Exhibition would be held a year later), Monet observed the ebb and flow of shoppers and strollers on the broad pavements of a busy commercial thoroughfare. In this version of the view we see a drab winter's day; there is possibly a light dusting of snow, or are we seeing reflections of the pale grey sky on the wet roofs of the cabs parked along the kerbside? Reminding us of our ability to look down on the scene from a privileged vantage point, Monet slips in two top-hatted viewers – mirror images of ourselves? – standing on a balcony to the right edge of the canvas.

Beyond the contrasts in weather conditions, time of year and location, it can be argued that Monet's *Boulevard des Capucines* and Renoir's *Pont Neuf* offer us fundamentally different perspectives on the urban scene. Where Renoir depicts the individual lives that constitute the city's population, allowing us to find human stories within the picture, Monet's figures are reduced to 'tongue lickings' of paint, as the critic Louis Leroy famously put it. In fact, by stressing his figures' anonymity, forcing us to see them as molecular units in a constantly shifting pattern whose surface movement interrupts the effect of perspectival depth, Monet presents us with one of the defining experiences of modern metropolitan life.

14. **Auguste Renoir**, *Pont Neuf*,
1872

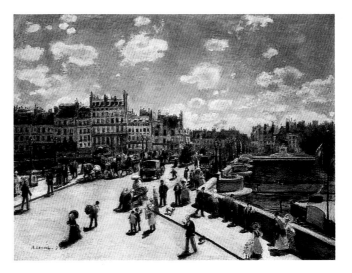

15. **Claude Monet**, *Boulevard des
Capucines*, 1873

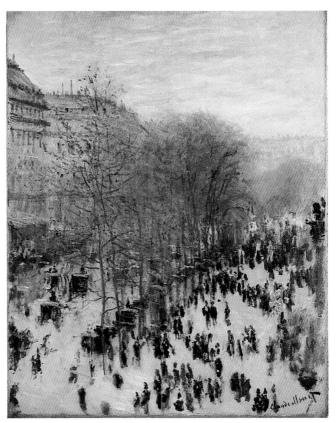

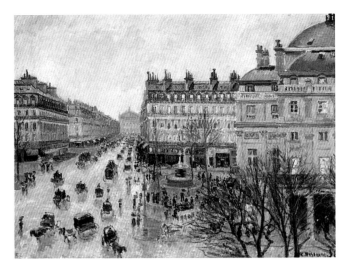

16. **Camille Pissarro**, *The Place du Théâtre Français, Rain*, 1898

To an extent the differences between the pictures are indicative of the contrasting tendencies of the artists' personalities. Renoir, who grew up in Paris and was primarily a figure painter, could not distance himself like Monet; for him, Paris was still a city rooted in the past, where human exchange was what mattered. Monet's position, as a relative newcomer to Paris and primarily an exponent of landscape and seascape, perhaps gave him the necessary detachment to render the novelty of the new urban experience in this radically modern way. Such an argument might extend to Pissarro, whose plunging views of Paris boulevards, painted late in his career – in the 1890s – from a range of strategically placed hotel windows, establish a distance between viewer and motif, which is comparable to Monet's. Pissarro undertook this series almost as a deliberate corrective to the rural subjects from which he had made his name. In them, we sense both his freshness and enthusiasm for the modern beauty of these luminous vistas and his Olympian ability to rise above the remote concerns of the city's street life. Caillebotte, whose own family fortunes had hugely profited from property deals under Haussmann, presents a somewhat different case again. It is interesting that when Caillebotte came to live in the Opéra quarter, he too chose to exploit the new boulevards' elevated balcony viewpoints, seeking, in Monet's wake, to translate the experience of living in the Haussmannized city. However, he did so in a stark and uncompromising way, seeing Paris in terms of abrupt, slanting angles and funnelling linear perspectives.

16

17, 18

17. **Gustave Caillebotte**, *Rue Halévy, Balcony View*, 1878

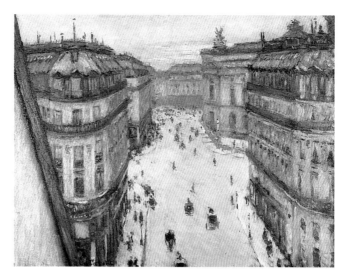

18. **Gustave Caillebotte**, *Boulevard Seen from Above*, 1880

Paris was Impressionism's cultural, practical hub. It was also emphatically Paris and the fertile basin around Paris known as the Île de France – not Brittany, not the Basque country, not the Mediterranean – that provided the necessary geographical and climatic inspiration for Impressionism. It evolved as a landscape technique that captured the mutability of season and weather specifically in northern Europe. One can extend the boundaries to encompass the Pas-de-Calais and the Normandy coastline, where artists like Monet and Manet worked successfully. Seen from Honfleur or Trouville, the skies and clouds over the English Channel were never the same from one moment to the next. One can even include neighbouring countries of temperate clime, such as Holland and southern England. But when artists tried to take their Impressionist techniques to other parts of France, particularly to the south, things started to go wrong. In 1872, on spending a holiday in the Basque country and completely unable to find the countryside around Saint-Jean-de-Luz in any way picturesque, Berthe Morisot complained: 'I do not like this place. I find it arid, dried up. The sea here is ugly. It is either all blue – I hate it that way – or dark and dull.... I have not yet found anything worth painting; everything is in the full sunlight, and on the whole nothing is very pretty.' A similar refrain was sung from Monte Carlo by her friend the Belgian painter Alfred Stevens (1818–85) twenty years later. Although known best for his

19. **Camille Pissarro**, *The Seine at Port-Marly*, 1872

fashionable interiors, Stevens was an accomplished painter of seascapes: 'I am staying in a very beautiful area, but ill-adapted to painting.... The sea is a formless lake and the clouds are not beautiful. The trees know neither summer nor winter, they stay continually the same, they don't have that certain something which appeals to painters.'

After several years painting Impressionist landscapes in the temperate agricultural Pontoise region, Paul Cézanne, when confronted by the intensity of light and hard rocky permanence of the southern landscape, ran into problems. Trying to devise a method of representing the Mediterranean coastline near Marseilles, he explained the difficulties to Pissarro: 'The sun here is so frightful that... objects are silhouetted not only in white or black, but in blue, red, brown, violet. I could be wrong, but it seems to me that this is the opposite of modelling.' But Cézanne, unlike these temporary visitors, seems to have risen to the challenge. During the 1880s he worked out a suitable adaptation of the Impressionist technique, replacing its subtle modulations of touch with blocklike patches and parallel strokes of colour which he felt gave his compositions a solidity and permanence comparable to that of his native Provence. But, in so doing, he was moving away from Impressionism's tonal and atmospheric concerns in a highly significant way.

Why? The Artistic Background
Clearly at one level, that of content or topography, one can discuss Impressionist paintings of the city and extract information from them. However they are not inert historical documents and once one moves to questions of style and artistic temperament, the suggestive, evaluative and interpretative roles of the historian come more forcibly into play. Before dealing more extensively with issues of style in Chapters Four and Seven, it is worth sketching some of the factors in the 1860s which prepared the ground for this major stylistic change.

One explanation for the marked concentration on colour and tactile qualities that we see in Impressionism lies in the swing of the stylistic pendulum. In the mid-eighteenth century, French rococo painters and decorators emphasized colour and introduced themes of lighthearted intimacy. By the early nineteenth century, the situation had reversed. After the Revolution, French painting was dominated by an austere form of neoclassicism with strong linear qualities. The Scottish artist David Wilkie (1785–1841) noted this when visiting a number of art studios in Paris in 1814.

20. **Warnod**, *Ships Entering the Port of Le Havre, c.* 1859

21. **Claude Monet**, *The Grand Quai at Le Havre*, 1874

He found Jacques-Louis David's (1748–1825) influence all-pervasive, particularly in the strength of figure drawing, and was disappointed by the complete dearth of any understanding of colour: 'I have not been able to discover in any of the French artists the slightest relish for this fascinating quality.' Wilkie himself was a notable colourist; together with Richard Bonington (1802–28) – and through their friendship with Eugène Delacroix (1798–1863) – he played his part in reintroducing colour and variety of subject to the French art of the period. But linear values continued to dominate the academic system, perpetuated through the pedagogic influence of Ingres and his pupils. By the mid-nineteenth century, a revival of colour, which some claim to be central to the French aesthetic, was long overdue.

It could also be argued that the dominance of mechanical forms of image-making, which increasingly constituted people's main experience of the visual in the mid-nineteenth century, led certain painters, in reactive self-defence, to optimize the special and exclusive properties of painting – namely, its colouristic and tactile values. Gustave Courbet (1819–77) for one, with his robust impasto technique, was crucial in reintroducing the tactile pleasures of painting per se to French art in the 1840s and 1850s. When photography was invented in the 1820s it had been supposed to herald the death of painting. Photographers consistently improved their techniques over subsequent decades, quickly achieving remarkable results in fields – architecture, portraiture, landscape – which were bound to make a forcible impact on the painting profession. At best, they affected its subject matter; at worst, they governed its working methods and threatened its very livelihood. In later chapters, I shall explore some of the many ways in which Impressionism betrays an awareness of photography. Suffice to say here that, at this period, painting and photography were in, and constantly presented as in, open competition. When a photographer named M. Warnod for example, having used a secret photographic technique, exhibited a work entitled *Ships Entering the Port of Le Havre*, a subject Monet would later paint repeatedly, the *Revue photographique* of 1862 hailed it as a major breakthrough. For a time Warnod stood alone as having achieved 'the instantaneity indispensable for the reproduction of objects in movement'. The same commentator observed that M. Warnod had achieved his success, 'with just as much harmony as on the canvases of the most highly esteemed painters and with an absolute truth, which the artist of the utmost genius would be powerless to attain'.

20
21

22. **Félix Bracquemond**,
Margot la Critique, 1854

If photography represented the most advanced image-making technology, the graphic arts, sometimes in tandem with photography, were still widely used for all forms of illustration. This was an era which saw an unprecedented expansion of the printed press. Graphic artists excelled at detail and precision: the tight and textured wood engraving was still the best form for conveying exact visual information, while the looser, more direct technique of lithography could convey more spontaneous effects. Etching produced more refined results and served as a reproductive medium but was largely practised by professional painters rather than by jobbing illustrators. Many fine etchings of animals, figures and interior scenes, as well as interpretations of older and more recent masterpieces (by Félix Bracquemond [1833–1914] 22 and Ludovic Lepic [1839–89], for example), were exhibited at the First Impressionist Exhibition; their presence must have made a striking contrast with the imprecise forms of the new manner of painting. Photography excelled at detail, too, but of an unselective, mesmeric kind. Both processes were still largely confined to black and white, while movement, as the example of Warnod shows, was still beyond the reach of all but a few technicians. In the fields of colour and motion, therefore, painters had an advantage they could exploit.

The new and larger audiences for painting that came into being in the nineteenth century were generally less informed and less educated than in the past and judged it by cruder criteria. Rather as in seventeenth-century Holland, the taste for grand idealized history painting waned and artists whose training equipped them to paint heroic historical scenes – Degas is a prime example – were forced to rethink in terms of representing their contemporaries, in portraits and small-scale, domestic and anecdotal genre pictures. The average art buyer's notion of value for money and suspicion of being duped made him naturally cautious of sketchy, suggestive painting. What appealed more were the highly polished and detailed pieces, which could be closely scrutinized and talked about. The highest-earning painter during the Second Empire was Ernest Meissonier (1815–91), who alternated rococo 23 pastiches with miniature versions of patriotic military painting. Another successful artist was Alfred Stevens, a protégé of 24 Meissonier, who began as a realist genre painter dealing with social issues, but settled, around 1860 on the specialism that would secure his lifelong popularity: pretty and fashionable women in meticulously detailed interiors, like birds in gilded cages. Morisot, Renoir and Degas were tempted by this route to success; certainly

23. **Ernest Meissonier**,
Painting Enthusiasts, 1860
This painting, a painstaking
reconstruction of an artistic circle
in the eighteenth century,
originally sold in 1860 for
10,000 francs, and five years
later fetched 27,200 francs.

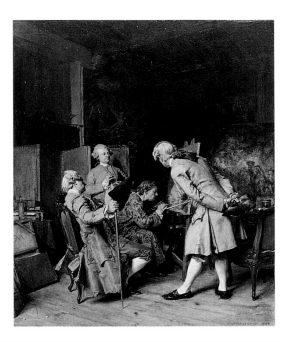

24. **Alfred Stevens**,
The Gift, 1865–70

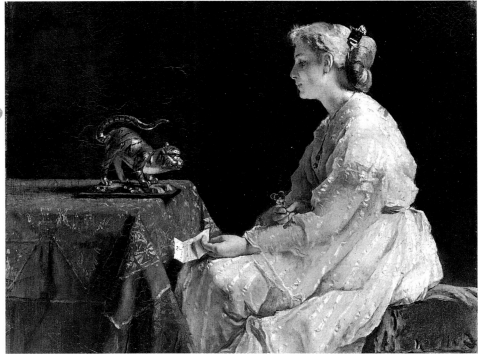

Degas's early genre interiors, which he himself regarded as commercial articles, appealed to the contemporary collector's appetite for minute precision. But Degas was dissatisfied by this style of painting and haunted by grander ambitions. 25

Charles Blanc's *Grammaire des arts du dessin*, first published in 1867, began to address this problem of lowered standards and neglected ideals specifically from the point of view of history painting. Blanc, as an informed Salon jurist, critic and art historian, was speaking from a standpoint which would become official policy under the Third Republic, when he was appointed Director of Fine Arts. His diagnosis was echoed from a different quarter by Jules Castagnary, an ardent supporter of realism, in his Salon review of 1867: 'We still haven't got beyond *la petite peinture* [by which he seems to have meant small-minded as well as small-scale], the painting of private life.' Castagnary however laid the blame for this state of affairs on the suppression of public life and trivialization of politics under the Second Empire.

What Blanc did not challenge, and perhaps did not see, were the inherent weaknesses of the academic system. Before establishing a career, the artist had major organizational barriers to overcome. In Paris, success was measured by having one's work selected, by a tightly controlled jury of academic French artists, for the annual state-run Paris Salon; better still, was to be favourably mentioned in the distribution of prizes. Winning an award ensured that the artist would be more respectfully considered by the jury in subsequent years. Certain artists gained

25. **Edgar Degas**, *The Rehearsal*, *c.* 1873–78

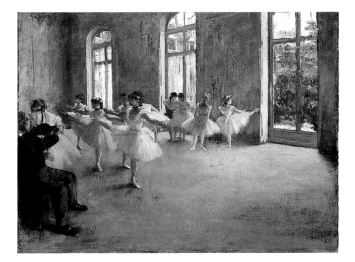

26. **Eugène Boudin**, *Setting Sun* or *Stormy Sky, c.* 1860

sufficient prizes and medals to be granted *hors concours* status, which exempted them from the jury selection procedure altogether and allowed them to show the maximum number of works (usually two) unchallenged. Meissonnier earned *hors concours* status in 1849, Stevens in 1867. Who sat on the judging panel was a key question when so much depended on a candidate's ability to win the jury's support. The whole system had given rise to a web of back-handed intrigue. For those without contacts in positions of influence, the gambit was to paint pictures that were bound to attract attention, by fair means or foul. One ploy was to ape the style of one's teacher, since the candidate had to announce the identity of his or her *maîtres* upon making a submission, and teachers on the jury tended to perpetuate their own influence by favouring their own pupils. A stipulation introduced in 1852 was the disclosure of the candidate's birthplace. This was intended to promote the regional schools and an artist might hope to gain favour with the jury by presenting an obviously regional subject. A third ploy was to paint on an unmissably vast scale. Indeed in the 1860s, as we shall see, size became a key issue for aspiring artists, such as Monet, Pissarro, Sisley and Bazille, anxiously preparing their main submission for the following spring.

Retrieving something of the critical discourse of the 1860s – as represented by its art criticism and by the various reputations of major artists – is a vital component of understanding the change in thinking that prepared the way for Impressionism. When considering the movement's antecedents, some people are puzzled to learn of the Impressionists' intense admiration for Delacroix. The standing and ideas of many painters of the previous generation had a self-evident bearing on the early development of the Impressionist style – Charles-François Daubigny (1817–78), Jean-François Millet (1814–75), Jean-Baptiste-Camille Corot (1796–1875), Courbet, Eugène Boudin (1824–98) and Johan Barthold Jongkind (1819–91) – but Delacroix's importance is less obvious. In his choice of subjects, he was inspired by the classics and the Bible, and his imagination was fired by romance and exoticism, by modern foreign literature and by his travels to North Africa. The Impressionists, on the contrary, gave a wide berth to the extremes of violence, drama and morbidity of the romantic generation and espoused instead unremarkable subjects drawn from their own time and place. Moreover, the Impressionists were working for a different audience, catering to the middle-class collector not to the grand secular or religious institution. They rarely set themselves, or were asked to undertake, ambitious

26

decorative schemes and their art finally cut ties with the baroque. Although the romanticism of Delacroix's subjects may have already lost its appeal for the artists of the 1860s, his free manipulation of intense colour, especially in his studies and pastels, was undoubtedly a major catalyst for change within studio practice. However, one might still object that, with the exception of certain canvases by Renoir, the cool blond hues that were favoured for the Impressionist palette do not look particularly similar to Delacroix's more fiery colour range.

27

Delacroix's importance lay also in his reputation, as an artist prepared to stand out from the academic prescriptions of the day and to withstand the assaults of the critics. Although the Impressionists did not know him personally, they learned of his thinking through the writers and critics of their generation. Delacroix's broad and literary culture, his noble sense of vocation and, above all perhaps, his serious dedication to the practice of art were all formative examples for Degas and Cézanne. And in a technical sense, his belief in the harmony and unity necessary to great art and in the need to preserve the verve and freshness of the sketch continued to hold meaning.

Henri Fantin-Latour's *Homage to Delacroix* is an important instance of the identification and solidarity Delacroix inspired in younger men. It includes two of the leading figures of realism in the 1860s, Whistler and Manet; the third, Courbet, is notable by his absence. To the right of the group sits the poet and critic Charles Baudelaire, champion of Delacroix's genius. In some ways his inclusion was paradoxical since Delacroix had scarcely answered Baudelaire's criterion for a modern artist, one who could seek out the epic quality in modern life. This was the challenge that artists of the 1860s were consciously addressing and which, in a sense, Fantin-Latour took up in these group portraits. Yet the eulogistic obituary of Delacroix that Baudelaire published in *Le Moniteur universel* in the autumn of 1863 reads like a blueprint for many of the innovations we associate with Impressionism: 'His was the most open of minds to all ideas and all impressions, the most eclectic and the most impartial sensualist [*jouisseur*].' Baudelaire went on to quote one of Delacroix's favourite dicta: 'Given that I consider the impression that nature transmits to the artist to be the most important thing to translate, is it not necessary for the latter to be armed in advance with all the most instantaneous methods of translation.' (By 'armed in advance' Delacroix meant with clean and ready sketching tools, but he was also openminded enough to acknowledge the assistance the camera could

28

offer.) Finally, Baudelaire's account laid great stress on the importance for Delacroix of imagination, which he considered 'queen of the faculties', and on using nature as a dictionary, to be consulted but not copied.

Given that Delacroix died in 1863, the date of Fantin-Latour's painted homage is highly significant. Little official notice had been paid of his death, just an insultingly modest exhibition of Delacroix's studio remains held in 1864 in the Boulevard des Italiens. (It was not until 1885 that the École des Beaux-Arts saw fit to honour him, as was customary, with a full-scale retrospective exhibition.) Admirers like Fantin-Latour were incensed by such an oversight; for them, Delacroix was one of the giants of the day who deserved to be revered.

As the case of Delacroix shows, in the writings of Baudelaire and others there was a mounting and concerted attack on the values of acceptable Salon painting, with its routine subjects and formulaic compositional devices, its inharmonious use of lighting, its high level of finish and its neat and glossy, licked surfaces. Reinforcing the broad message of Baudelaire was the art criticism of Théophile Thoré, a close ally of Courbet. In 1860, Thoré had returned to Paris after a period in political exile, but his socialist beliefs and former involvement in the 1848 Revolution meant that he was still regarded with suspicion by the Second Empire

28. Henri Fantin-Latour,
Homage to Delacroix, 1864
Standing, from left to right:
Louis Cordier (b. 1823),
Alphonse Legros, James McNeill
Whistler, Édouard Manet, Félix
Bracquemond, Albert de Balleroy
(1828–73). Seated, from left to
right: Edmond Duranty, Henri
Fantin-Latour, Jules Champfleury
(1821–89), Charles Baudelaire.

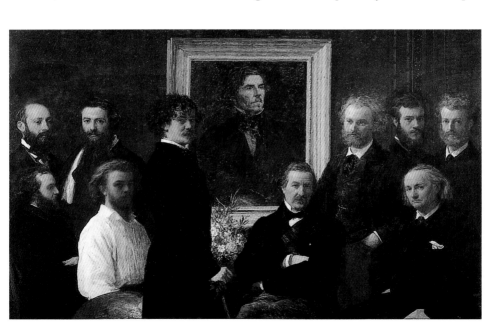

authorities. His endorsement of the realist painting tradition led him to write with equal enthusiasm of Rembrandt (1606–69), Jan Vermeer (1632–75) and Jean-Baptiste-Siméon Chardin (1699–1779). He revered them as exemplars of pure painting, painting that relied upon its own means – colour, light and chiaroscuro – rather than stealing the means of the 'draughtsman, the sculptor, the carver or the writer'. In the Salon of 1864, he chided Gustave Moreau (1826–98) for doing just that, while congratulating Manet for daring to pour scorn on 'the bashful lovers of discreet, neat and tidy painting'. Manet, with the luminous effects of his Velázquez-inspired brushwork and the blatant impudence of his Renaissance borrowings, served as a corrective to the unthinking recycling of Old Master prototypes which were taught in the École.

If Manet was a vital and direct inspiration for the future Impressionists, as we shall see in the following chapter, so was Gustave Courbet. Despite belonging to an earlier generation and having shed something of his dangerous political reputation by this date, Courbet was still an insistent and influential force in the art world of the 1860s. Proudly parading his origins – he hailed from the Franche-Comté in eastern France – Courbet had made it his mission in the late 1840s to ensure that the newly urbanized Parisians did not lose touch with the values of the countryside. Paintings such as *Burial at Ornans* (1850) and *The Stonebreakers* (1849) served as uncomfortable reminders for Salon-goers of the

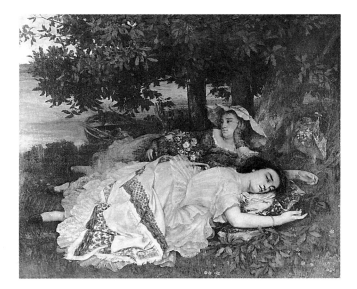

29. **Gustave Courbet**,
Young Women on the Banks of the Seine, 1856–57

30. **Honoré Daumier**, *Landscape Painters. The First Copies Nature, the Second Copies the First.* Lithograph from *Le Charivari*, 12 May 1865

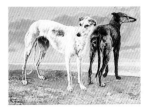

31. **Gustave Courbet**, *The Greyhounds of the Comte de Choiseul*, 1866

earthy peasant stock from which they often sprang. Having made his name during the Second Republic with a sequence of vast canvases of self-confessed socialist intention, featuring life-size real characters from his home town, Ornans, Courbet had survived the more repressive climate of the Second Empire with energy and resourcefulness. Admittedly, his name was linked to a somewhat down-to-earth vision of womanhood, expressed in lusty nudes, which not infrequently got him into trouble (see p. 168). His macho swagger and earthy subject choices never held much appeal for the city-born landscapists with a more delicate vision, such as Morisot and Sisley, who learned more from Corot. However, his commitment to an art of the real and his ability to wield a palette knife with gusto, coupled with his willingness to stand up to his critics and snub the authorities, earned him the admiration of the younger men.

In September 1863, Frédéric Bazille returned to Paris for his second year as a medical and art student with a letter of recommendation to Courbet. He had been given the letter by Auguste Fajon, a mutual artist friend from Montpellier. He was eager to act upon it and doubtless did so as soon as he could, but at the time Courbet was in Ornans for a long stretch. Bazille already knew Monet, a fellow student at Charles Gleyre's (1808–74) studio, and one imagines that their admiration for Courbet was a strong element in their friendship.

Courbet represented the rural outsider who had taken Paris by storm. As such, he was an important model for other ambitious provincials, among them, Monet, Bazille, Pissarro and Cézanne. His career had not conformed to the conventional academic pattern and he was committed to taking control of his own destiny. Part of this involved cultivating rich patrons, such as the Montpellier collector Alfred Bruyas who was well known to Bazille. Monet found himself drawn into Courbet's orbit, particularly in the year 1865. That summer, the artist from Ornans was to be found, incongruously, in Trouville, the favourite Normandy resort of well-to-do Parisians. Its promenade became a permanent fashion parade and its hotels vied with various spa towns for the custom of dukes and marquises. For an artist like Courbet, whose reputation preceded him and whose showman's instincts responded to an audience, Trouville offered rich pickings. He delighted in the bathing and turned out seascape after seascape, some with figures and dogs, emulating the success of the local artist Boudin whose ability to capture skies he acknowledged to be unrivalled. In between times, he fitted in a succession of portrait

29

30

31

32. **Berthe Morisot**,
Reading (The Artist's Sister),
1873

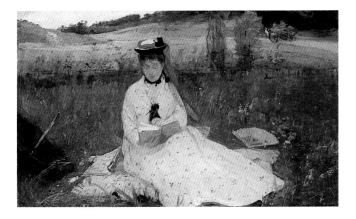

33. **Alfred Sisley**, *View of
Montmartre from the Cité
des Fleurs*, 1869
Although not exhibited there,
it is likely that Sisley had the
Salon in mind when composing
this Corotesque, poetic but
unpicturesque view of
Montmartre. At the time, he was
living with Eugénie Lescouezec
and their son in this marginal
district to the north of Paris,
which still retained something
of its rural character.

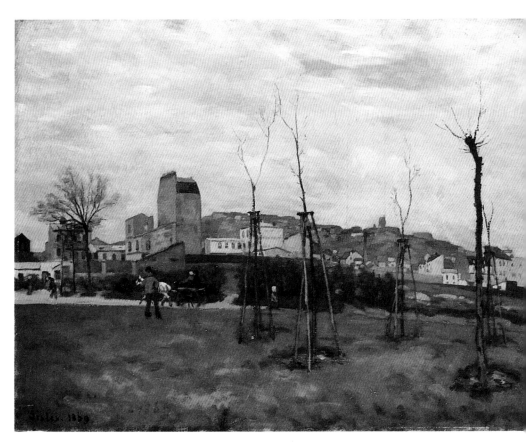

commissions. Monet would have been particularly interested in Courbet's seascapes, having already spotted this as a theme worth developing. He himself regularly submitted seascapes to the Salon in the late 1860s.

In Trouville, Courbet the radical did not hesitate to court the aristocracy, an object lesson for the younger artist in how such networking could further one's career. Courbet was adept, above all, at keeping his name and his ideas in the public eye through the Salon, private exhibitions, published statements and letters to the press. Although excluded from the official Universal Exhibition of 1855, he had nevertheless made his presence felt by staging his own one-man show in a temporary stand. At the Universal Exhibition of 1867, he repeated the strategy and Manet, at considerable financial cost to himself, followed suit.

It is difficult to say what kind of influence Courbet might have continued to exert in the 1870s had he remained in France. Instead he was forced to live out his final years in exile in Switzerland. This, and the vindictive rejection of his paintings from the 1872 Salon, was due to his known involvement in, and probable instigation of, one of the most deliberately provocative acts perpetrated by the Communards in 1871 – the toppling of the Vendôme Column. The destruction of this monument to Napoleon I's military victories was judged by the new Third Republic government as an example of rank anti-patriotism. Although Courbet served six months in prison, the huge fine he was required to pay to the French state remained an outstanding debt at his death.

Another crucially important strand of landscape practice to influence Impressionism was the painting of Jean-Baptiste-Camille Corot. 'Oh Corot, Corot, what crimes are committed in your name!' was one dismayed reaction to the First Impressionist Exhibition. Certainly an awareness of Corot's style – particularly of what Monet called 'his calm, hazy effects' – was evident in several of the works on show in 1874. It could be found in the limpid oil and watercolour landscapes studies of Morisot, whom he had taught, and in the carefully constructed *plein-air* scenes by Pissarro and Sisley, both of whom had consciously emulated the older painter's ability to create elegant and harmonious compositions and convey unified landscape effects. Indeed in the subtle minor key colouration of Monet's *Impression, Sunrise* and of Sisley's *Misty Morning*, we see Corot's preference for painting in the muted light of dawn. As these artists developed their landscape techniques in the 1860s and early 1870s, Corot's example, albeit a less emphatic one than Courbet's, came to mind unbidden,

32

33

119

36

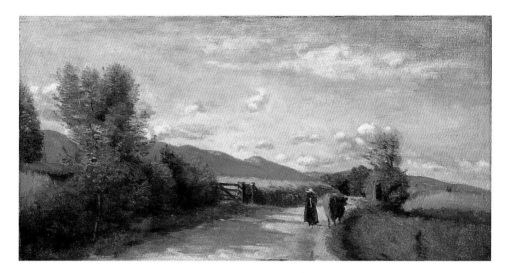

34. **Jean-Baptiste-Camille Corot**,
Dardagny, Morning, 1853

35. **Camille Pissarro**,
The Crystal Palace, 1871

in certain motifs or effects, such as a path or road with small 34 figures leading the eye into a composition or a certain grouping of trees. It happened to Monet, when he set about painting the road near the Saint-Siméon farm, and to Pissarro, when he began to explore the motifs around Louveciennes, Dulwich and Pontoise. 35, 156

Just as Delacroix was the name to conjure with for Whistler, Manet and Fantin-Latour, within the broad realist tendency of genre painting and landscape, Courbet and Corot were the dual touchstones of quality. By the end of the 1860s, for the ambitious young painters who would go on to form the Impressionist group – Monet, Pissarro, Cézanne – there was a tangible excitement, a real sense of being in the right place at the right time, of revolutionary change being in the offing and a new art, like the new city, being about to emerge from the rubble of past traditions.

36. **Alfred Sisley**, *Misty Morning*, 1874

37. Henri Fantin-Latour,
A Studio in the Batignolles, 1870
The studio gathering brings together,
on the right, Monet and Bazille
(in profile), and standing on the left
Renoir and Otto Scholderer
(1834–1902), all four associated
with the new realism; in the centre,
next to Bazille, stand the critic and
musician Edmond Maître and the
novelist and art critic Émile Zola, his
right hand prominent; the critic and
painter Zacharie Astruc poses while
Manet paints his portrait.

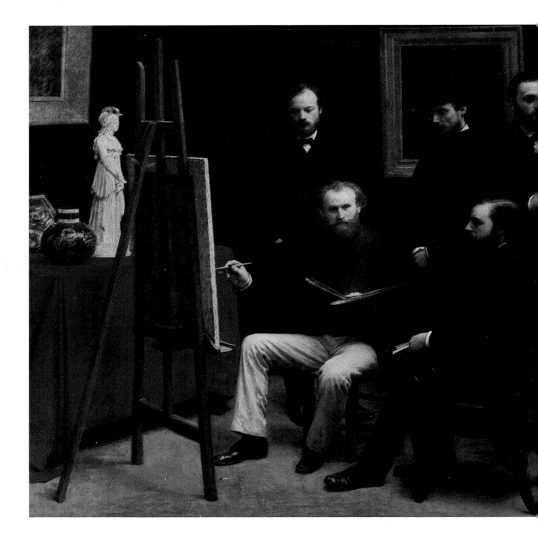

Chapter Two: The Artists of the Batignolles

When discussing the elective affinities of the artists who would become the Impressionists, art historians frequently cite Fantin-Latour's 1870 group portrait of a collection of artists and writers gathered around the central figure of Édouard Manet, a painting entitled *A Studio in the Batignolles*. It is certainly a historically important work, both for proposing Manet in the role of leader and for pointing to the Batignolles quarter as the new home of advanced modern art. Although, in some ways, it is convenient to look at it as a summation of the issues of the 1860s, Fantin-Latour's painting also raises more questions than it answers.

37

The Batignolles, to the north-west of Paris's city centre and bordered on one side by the raucously popular Boulevard de Clichy and on another by the still semi-rural heights of Montmartre, was indeed fast developing into an artistic quarter, supplanting the Latin quarter with its romantic and academic associations. Manet was undoubtedly a catalyst and rallying figure for the rising generation, which included Renoir, Bazille and Monet, who shared studios nearby. But did his admirers form a cohesive group in 1870? More importantly, was Manet really the leader of the new movement in painting as Zola thought or the leader of Impressionism as his biographer, Antonin Proust, would later claim?

In some ways *A Studio in the Batignolles* is a reprise, with a different cast of characters and less fervent emotion, of the *Homage to Delacroix* of six years earlier, but interestingly this time Fantin-Latour excludes himself. In the interim he had essayed a painting of a group of artists paying homage to truth as represented by a female nude, before giving up the idea as hopelessly incongruous. If Delacroix had stood for painting inspired by imagination, Manet emphatically represented painting inspired by nature. But Delacroix was a haunting memory where Manet was clearly the man of the future. All of Fantin-Latour's group

28

38. **Bertall**, *Jesus Painting amid His Disciples* or *The Divine School of Manet*, 1870

portraits (there were two more to come, showing writers and musicians) represent young friends paying homage not to their actual teachers and patrons but to their chosen heroes from the present and recent past. One might suggest that those involved were undergoing a common crisis of identity, a sense of uncertainty as to who they were and what they now believed in, which found reassurance in these traditional expressions of professional solidarity around a substitute father figure. Such groupings can be seen as expressions of the advanced and rebellious aesthetic tastes of the young men depicted. In 1864, Delacroix still stood for certain notions of opposition and expressive freedom, while in 1870 Manet's turbulent relationship with the Salon authorities and critics was well known. Although the impulse to stand up and be counted as a group became more or less *de rigueur* for successive avant-garde movements, it is important to recognize the danger of allowing the idea of the avant-garde to oversimplify historical facts.

38

39. **Thomas Couture**, *A Cuirassier*, c. 1856–58

Take the notion of these artists rebelling against and breaking free from their teachers. Manet had been a pupil of Thomas Couture (1815–79), himself an artist of considerable daring particularly in his departure from the smooth polished surfaces accepted by academic convention and in his cultivation of an abrupt and sketchy technique. It used to be claimed that Manet and Couture had such a stormy relationship that Manet rejected everything he had been taught. A comparison of the two artists' techniques suggests otherwise. Monet, Renoir and Bazille were all former pupils of Charlés Gleyre. Indeed it was through the studio of this somewhat paradoxical Swiss artist, renowned for his low

39

fees, that they first met. Gleyre's own painting style, a somewhat fusty and precise neoclassicism overlaid with orientalism (Gleyre had spent time in Egypt as a young man), can have held little appeal for a devotee of landscape such as Monet. Gleyre's teaching placed the conventional emphasis on outlines and draughtsmanship. His attachment to the ideal of beauty, as handed down from the Greeks, and his opposition to the new school of naturalism, as preached by an artist like Courbet (for Gleyre, nature was an embellishment to a composition, no more), marked him as conservative. Yet Gleyre was described as an admirable teacher by Castagnary, Courbet's friend, due to his tolerance towards the individual's natural aptitudes. As well as several of the future Impressionists (Sisley was another pupil), he had played a part in training artists as varied as Whistler, Lepic and Albert Anker (1831–1910), a fellow Swiss. Gleyre was also an anti-establishment figure; his principled republicanism led him to avoid exhibiting at the Salon throughout the Bonapartist Second Empire.

40. **Charles Gleyre**, *Minerva and the Three Graces*, 1866

Renoir, who was enrolled in Gleyre's class for the longest, from 1861 to 1864, took the teaching programme most seriously. This perhaps accounts for his continuing with certain themes and artistic attitudes that sit oddly in the context of Impressionism, whose predominant commitment was to modern-life realism. Renoir's nude Salon submission *Diana the Huntress*, rejected in 41 1867, was recognizably a Gleyre subject, albeit executed in a manner that revealed Renoir's admiration for Courbet and his first-hand experience of studying nature. His occasional orientalist fantasies and his later golden-age arcadian images featuring nudes, who conformed to his own ideal, perhaps carry distant echoes of Gleyre's own fascination with the idea of the earthly paradise. But studying nature direct and working *en plein air* (in the open air) did not form part of the Gleyre syllabus (despite those who have stated the contrary, based on a misinterpretation of one of Bazille's letters). This was a grave omission in the eyes of the young radicals in his charge, who took delight in deserting the teaching studio for the Forest of Fontainebleau.

While all those present in Fantin-Latour's *A Studio in the* 37 *Batignolles* admired or supported Manet and were his friends, none had been taught by him as the composition suggests. Certainly there were interrelationships which the painting catches: both Astruc and Maître owned pictures by Monet, the former having bought his *Saint Germain l'Auxerrois Church*, for instance. Manet 11 and Bazille had first met at the salon of the cultivated Commandant and Madame Lejosne and the latter features in Manet's *Music in the Tuileries Gardens*. But the *Studio* conveys a 44 seriousness and unity of purpose which, with hindsight, looks premature and misleading given the precariousness of the artists' careers and unstable nature of their affiliations. Just as Zola was Manet's defender in print, Maître was a close friend primarily of Bazille and Fantin-Latour. Within a year, two of those present were no longer part of the Paris art scene: Scholderer, a German artist, returned to his native Frankfurt, while Bazille lost his life in the Franco-Prussian War. The painting predates and does not comprise the full membership of the Impressionist group, whose founding principle of exhibiting outside the official Salon Fantin-Latour would in any case oppose; it omits Degas, Pissarro, Armand Guillaumin (1841–1927) and Sisley. Although this fraternal image excludes women, by 1869 close ties of friendship and art practice already linked Fantin-Latour and Manet to Berthe Morisot, former pupil of Joseph Guichard (1806–80) and protégée of Corot. She had posed for Manet on more than one occasion and

41. **Auguste Renoir**,
Diana the Huntress, 1867

42. **Berthe Morisot**, *Reading*, 1869–70
Here the sitters are the artist's mother, in black, and sister Edma, in white and expecting her first child. Berthe Morisot's sister Yves had posed for Degas in the same room and on the same sofa only a few months before. Morisot had qualms about sending it to the Salon as her own work after Manet had made several alterations to Madame Morisot's skirt and head, but it was nevertheless accepted and exhibited there in 1870.

43. **Frédéric Bazille**, *Manet Drawing*, 1869

in 1870 he was taking a close interest in her development as a painter.

Strangely, when the Impressionists began to be seen as a coherent movement later in the 1870s, no attempt seems to have been made to produce a group portrait of the members, in photographic or painted form, despite the fact that there are individual portraits aplenty. Were such a document to exist one would also wish it to include Caillebotte, who joined in 1876, the longest-serving active female member Berthe Morisot and, depending on the date, Mary Cassatt, Félix and Marie Bracquemond (1840–1916) and Paul Gauguin (1848–1903). One might baulk at the inclusion, however, of artists such as Jean-François Raffaëlli (1850–1924) who took part in only two exhibitions. And so the arguments would go on, for Impressionism was a fluid and elusive artistic movement. The lack of just such a self-conscious documentary record is in itself, I believe, symptomatic of a change in the perception of the avant-garde between the 1860s and 1870s.

Rather than any image of a clear-cut group gathered around a figurehead, we have documentary evidence of a sequence of exhibitions and the critical responses they spawned.

So how finally does Fantin-Latour's painting address the topic of Manet's significance for his peers? Manet was a charming and convivial artist who thrived on contacts with others. He was an habitué of the café, a witty man about town or *boulevardier*. If, in the 1870s, he stood out from the Impressionists by remaining committed to showing his work at the Salon, it was probably due to his belief in addressing the broad democratic public that attended the Salon, a belief he considered consistent with his republicanism, rather than because he had grander designs than the others on the judgment of posterity. Fantin-Latour, however, shows a sober and neat studio setting, summarily indicated by the easel and a few other references to works of art, including the empty frame on the wall behind Renoir. The painting's somewhat melancholy mood and meticulous style gives little sense of what made Manet an artist to talk to and to watch: his bravura *alla prima* technique, his stark use of lighting which allowed him to dispense with fastidious half-tones and his highly individual modern subjects. The incongruous statuette of Minerva – perhaps a hangover from his earlier image dedicated to truth – and the decorative oriental porcelain jar on the table seem to derive from Fantin-Latour's own commitment to tradition and the still life.

43

78

44, 224

44. **Édouard Manet**, *Music in the Tuileries Gardens*, 1862 Although many of Manet's paintings in the 1860s were single figure subjects, here he tackled an outdoor crowd scene. As well as the artist himself (far left), the following have been securely identified: the artists Fantin-Latour and Zacharie Astruc; the writers Théophile Gautier, Aurélien Scholl and Baudelaire, who had urged artists to tackle just such contemporary subjects; Madame Lejosne (see p. 70) unveiled and facing the spectator; and Jacques Offenbach, to whose music they could well all be listening.

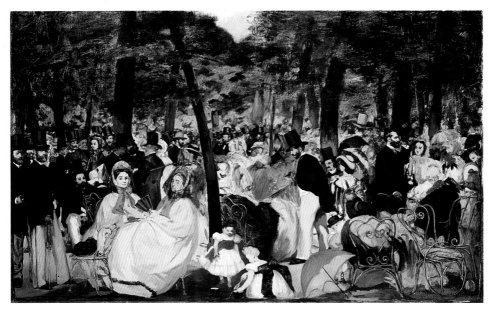

A livelier impression of Manet is conveyed by Bazille's *The Studio in the Rue La Condamine*, a parallel document to Fantin-Latour's painting. Here an informal atmosphere reigns. Edmond Maître is at the piano. The studio is a light-filled room with a wide range of pictures, framed and unframed, stacked and hung. Manet, asked to give his opinion of the painting by Bazille on the easel (*View of the Village*, painted in 1868 and exhibited to some acclaim in the Salon of 1869), is clearly in full flow and although Bazille and Monet listen attentively, others in the room pursue a different conversation. Bazille, like Renoir and to a lesser extent Monet, almost certainly modelled his early ambitions on the example of Manet. This is clear from his direct and bold painting style and the wide range of subjects he undertook – glimpsed in the studio are not only his own works, but paintings by Renoir and Monet too – male and female figure compositions, portraits, landscapes, seascapes and still-life subjects. Manet's high reputation in his own day was due to both his technical skill and his breadth of range. He worked in every genre, even tackling religious and military subjects.

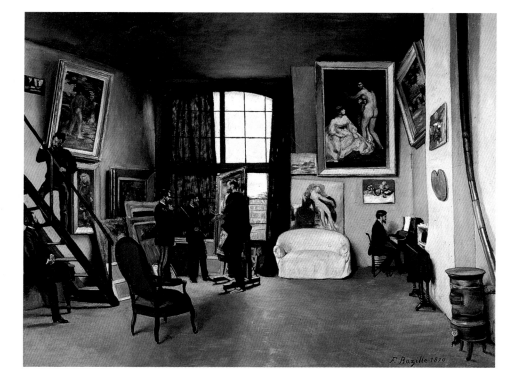

45. **Frédéric Bazille**, *The Studio in the Rue La Condamine*, 1870

46. **Édouard Manet**,
Le Déjeuner sur l'herbe, 1862–63
Exhibited at the Salon des Refusés
in 1863

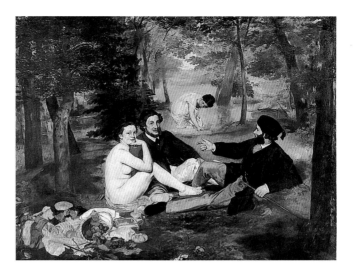

47. **Gillot**, *Salon de 1863: les
Refusés*. Published in *La Vie
Parisienne,* 11 July 1863

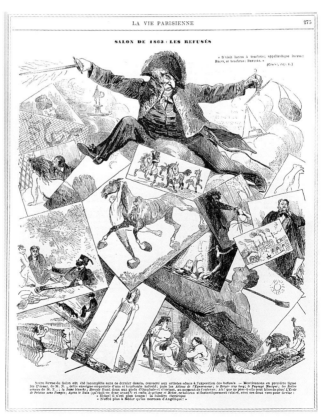

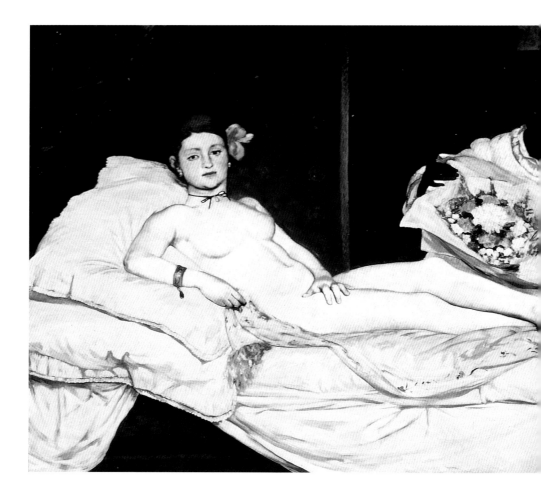

48. **Édouard Manet**,
Olympia, 1863
Exhibited at the Salon of 1865

49. **Bertall**, caricature of Manet's
Olympia. Published in *Le Journal
amusant*, 27 May 1865

MANETTE, ou LA FEMME DE L'*ÉBÉNISTE*, par MANET.
Que c'est comme un bouquet de fleurs.
(*Air connu.*)

Ce tableau de M. Manet est le bouquet de l'Exposition. — M. Courbet est distancé de toute la longueur
du célèbre chat noir. — Le moment choisi par le grand coloriste est celui où cette dame va prendre un bain
qui nous semble impérieusement réclamé.

What first drew Manet to public notice were his two provocative early nude paintings, which continued the themes of Old Master painting but, in doing so, confronted problematic issues of the modern world. However, the recent tendency to see his approach to this ostensibly timeless subject as the central issue of his career is over-reductive. In *Le Déjeuner sur l'herbe*, exhibited at the Salon des Refusés of 1863, an undressed woman who shares a picnic with a couple of young men, taken to be students by *Le Figaro*'s critic, engages the viewer with her bold stare. In *Olympia*, painted the same year but not exhibited until the Salon of 1865, we come face to face with the same naked model; with her fashionable red hair, her tell-tale black velvet ribbon choker and her fancy satin mules, she is unquestionably a woman of the 1860s. Such titillating details of costume and jewelry, the discarded oriental shawl and the bouquet presented by the black maid, all unmistakably marked her for the audiences of the day as a courtesan. In this era of public moral decline, there was nothing unusual in mistresses and *filles de joie* (women of easy virtue) being presented to Salon or theatre audiences in the unconvincing guise of classical goddesses. The name 'Olympia', which is given to the model, whose real name was Victorine Meurent, paid lip service to this convention, whilst also being redolent of the pseudonyms of the more well-known courtesans of the day. But what critics and the public found more disconcerting, indeed outrageously shocking, was the matter-of-fact attitude of her uncoquettish stare, which implied an exercise of power over men devoid of all qualms. Those few who noticed that Manet had invented neither of these compositions but had borrowed and adapted them from the most respectable sources – namely the paintings of Giorgione (1477–1510) and Titian (1487–1576), and a print by Marcantonio Raimondi (1480–1534) after Raphael (1483–1520), as spotted by the critic Ernest Chesneau – could only wonder at his brazen audacity, seeing a desire to scandalize as paramount. Few enquired as to the deeper motivations Manet might have had for playing around with classical tradition in this way, steeped as he was in admiration for the figure-based art of the Old Masters.

In many ways Manet's preoccupations as an artist could not have been further from the landscape concerns of Claude Monet. Where Manet was steeped in the Venetian and Spanish traditions and admired the technical mastery of a Frans Hals (1580/5–1666), Monet, after showing initial skill as a caricaturist, had been taught in Normandy by the sky and seascape specialist Eugène Boudin, to whom he referred back with his first responses to art in

50. **Charles-François Daubigny**, *The Banks of the Oise*, 1859 The degree of realism achieved by Daubigny in tranquil riverscapes such as this led Théophile Gautier to describe them as 'pieces of nature cut out and set into a golden frame'. Nadar's amusing caricature of a Salon visitor stripping off to dive in to the picture makes essentially the same point.

Effet produit sur un visiteur du salon par l'eau des merveilleux tableaux de M. DAUBIGNY.

51. **Nadar**, caricature of Daubigny's *The Banks of the Oise*. Published in *Le Journal amusant*, 16 July 1859

Paris. Monet found himself naturally drawn to the artists of the Barbizon school, to artists such as Théodore Rousseau (1812–67), Narcisse Diaz (1808–76), Courbet and Daubigny. But in 1865–66, when Monet was casting around for a suitable idea to present at the next Salon, Manet made a decisive impact.

50, 51

Although, unlike his fellow students Bazille and Renoir, the idea of tackling a Courbetesque figure composition or a nude had never crossed his mind, something about Manet's *Déjeuner sur l'herbe* made Monet want to attempt his own version, an undertaking he tackled on a vast canvas and, somewhat mulishly, out of doors. He may have been inspired in part by a career-driven wish to exploit the critical debate that Manet's treatment of the subject

53

had aroused, since Monet had an instinctive feel for publicity. But Monet clearly also wanted to experiment with Manet's exciting broad brush technique and to try to depict on a grand scale the kind of informal grouping of unequivocally modern figures that Manet had represented in his *Music in the Tuileries Gardens* of 1862. He would surely have been aware of Manet's weak rendering of the landscape setting, which looks more like stage scenery than an actual forest. Monet, with Bazille, had already spent time in the Forest of Fontainebleau studying trees, singly like Rousseau, or in clearings and avenues. Sisley and Renoir were also devotees of the forest around Marlotte. When it came to rendering the outdoor setting, Monet and his friends could outdo Manet with ease. Perhaps there was also an element of realist critique in his determination to dispense with the awkward nude in favour of the more plausible arrangement of a group of fashionably dressed figures, male and female, gathering for a picnic. Bazille obliged Monet by travelling out to the Forest of Fontainebleau and posing for several of the male figures. As we know from Bazille, who shared his studio with Monet at this date, Courbet, with whom Monet had fraternized that summer, made a point of keeping a watchful eye on the painting's progress. Monet seems to have acknowledged this support by making the seated man to centre left resemble Courbet.

44

2

52

52. Anonymous photograph, 1860s

(overleaf)
53. **Claude Monet**,
Le Déjeuner sur l'herbe, 1866
This was probably painted as a study for the full-size version of the same subject. Monet subsequently cut the larger painting up into segments (Musée d'Orsay; the central portion is reproduced on the cover). The Moscow painting gives the fullest idea of the daring composition with which Monet planned to create a stir at the Salon of 1866, before he ran out of time and funds.

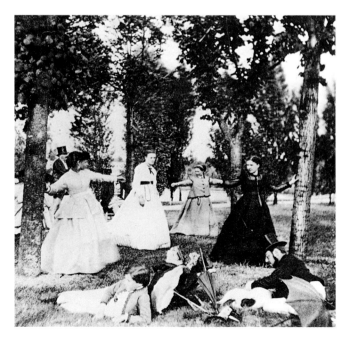

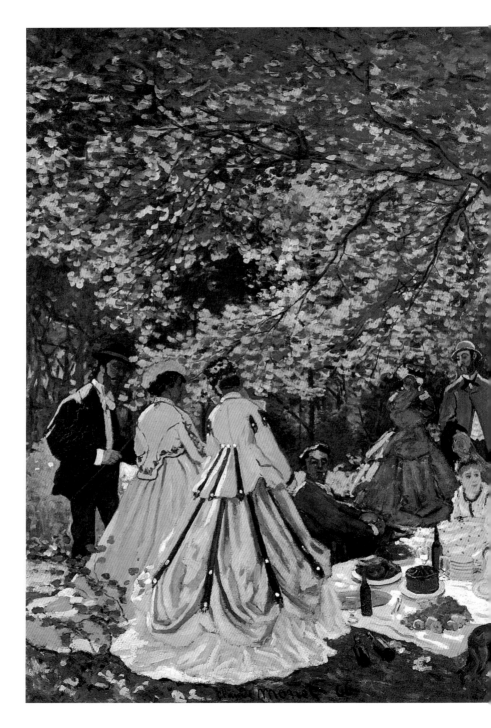

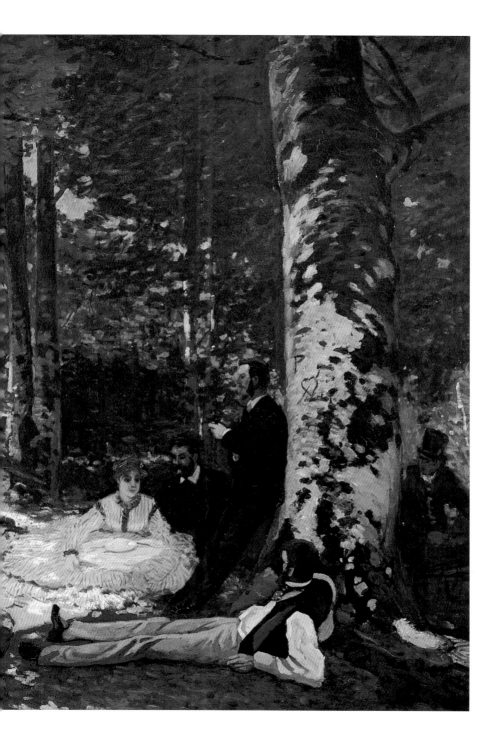

Eventually Monet came to the conclusion, with a few days to go before submission date, that the work could not be completed in time. He decided to cut his losses and attacked, at great speed and on a huge canvas, another Manetesque idea. This was a standing figure in a neutral setting, for which his girlfriend Camille Doncieux posed in a striking green striped satin gown. The painting is a good example of Monet's energy, extraordinary confidence in his abilities and opportunism. The dress, the focal point of the composition, was one that Bazille had hired for his own Salon submission that year, the equally ambitious *Young Woman at the Piano* (1866), so it was still hanging about the studio they shared. Whereas Bazille's painting, now lost, was rejected by the Salon jury, Monet's *Camille in a Green Dress* was accepted and gave him his first triumphant success.

54

54. **Claude Monet**, *Camille in a Green Dress*, 1866

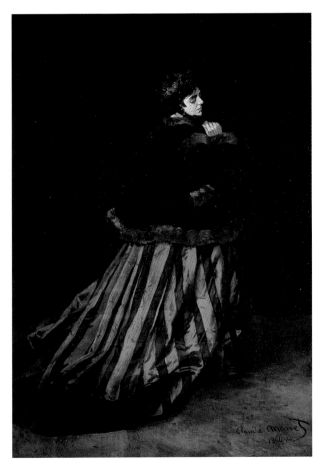

The innovative importance of such paintings as Monet's *Camille*, as Leila Kinney has argued, lay in the artist's collapsing or confusing the category of portraiture and making inroads into the notion of distinct genres. Manet's figure paintings, for example, often contain prominent still-life elements whose presence has no clear motive other than that of providing a colour accent. The scale of *Camille* was larger than a conventional portrait (canvases of portrait format were sold ready-prepared by the colour merchants), larger even than Manet's lifesize *Street Singer* of 1862. The choice of a rear viewpoint, a standard device of the small-scale coloured fashion print because it enabled the details of the costume to be seen to advantage, again flouted portrait conventions. Although, according to Monet himself, it was an unmistakable likeness, Camille has more the look of a mannequin than an individual personality. This, together with Monet's handling, with its abrupt transitions from dark to light and the most schematic treatment of the face, made nonsense of any traditional understanding of portraiture.

Just as his pictures offered direct challenges and examples of a new way of painting, Manet's management of his career in the 1860s offered a piquant precedent to younger ambitious painters like Monet, Renoir and Bazille. They observed how his works were alternately accepted and rejected by the Salon jury for apparently arbitrary, possibly vindictive, reasons, which in either case highlighted the injustices of the official system. They applauded the fact that, when rejected, he resorted to the expedient of holding private exhibitions, such as the one at Louis Martinet's gallery in 1863, or outside the Universal Exhibition of 1867.

Despite the success of *Camille* in 1866, in 1867 a particularly harsh selection procedure resulted in Monet, Renoir, Sisley and Pissarro all being rejected by the jury. This arbitrary slap in the face gave the cue for the younger generation's long-held discontents to come to the surface. The previous year Antoine Guillemet (1841–1918), a painting companion of Cézanne and Pissarro (they had met at the Académie Suisse), had recorded in a letter the semi-serious revolutionary discussions that he and Pissarro had been having over lunch, for the benefit of their mutual painter friend Francisco Oller (1833–1917), back in his native Puerto Rico. After comparing the merits of Courbet and Manet and the importance of employing bold *taches*, or patches, the painters had railed against the obduracy of the Salon jury and, as the arguments became more heated, toasted the idea of overturning the old order, burning the Louvre, destroying all museums and dancing on the stomach of

the terrified bourgeois. In the spring of 1867, Comte de Nieuwerkerke, Superintendant of Fine Arts and, as such, the intermediary between the general body of practising artists and the imperial administration, was made forcibly aware of the existence of this clamorous band of young artists no longer prepared to swallow their grievances and accept their fates lying down. He received a letter of petition requesting the reinstatement of the Salon des Refusés. It was penned by Bazille and signed by a long list of artists who had been rejected, starting with Monet, Renoir, Pissarro, Sisley and Guillemet, and including Manet. It also contained the names of artists who had been accepted, but supported the move, among them Jongkind, Daubigny and Diaz. The letter probably arrived on 1 April and so may well have struck de Nieuwerkerke as an unwelcome April Fool. He would ignore it at his peril for, as Bazille wrote to his mother, the petition had been signed by 'all the painters in Paris who had any value'.

A factor that might have steeled Bazille's resolve for such a task was the experience he had already gained in another sphere of the tyrannical control the Second Empire government could wield and the resentment and unrest this caused. In 1862, in his first year as a medical student, Bazille witnessed a student riot which erupted when the faculty inaugurated a new dean, whose nomination to the post was unpopular, inappropriate and blatantly political. The government had overstepped the mark, for the École de Medicine prided itself on its freedom from government interference. The students' disruption of the ceremony and the resulting injuries and arrests, which Bazille described to his parents, were, as he predicted, completely covered up by the press. For the painters who would soon form the Impressionist group, events in 1867 brought their dissatisfactions with the Salon system and the dictatorial government to a head and gave them the confidence to make themselves heard. But de Nieuwerkerke did little apart from promise adjustments to the jury selection procedure the following year. The request for another Salon des Refusés fell on deaf ears, as the artists had expected it would.

Manet's one-man show opened, accompanied by a catalogue which reprinted Zola's spirited defence of the artist, outlining his unfair treatment by officialdom. Zola had first written in praise of Manet in *L'Événement* the previous year. Indeed Zola's trenchant views on art and his inflammatory opinions about the corruption of the Salon jury system had resulted in his losing his job on a paper which was, incidentally, widely read by artists. It was largely in a spirit of solidarity and gratitude that Manet undertook to

paint that winter his *Portrait of Émile Zola*, in many ways a manifesto of the modern ideas in painting that he, with the support of Zola and his younger colleagues, represented.

Events in 1867 had given younger artists good reason to rally around the figure of Manet. Bazille had shown the makings of an activist. It is difficult to say whether, given the tempered nature of his revolutionary ambitions, he would have emerged as a leader in the 1870s. In any case his premature death in 1870 brought a brutal end to his contribution to the new painting impetus. It was important nevertheless that the possibility of separate exhibitions had been mooted. The artists with whom Manet associated were now hardened in their determination to take affairs into their own hands. Although nothing further was done that decade, a number of the ideas aired then were revived six or seven years later, when the group of Manet admirers joined forces with Morisot, Degas, Pissarro, Cézanne and Guillaumin to organize their own exhibition.

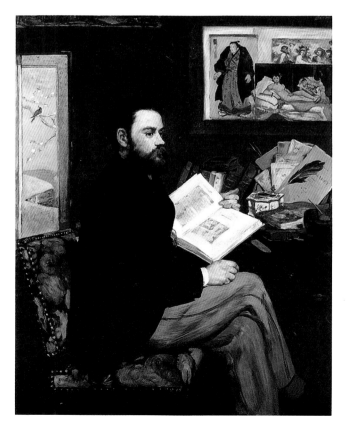

55. **Édouard Manet**,
Portrait of Émile Zola, 1868

Chapter Three: Personalities and Family Histories

For a small group of individuals, the Impressionists sprang from a wide spectrum of social classes and from a variety of provincial and urban milieux. In fact, exploring their family backgrounds and professional and personal circumstances tells us much about the state of France in the 1860s and 1870s as well as about the changing status of the artist. The social mix and diversity within the Impressionist group helped, I believe, to give it its potency and sense of common purpose; unity came from diversity, *unum de pluribus*. I shall also argue that another significant factor was the absence of artistic tradition in the families concerned. The fact that each of these individuals was striking out on a new path in itself offered certain freedoms, but also provoked intriguing, and sometimes liberating, social disruptions.

Although born in Paris, Claude Monet was a provincial who grew up on the Normandy coast. He first arrived in Paris as a student in 1859. Like Edmond Maître, who came from Bordeaux, he formed a close friendship with Bazille in the mid-1860s. However, Monet was from a less educated, more commercial bourgeois background; his father ran a successful chandlery outlet in Le Havre, the fast-expanding Channel port at the mouth of the Seine. Nevertheless, Monet's studies were not supported financially by his father, but by his widowed aunt, Sophie Lecadre.

Camille Pissarro was also a newcomer to Paris in the 1850s. The only Jewish member of the group, Pissarro came from a family whose fortunes had been made in the Danish West Indies – he was born and raised on the island of St Joseph – and were thus tied up with colonial trade. It was probably this early experience of the Central and South American tropics that was to give Pissarro a natural affinity with Paul Gauguin, much of whose youth had been spent in exotic foreign climes, when the latter came into the Impressionists' orbit in the later 1870s.

Alfred Sisley, one of the youngest associates, although Parisian by birth, was the son of English parents. His father William had established an import/export business in the French capital in 1839 and, over the next thirty years, he built up a successful trade

56. **Étienne Carjat**, *Claude Monet* Monet was friendly with Carjat in 1864, a possible date for this photograph.

56

57. Photograph of Alfred Sisley, *c. 1872–74*

in imported luxury goods, such as gloves. He could easily afford to fund his son's art studies in the early 1860s and at this date the young Sisley, like the tall Bazille, stood out among his peers as a fine, elegantly dressed figure. 57

Auguste Renoir came from more straitened circumstances and a strictly artisanal background. His father, a tailor in Limoges, brought his sizeable family to Paris in 1845 in search of better prospects. Renoir had expected to make his living in one of the more lowly applied arts – indeed, he trained as a painter of porcelain – until he too began to aspire to the fine arts, his sights raised by the heady peer pressure exerted by fellow students such as Monet. In the convivial company of friends like Bazille and Sisley, Renoir too could dream of bettering himself socially, the ultimate reward of becoming a successful painter. Renoir's attitude to earning his living as a painter was pragmatic. He was always the most prepared to temper his style and, if necessary, compromise his artistic beliefs, in order to please a client, particularly when a 58 59

58. Photograph of Auguste Renoir, *c.* 1885

59. **Frédéric Bazille**, *Portrait of Renoir*, 1867

60. Photograph of Cézanne (centre) and Pissarro (right) setting out for a walk in the region of Auvers, c. 1874

61. **Étienne Carjat**, *Frédéric Bazille*, 1864

62. **Auguste Renoir**, *Portrait of Frédéric Bazille*, 1867

portrait commission was involved. As a result his oeuvre is of variable quality. Monet was more single-minded and consistent. From the early 1860s he was a committed worker and determined to earn his living through picture sales. He constantly urged Bazille to work with equal application.

Frédéric Bazille was a southern-born artist who hailed from Montpellier in the Languedoc, where his father Gaston, an agriculturalist, wine grower and prominent local dignitary, became assistant mayor in 1867. An affectionate and punctilious father, he gave his son sufficient funds for the young artist to partake fully in the cultural life of Paris, occupy a series of studios and offer a certain amount of help, financial and practical, to his less well-off friends. Had Bazille lived beyond the Franco-Prussian War, he would in all likelihood have taken his place alongside his friends in the 1874 Impressionist exhibition. Unlike his fellow southerner Cézanne, Bazille had natural charm and social grace. Therefore, on arriving in Paris, officially to study medicine but with the firm intention of pursuing art studies as well, he fitted easily into the musical circles of cultivated family friends like the Lejosnes. His encounters at Gleyre's studio, however, drew him into a different, more bohemian, world.

61, 62

Probably the most extreme example of an outsider was Paul Cézanne, the Provençal from Aix, who raised eyebrows in polished urban society with his heavy accent, his rough-and-ready manners and occasionally violent emotions. His father was a small town bourgeois who had made his fortune rapidly, moving from the hat business into banking; however, his newfound prosperity did not carry with it much social ease. At the Jas de Bouffan, the sizeable villa he had bought outside Aix-en-Provence, life was somewhat rigid and reclusive. Unwilling to conform to the strict discipline of the parental home and the law career that his father had mapped out for him, Cézanne left Aix for Paris in 1861. He arrived there hard on the heels of his old schoolfriend Émile Zola, an aspiring author, whose family had recently moved to the capital. Although Cézanne *père* viewed his son's risky choice of an artistic career with severe disapproval, he eked him out an allowance. Cézanne enrolled at the Académie Suisse in the early 1860s, where he met fellow southerner Bazille and the sympathetic recent immigrant Pissarro. Yet he found his closest comradeship in the company of Armand Guillaumin, who hailed originally from the

60

63. Photograph of Berthe Morisot.
c. 1877

64. **Nadar**, *Édouard Manet*,
c. 1865

Creuse region and was paying for his art studies by working for the Orléans railway company. Cézanne and Guillaumin's early experience of Paris centred around the cafés and cheap lodgings of the eastern quarter of Bercy, overlooking the working river with its barges and wine warehouses. It was worlds apart from the smart new residential suburb of Passy to the west.

Passy was where Berthe Morisot lived with her parents and sisters and exchanged social calls with Manet, Pierre Puvis de Chavannes (1824–98) and Degas. It was a world where relative outsiders like Tissot, Fantin-Latour and Alfred Stevens, the successful genre painter, felt at ease. In social terms, the Manets and Morisots, Parisians of long standing, were out of the same upper-middle-class drawer, sons and daughters of *haut fonctionnaires* (high-ranking civil servants) from the professional fields of tax inspection and engineering. In the vocabulary of families such as these, 'bourgeois' was used with disdain to denote 'vulgar, ill-bred'. If the Café Guerbois, and later the Nouvelle Athènes, served as a rendez-vous, where provincials could rub shoulders with Parisians, the Morisots' house and garden in Rue Franklin was also a regular meeting point for these well-connected artists. It had a magnificent vantage point over a curving sweep of the Seine and across the river, on the Left Bank, was the Champ de Mars, the site of the 1867 Universal Exhibition. The view from the Trocadéro was exploited by both Manet and Morisot at different dates. [63] [64] [9, 65]

Edgar Degas was different in that part of his family, who were bankers, lived in Italy. (The aristocratic pretensions suggested by the name are highly dubious but certain cousins married into the fading Italian aristocracy.) His relatives on his mother's side had emigrated, in the previous generation, to America and he had numerous cousins involved in the cotton trade in Louisiana, where both his brothers, at various times, went to seek their fortunes. Degas's familial links with America, which he visited in 1872–73, may have predisposed him favourably towards the talented Philadelphian artist Mary Cassatt, whose upper-middle-class family background was similar to his own. He took note of her picturesque painting *Ida* at the 1874 Salon and, in 1877, following a rejection by the jury of one of her portraits, invited her to join the breakaway group. [66]

I have already suggested that a possible reason for the willingness of Fantin-Latour's friends to be represented paying homage to a leader in the form of Delacroix or Manet was that they were in need of an identifiable figurehead. A salient shared trait of the

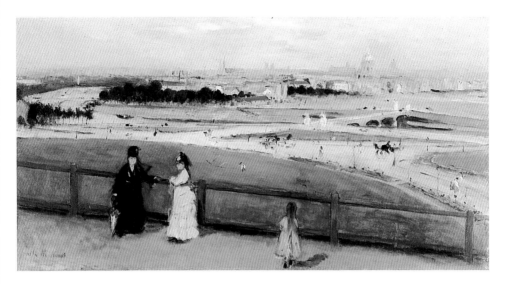

65. **Berthe Morisot**, *View of Paris from the Trocadéro*, 1872

66. **Edgar Degas**, *Self-Portrait: Degas Lifting His Hat*, c. 1863

Impressionists was that they were from non-artistic backgrounds, each representing the first generation within their families to follow professional artistic careers. This in itself, I suspect, may have played its part in the development of a group mentality. But why, it might be asked, should this be of any importance?

Part of the problem may be that we have grown too used to hearing how the Impressionists, and indeed subsequent avant-garde groups, reacted against their teachers' and parents' authority. We are sometimes in danger of seeing rebelliousness itself as the norm. In fact, traditionally, a large percentage of Frenchmen took up their calling in life, be it art or law or silversmithing, precisely because it ran in the family. Art, in particular, was regarded as a risky career, which offered few rewards and it certainly helped if one's name already carried a reputation. Second- or third-generation artists had a tendency to follow well-worn paths, and family tradition also militated against experimentation and new initiatives. One might argue that the professional techniques passed down from one generation to the next, especially in the applied arts and architecture, had lent French art tradition and continuity. By the mid-nineteenth century this broad rule was beginning to change. A few notable newcomers were making enormously successful careers as high-profile artists. Painters from outside the conventional art world – Tissot, Carolus-Duran (1837–1917), Jules Bastien-Lepage (1848–84) and Léon Bonnat (1833–1922) – as well as the members of the Impressionist group began to infiltrate the time-honoured system. The Impressionists shared the problems and challenges of creating their own career paths without family precedence and guidance, meeting varying degrees of parental dismay or disapproval in the process.

The absence of family tradition also left the Impressionists the crucial advantage of freedom, freedom from the obligation to repay the investment and meet the expectations of their parents. How different was the case of Monet from that of his contemporary, Tony Robert-Fleury (1837–1912). Robert-Fleury, as Jane Mayo Roos has shown, tasted immediate success at the Salon of 1866 thanks to the influence on the voting jury of his father, a key academician. As a consequence, he received an enviable flood of public commissions and was shoehorned into a conventional teaching career at the École des Beaux-Arts. But while Robert-Fleury was destined to enjoy worldly success, he would not introduce innovations which would alter the course of French painting. Monet, meanwhile, was free to invent his public image as the *plein-air* painter and did so with increasing aplomb as the years went by,

both in occasional self-portraits and through the pictures of him painted by friends. In 1880, the image was confirmed for posterity 67, 68 when he gave the first of a sequence of press interviews for the journal published by his friend and patron Georges Charpentier, *La Vie moderne*. Monet insisted upon his preference for working out of doors, claiming, somewhat disingenuously, that he had no need of a studio, that nature was his studio.

67. **Ludovic Piette**, *Camille Pissarro Painting in a Garden*, *c.* 1874
Informal portraits such as Piette's of Pissarro and Renoir's of Monet helped to entrench the image of the Impressionist as the spontaneous *plein-air* painter. In later years Pissarro would insist on the importance of reflective work in the studio.

68. **Auguste Renoir**, *Monet Painting in His Garden at Argenteuil*, 1873

One could make the further point that despite financial difficulties, none of the Impressionists settled for the kinds of fall-back bread-and-butter artistic activities – such as illustration and photography – to which many second- or third-generation artists resorted. After a long career of difficult struggles, even Pissarro would direct his own artistic sons towards illustration rather than towards painting.

The one exception to the first-generation rule was the artist who documented their group identity, Fantin-Latour. A close friend of Bazille, Manet, Morisot and others in the 1860s, Fantin-Latour is often detached from this close-knit group of friends who went on to form the Impressionists because of his timidity and conservatism in career terms. Certainly it was he who strongly opposed their decision to boycott the Salon and mount an independent group exhibition in 1874. He even dissuaded Manet from participating, although he did not have the same success with Morisot. But surely biographical factors once again account for his cautious attitude. He was the son of an unsuccessful provincial painter and burdened with heavy familial responsibilities, including paying the asylum fees of a beloved sister who had been certified insane. In his circumstances, taking the step into the unknown which the Impressionists' independent action represented was out of the question.

Another still more striking feature – of puzzling and hitherto overlooked significance – linking and shaping the lives and careers of the majority of the male artists who formed the Impressionist group is the fact that they so frequently married beneath them on the social scale, thereby forfeiting the goodwill and support of their parents. At a time in French history when major forces, particularly urbanization, were having an increasing impact on social mobility, the old-fashioned concept of the arranged marriage had by no means died out. The persistence of this tradition, which had its origins in economic and class concerns as well as in religious ones, was understandable: it allowed parents to ensure the continuity and safekeeping of the family fortunes. By following artistic careers and marrying outside their family's milieu, the Impressionists were effectively cutting themselves off from their origins and class.

Claude Monet first met his future wife Camille Doncieux, a 69, 70 seamstress from the Batignolles who became his model, in 1865. Their liaison was already a fait accompli by the time he tried to introduce her to his family circle. The news that they already had a child on the way was clearly a blow to his father, with whom he

maintained a rocky relationship, and threw into jeopardy the financial support which his aunt had only just decided to continue. Notwithstanding Monet's lack of financial independence and his father's opposition to the match, they married in 1870, by which time their eldest son Jean was already three. Earning money from sales was a pressing need for Monet even before he had the added complication of a woman and child to support. Selling paintings was not so important for Bazille, whose family constantly pressed him to let them have examples of his work to hang at home. Monet – with no false modesty – took absolutely for granted his worthiness to be helped and made demands of Bazille in a ruthless and increasingly insistent way as his domestic difficulties multiplied. He later made similar requests of Caillebotte. Yet he seems to have had the spendthrift's inability to hang on to money.

Bazille's family had made various attempts to partner him with a suitable girl, but at the time of his death, aged just twenty-eight, he remained unattached. His single status was partly due to his success in fending off their contrivances, partly due to a disappointment in love and partly due to his jaundiced Flaubertian view of what bourgeois marriage might entail.

Camille Pissarro, as a well-brought-up Jewish bourgeois, would have been expected to find a wife among his familial acquaintances. However, either because he lacked opportunities to meet eligible young women or because he had an aversion to such a traditional obligation, he set his heart instead on Julie Vellay, a Gentile of peasant stock from Burgundy. He met her in 1860, at which time she was employed as assistant to his family's cook. Both on social and religious grounds, the match met with opposition from his parents, on whom he was still financially reliant,

71, 72

71. Camille Pissarro, *The Road to Louveciennes at the Outskirts of the Forest*, 1871
Its dating and large size suggests this painting may have been intended for the Salon. However, Pissarro and most of the future Impressionists chose not to submit work in 1872, protesting againt the state's arbitrary reduction of the scale of that year's exhibition. Bought by Caillebotte, it was one of the works dropped from the eventual bequest that he left to the nation.

72. Paul Cézanne, *View of Louveciennes* (after Pissarro), 1872
Cézanne frequently painted out of doors with Pissarro in Pontoise in the early 1870s. Yet here, as this pairing shows, he copied a canvas by the elder artist, in the process simplifying the technique, heightening Pissarro's delicate colour range and reinforcing the composition's structure.

especially from his mother Rachel. For most of the 1860s, their ménage was regarded with disapproval and Julie was ostracized by Pissarro's mother. Perhaps it was partly for this reason that they chose to live in the country, yet not too far from Paris, an option that enabled them to live more frugally and yet allowed Pissarro to remain in touch with the art world, his mother and other relations.

When Jean Monet was baptized in Paris on 2 April 1868, Bazille and Julie Vellay acting as godparents, the Pissarros and the Monets gave the same address, 8 Impasse Saint-Louis in the Batignolles quarter. But that same year also found Pissarro living in Pontoise, and then Louveciennes, a western suburb of Paris. When, in August 1870, the Pissarros were forced by the rapid advance of the Prussian army to leave their house in Louveciennes, they already had a third child on the way. They threw themselves on the mercy of Ludovic Piette (1826–77), a fellow painter; in his manorial farmhouse in Montfoucault in the rural Mayenne, Julie Vellay gave birth to their second daughter whom they named Adèle after Piette's Jewish and childless wife. The baby sadly died six weeks later. As their correspondence reveals, given the irregularity of Camille and Julie's liaison, Piette felt obliged to pass his friends off tactfully as a married couple – country mores being considerably less advanced and tolerant than Parisian ones at this date. In reality, however, it was not until June 1871 that the Pissarros were married in London, by which time Julie was expecting their fourth child. The pressures on Pissarro and Monet to support their growing broods remained constant and significantly affected the way in which they managed their careers and decided how and where to live.

Alfred Sisley and his lifelong partner, Eugénie Lescouezec, only concluded their formal marriage arrangements in 1897 during a stay in South Wales, by which time they were both already terminally ill. Since he still had British nationality, despite never having resided outside France, it was more straightforward for him to marry under English law, a step designed to secure the future inheritance of his two children. It was previously thought that the financial hardships that dogged Sisley's career (he was constantly in arrears with his paint supplier, for instance), stemmed from his father's reversal of fortunes after the Franco-Prussian War. However, it is now likely that they date back to the rift in the late 1860s caused by his liaison with Eugénie, a humble, impecunious florist several years older than himself, a highly unsuitable match in his father's eyes.

For years after they met in 1869, Paul Cézanne dared not divulge to his father the existence of his mistress Hortense Fiquet, an artist's model, let alone the news of the birth of their son Paul in 1872. However, his father's suspicions were aroused and he finally came round to the situation. They did not marry until 1886, a few months before his father's death, by which time Cézanne presumably already knew he would come into his inheritance.

Although Renoir had a six-year relationship in the late 1860s with Lise Tréhot, the model who posed for some of his most important early canvases – nude and clothed female subjects intended for the Salon such as *Diana the Huntress* and *The Engaged* 41, 73 *Couple* – he took care not to get too attached. As he made clear in a letter to Bazille, he was only too aware, from Monet's example, of the costs. He was one of the last members of the group to decide to marry and, once again, it was to a young woman with a different background to his own. Like so many of the female workforce who serviced the Parisian bourgeoisie in the mid-nineteenth century, in 1879, the nineteen-year-old Aline Charigot came to the city in search of employment. Working as a seamstress she still kept in touch with her family in her native village of Essoyes in the Champagne region. Her good looks, hearty constitution and practical, rustic good sense seem to have appealed to Renoir, who was nearly forty when they met. She posed for several key paintings, including *The Luncheon of the Boating Party*, and in 1885 gave birth 234

73. **Auguste Renoir,**
The Engaged Couple, c. 1868
Alfred Sisley and Lise Tréhot agreed to pose as betrothed lovers for this charming full-length painting. They adopt the conventional stance of newly-weds in a photographer's studio, and Renoir seems to continue the analogy by paying scant regard to the realism of the garden backdrop.

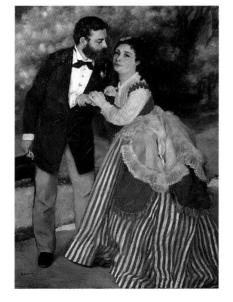

to their first son, Pierre. She and Renoir eventually married in 1890. While he would entrust her implicitly with the upbringing of his children, socially and professionally her role in his life was less clear cut. When it suited him, Renoir seems to have maintained the pretence of a carefree bachelor existence, accepting the invitations of his wealthy clients such as the Bérards, the Charpentiers, the Cahen d'Anvers, even of close professional friends such as the Manets (Berthe Morisot and her husband Eugène), solely on his own account. It therefore came as a complete surprise to Morisot when one day, in 1891, Renoir turned up unannounced and introduced his wife and six-year-old son Pierre! As she confessed to Stéphane Mallarmé, 'I shall never succeed in describing to you my astonishment at the sight of this ungainly woman whom, I don't know why, I had imagined to be like her husband's paintings.'

The regularity of the pattern outlined, whereby an assertion of independence in artistic terms seems also to have involved breaking away from parental precedents and adopting unorthodox attitudes to family tradition, cannot be ignored. Yet, if these young men thought they were kicking over the traces, unerringly they plumped for another form of the tender trap, this time set by the ambitious working-class girl. One explanation of this phenomenon lies in the very nature of the studio-based lives they led, for the pursuit of an artistic career largely cut them off from the bourgeois marriage market. Instead of meeting and courting respectable, educated, chaperoned girls of their own class, their long-term relationships tended to develop from chance encounters in the street and studio. The relationship which Émile Zola invents between the artist Claude Lantier and the model Christine in *L'Oeuvre*, the novel inspired by his contact with the Impressionists, seems largely stereotypical.

The question remains: why did so many of the Impressionists marry beneath them? Whether they did from choice is a moot point. It would be dangerous to infer that in their personal lives, as in their painting, they were in some measure embracing the democratic society of the future which would do away with class distinctions. In any case, social ideals or bohemian romanticism were probably less of a factor than carelessness, moral scruples (often the girls were already pregnant) and pragmatism. Perhaps the essential link between Camille Doncieux, Julie Vellay, Hortense Fiquet, Eugénie Lescouezec and Aline Charigot was their humble expectations. They were capable, resourceful, hardworking women who could not only serve as models but could turn their

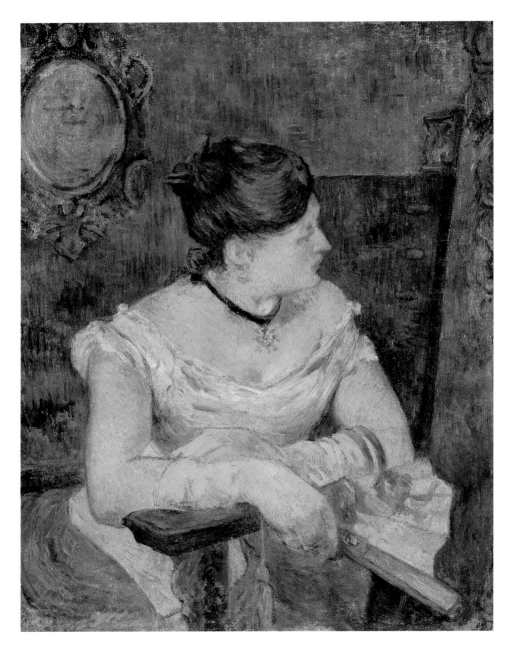

74. **Paul Gauguin**, *Mette Gauguin
in Evening Dress*, 1884

hands to a variety of tasks, without demanding regular outings to the opera or the ball or expecting, like Mette Gad – Gauguin's well-educated and bourgeois Danish wife – fashionable clothes, domestic servants and good schools for the children. It is hardly surprising that Gauguin's mid-life change of career from stockbroker to Impressionist painter proved disastrous for his standard of living and, in the end, for his marriage. In short, the Impressionists found they needed wives, like Julie Pissarro, who could cope with the uncertainties of the artistic life, even if, as Julie's surviving letters suggest, they may have held that life in the utmost contempt. In 1884, Julie wrote to her eldest son Lucien beseeching him, in her scarcely literate French, not to follow his father's example: 'Above all don't fool around wanting to make works of art. That's stupid. Do commercial work and leave art for those who have enough bread on the table.' One suspects these sentiments were fairly typical of the long-suffering Impressionist artist's spouse.

74

75

75. **Camille Pissarro**, *Madame Pissarro Sewing, c.* 1885

Edgar Degas was the exception to the rule. His reasons for not marrying were probably as complex as his own personality was contradictory. He certainly considered marriage an ideal, desirable state, but he could equally see the attractions of a monkish existence. It seems likely that at a critical stage in his life he had difficult or bruising encounters with the opposite sex which led him to renounce the idea for good. He could turn on the charm with women of his own class, such as Berthe Morisot and her sisters, yet gallantry did not come easily to him. As a renowned painter of women of the lower orders, including prostitutes, he from time to time consorted with them, as so many wealthy haut-bourgeois men of his acquaintance did. Above all, perhaps, he harboured the conviction that a wife would compromise his work by pressurizing him to produce more 'comprehensible and remunerative' art. In the end, by remaining a bachelor, Degas stayed true to the traditional idea held by Delacroix that celibacy was the correct and only state for the totally single-minded artist.

The readiness to keep domestic and professional concerns rigidly separate was not uncommon among French painters, and indeed intellectuals in general, at the time. Manet, like Renoir and Cézanne, seems to have found it easier on the whole to lead a double life, keeping his wife, the plain, plump and musical Dutchwoman Suzanne Leenhoff, apart from his professional friends. Much has been made of the apparently mutual infatuation between Manet and Berthe Morisot. Whatever the story's substance, given the circumstances – the fact that Manet was married and the two families were extremely close – there was no question of either party flouting bourgeois conventions of respectability. In 1874, aged thirty-three and already considering herself an old maid, Berthe in a sense resolved her difficult situation by marrying Eugène, Manet's younger brother. It was a practical, rational, mutually supportive union, encouraged by both families (particularly by Édouard Manet himself), for, in Eugène, Berthe found a man who had the wealth, leisure and taste to support her unusual career. The other prominent female member of the group, Mary Cassatt, remained a spinster and devoted her affections to her immediate family circle who came to join her in Europe. As an American, she enjoyed a measure of freedom to travel and meet people, which was denied to Berthe Morisot, whose social life centred around her home.

Artists' lives and the subterfuges to which they sometimes resorted testify to the limitations of social and female emancipation in late nineteenth-century France and to the double

standards that continued to prevail. Certain gatherings, for instance, were still exclusively male; although ostensibly accepted as equals, the Impressionists' middle-class female colleagues lived very different and considerably more restricted lives. Morisot may have been treated on an equal footing with the men in the organization of Impressionist exhibitions – indeed as the only woman she sometimes saw herself as playing an important placatory role amid so many inflated male egos – but there was no question of her dropping in to the Café Guerbois or the Nouvelle Athènes, nor does she seem to have been included in the Impressionist dinners at the Café Riche. Later in life she became a close friend of Mallarmé, appointing him, with Renoir, guardian of her daughter Julie after her husband's death. However, she did not feel able to join the benches of male student poets who regularly turned up to listen to the great man reading a lecture at one of his famous Tuesday evening gatherings. Furthermore, an unspoken rule

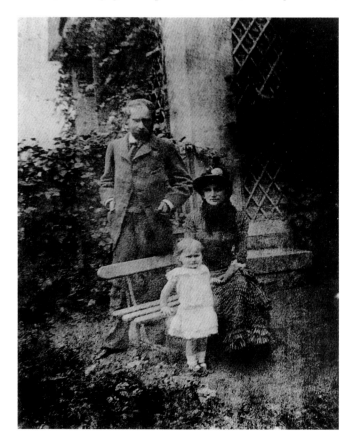

76. Photograph of Eugène Manet, Berthe Morisot and their daughter Julie Manet in the garden at Bougival, 1880

allowed professional married men to retain their sexual freedom but consigned professional married and unmarried women alike to the hearth and home.

If such cumulative biographical details give interesting pointers to historical and social forces, the real importance of knowing something of the domestic lives of the Impressionists becomes clear when one confronts and tries to understand their paintings. For their families and personal circumstances were who and what they depicted. By the 1870s, the Impressionists were united by their aim to paint modern life, a specific, intimate, narrow and subjective version of modern life, identifiable with the domestic sphere and with the nuanced sensations of the private individual. In this broad undertaking, those whom they married or lived with and the children they bred had central roles to play.

77

77. **Berthe Morisot**, *Eugène Manet and His Daughter in the Garden at Bougival*, 1881

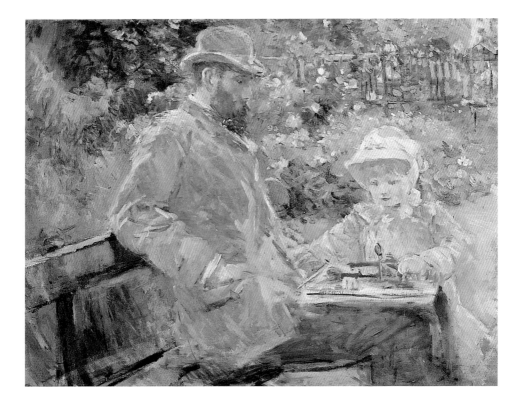

Chapter Four: Towards Impressionism

'Impressionism was born from the meeting of two men with names so alike that at first they were often taken for one another: Monet and Manet. From the crossbreeding of their two methods was born modern painting.' So wrote Germain Bazin when Chief Conservator of the Louvre in 1958. Statements of such superb and sweeping simplicity were only possible at a time when artists were still conceived as the prime and heroic agents of art-historical change. Nobody today would dare to endorse such a monolithic and reductive claim. Impressionism now seems a more multi-faceted concept whose birth could never be explained by a simple pairing of two individuals. What about the important parts played within the movement by other artists, Renoir, Pissarro and Degas for example, or by the complex combination of other circum-stances: modernity, politics, the art market, the critical climate? Nevertheless, when one examines how Impressionism developed, what it consisted of and why it was quintessentially modern, Monet and Manet play central roles. The modernity of Impressionism lay not only at the level of its new range of subjects and themes; more crucially, certainly more provocatively, it lay in the stylistic means it used to capture their essence. As Zola emphatically explained in 1875, when writing about Manet: 'the tiresome thing is, that the artist has created a new form for the new subject, and it's this new form which terrifies everyone.'

For Zola, Manet's chief stylistic characteristics were, on the one hand, seeing in terms of broad shapes so as to capture the gen-eral impression rather than the minute details; on the other, using a light-toned palette of bright, unmixed colours. Accepting such formal innovations was difficult for viewers accustomed to artists who built up solid forms by working with subtle gradations from dark to light, whose predictable, sober palettes dealt predomi-nantly in tonal values. 'The first impression that a canvas by Édouard Manet produces is a bit hard and sharp. We are not used to seeing such simple and sincere translations of nature', Zola con-ceded. Although he was by no means the first artist in history to paint in broad, swaggering strokes, Manet's freedom of touch and cultivated simplicity are largely what earned him 'modernist'

status in the twentieth century, since modernism has been defined in terms of a painterly technique that draws attention to itself and to the surface of the canvas, rather than to what it represents.

Using the rather different terminology of the nineteenth century, Zola saw Manet as an analyst because of his direct relationship to nature. This approach was typical of his times when, in all fields of knowledge, there was a wish to establish firm and definitive principles based on empirical observation (certainly this was Zola's own preferred method). For Zola, Manet's virtues were simplicity, energy, harmony and elegance or grace. Looking at Manet's *Portrait of Victorine Meurent* of 1862, which takes the viewer aback even today, we can see how he jettisons modelling – patient modulated transitions from dark to light – in favour of abrupt contrasts. Manet was an artist who dared to risk all on the first throw. According to those who sat for their portrait, he worked in an uncompromising way and if, after a session's work, his attempts at rendering the immediacy of his impression did not satisfy him he would scrape down and start again. The source for his bravado technique was the seventeenth-century art of Italy, Holland and above all Spain, in particular the painterly manner of Rodriguez de Silva Velázquez (1599–1660), for which he developed a passionate enthusiasm during the 1860s. In turning to

78

78. **Édouard Manet**, *Portrait of Victorine Meurent*, 1862

parts of the realist tradition that were largely overlooked by conventional academic teaching, Manet was doing what Courbet had done before him. The group of Courbet followers, comprising Whistler, Legros and Fantin-Latour, looked primarily to Rembrandt and his school. In his ardent hispanicism Manet was joined by his friend Astruc, but also by more conservative artists like Bonnat and the now-forgotten Alfred Dehodencq (1822–82) and Jean-Pierre Briguiboul (1837–92). Yet no-one emulated the bravura of Spanish painting with quite the panache of Manet. By his insistence on the qualities of the *premier jet*, or first throw, as a means of retaining the freshness and rawness of life and colour, Manet opened the way for Impressionism's breakdown of barriers between preparatory sketch and finished painting.

Of the future Impressionists, Claude Monet was unquestionably the artist who made the most salient technical innovations in the 1860s. Indeed, never content to rest for long on his laurels, he would set the benchmark for innovative handling throughout his career. We catch early signs of his preference for the spontaneous, improvisatory qualities of the sketch in a letter he wrote to Bazille in October 1864. Referring to pictures he hoped to sell to Alfred Bruyas, Courbet's patron in Montpellier, Monet differentiates between *plein-air études*, studies done in front of nature, and *tableaux*, paintings based on such studies but executed away from the motif and to a higher level of finish. Yet although he is still distinguishing between two separate stages in his working process, he ends up preferring and sending the studies, claiming them to be 'a lot better'. As his career progressed the distinction between sketch and finished work came to have less and less validity.

As Monet's letters to Bazille reveal, through the 1860s he was an artist uncommonly sure of his talent, already receiving compliments from others and hatching ambitious plans. If, as a landscapist, he was first attracted to the picturesque and eye-catching aspects of nature, he had a unique and seemingly effortless talent for turning what he saw into a striking arrangement on the canvas. Too often this gift, coupled with Monet's scanty artistic education, has led him to be dismissed as unthinking and unreflective, when in fact his working method involved a highly sophisticated process of selection. Certainly, he was neither burdened by a sense of artistic tradition nor inclined to theorize about his work. While he clearly absorbed much from his dominant artist peers, Manet and Courbet, in his letters he does not attempt to analyse what he admired about them. In the summer of 1864, however, when spending time among an artistic crowd at the Saint-Siméon farm

outside Honfleur, he admitted that 'there was much to be learned' from men like Boudin, Jongkind and Théodule Ribot (1823–91).

All three artists in their very different ways could be described as minor masters of realism. Johan Barthold Jongkind, a 79 Dutchman, specialized in rapidly executed watercolours and had inherited his national school's feel for landscape and marine composition; his work was esteemed by Castagnary, Thoré and Zola, the latter praising his sensitivity to 'the first impression'. Ribot, on the other hand, excelled in painting in oil with thick, buttery brushstrokes, which were well suited to translating the varied textures of his still-life motifs and dark Chardinesque interiors. Boudin was especially attuned to capturing the luminous changing light of the Seine estuary and the migratory appearance of Normandy's fashionable summer visitors. The most innovative aspects of his work were his spontaneous pastel cloudscapes, but these were on small-scale supports and served essentially as 26

79. Johan Barthold Jongkind, *View of the Schie*, 1867

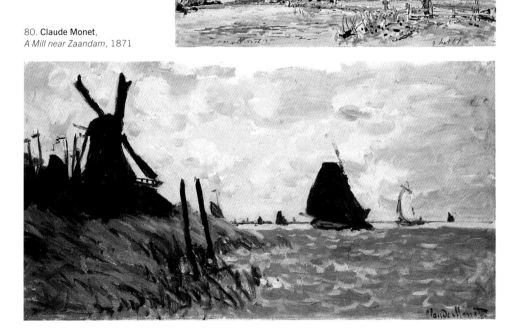

80. Claude Monet, *A Mill near Zaandam*, 1871

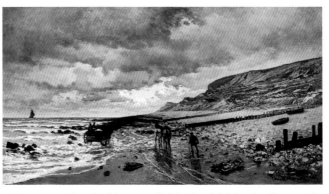

reference studies for his more finished exhibition landscapes. In 1859, although they were not on show (Baudelaire had seen them in Boudin's studio), they had been singled out for praise by Baudelaire in his review of the Salon. It was at the First Impressionist Exhibition in 1874 that Boudin chose to show several of these pastels to the public, probably for the first time.

The lessons each of these artists had to teach can be traced in the various directions Monet took in his early work, where seascapes and still lifes play a prominent role. One senses his determination to amaze the viewer with the raw boldness of his ability to overhaul these tried and tested realist themes. In the first landscape he had accepted at the Salon, *Headland of the River Hève at Low Tide* shown in 1865, he sided firmly with the Normandy painters, using a subdued yet luminous grey brown palette and applying, on a more monumental scale, Jongkind's compositional lessons and Boudin's sensitivity to weather effects. Several critics drew attention to this promising and vigorous young painter. Writing about Monet's technique in the Salon of 1866, Zola admired the masculine energy that had gone into the painting of *Camille*; in 1868 it was 'the candour, even roughness of his touch' that were praised. Words that crop up frequently in these critiques are *franchise* (frankness), *âpreté* (rawness), *naiveté* (innocence), *impression* and *tempérament*. Zola drew attention to Monet's unique ability to paint water, without tricks or artifice, just as it was. He could paint glaucous and dirty waves, or the stagnant and oily water of harbours, and could capture water's broken reflections, 'its wan and murky hues, lit up by sharp accents of light'. A crucial aspect of what Zola takes such delight in describing is Monet's skill as a colourist. Recent laboratory analyses have shown that Monet rarely used completely unmixed colours; to create those exact and rare tints, he made elaborate mixtures of pigment.

80

81

54

82. Fashion plate from *La Mode de Paris*, 1 September 1864

For his part, Bazille, Monet's closest friend during these formative years, had no doubts about the strength of Monet's talent. Witness the remark he made in writing home to his parents in 1867 about reviving the Salon des Refusés, an idea supported by Courbet, Corot, Diaz, Daubigny and many others: 'With these people and Monet, who is stronger than the lot of them, we are sure to succeed.' His belief in that talent led him, in the summer of 1867, to take on a major and onerous financial commitment given that he had little to spare from his allowance, namely, buying Monet's enormous *Women in the Garden* which had remained unsold after its rejection by the Salon jury that spring. Buying it for 2,500 francs was a practical way of assisting Monet, who was in dire penury and working non-stop to support Camille, then expecting their first child. Unfortunately the terms of the payment by monthly instalments of fifty francs led to a serious misunderstanding between the two. Monet, who resented the fact that

83

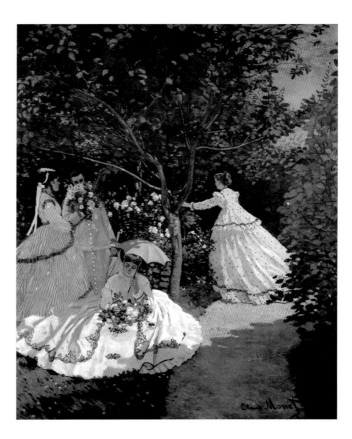

83. **Claude Monet**, *Women in the Garden*, 1866

Bazille was not quicker to pay off his debt, sent him repeated begging letters full of recriminations.

Bazille took the painting down to his family home in the south, the Mas de Méric, where he embarked upon an ambitious figure composition of his own, a group portrait of the various members of his family: parents, aunts, uncles and cousins. Aimed at the Salon, it took him several months to complete. With the object lesson of Monet's brilliant, but rejected, canvas at his side, Bazille succeeded in executing his ambitious composition in a manner which proved acceptable to the Salon jury. The painting was shown in the Salon of 1868 as *La Famille X.*

Comparing these two large paintings – one essentially a genre scene, the other a group portrait – tells us much about the development of what can begin to be called an Impressionist technique. Both deal with similar painterly problems: how to represent groups of figures in open-air settings illuminated to varying degrees, partly in bright sunlight, partly in shade. Monet sets his gathering of attractive young women in a generalized and luxuriant rose garden; Bazille's sparser setting is the terrace of a specific southern garden, where his figures are shaded by a chestnut tree. Perhaps they are there to enjoy a post-prandial chat, more plausibly, simply to pose for their portrait. There is a marked imbalance between the two paintings' attention to detail, indicative of major

85

85. **Frédéric Bazille**, *Family Reunion*, 1867

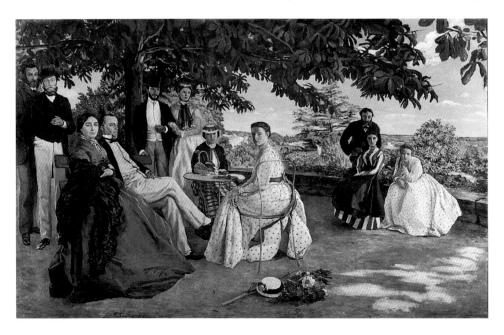

differences in the artists' working methods. Bazille elaborated his composition from drawings, referring to photographic documents for the appearance of each of the models. Indeed, the work owes its frozen tableau effect to the conscious acknowledgment he makes to photography, whose ability to record nature and portraits fascinated the kind of well-to-do bourgeois family to 84 which he belonged. Since 1864, he and Monet had been on friendly terms with the photographer Étienne Carjat who executed their carte-de-visite photographs free of charge. Bazille's palette is 56, 61

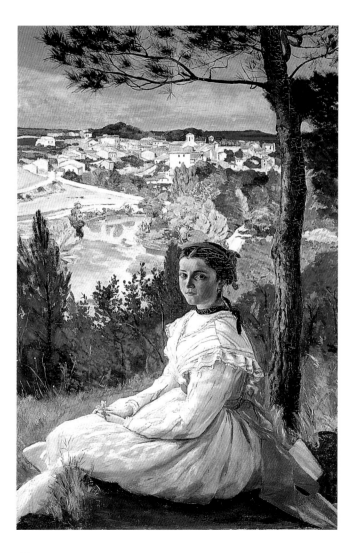

86. **Frédéric Bazille**, *View of the Village*, 1868

87. **Frédéric Bazille**,
View of the Village, 1868

light-hued but his handling is smooth and highly detailed, particularly in the crisp foliage. Monet's painting, by contrast, is far more schematic in its execution. Whereas Bazille worked on his canvas in the studio, even continuing to refine it back in Paris, Monet's painting had allegedly been executed entirely out of doors. One imagines Monet working swiftly to convey the fast-changing dappled effect of the foliage in broad approximative *taches,* or patches.

Yet *Women in the Garden* was not as direct an impression of nature as all that. For one thing, the same model, Camille, posed for all the figures. As Mark Roskill and Joel Isaacson have shown, the inconsequential appearance of the composition is due to its being essentially an enlarged version of a fashion plate. Just such self-contained vignettes were regularly to be found in the pages of, for example, *La Mode de Paris.* Naturally for the fashion illustrator, 82 the primary aim was to show the month's latest outfits to advantage from several different angles, attending to particularities of cut, trim and colour. Narrative plausibility was secondary. Decorative, up-to-the-minute and comparatively free of anecdotal interest, fashion plates admirably paralleled Monet's requirements as a modern, non-literary painter.

During the summer of 1868 Bazille decided to follow up his family portrait with another substantial figure painting. *View of* 86 *the Village* once again used the setting of the gracious park at Méric, incorporating a luminous view of the village of Castelnau-sur-Lez beyond. And again Bazille prepared his way by stages with drawings. By February 1869, back in Paris, he was boasting 87 to his mother that the painting had had, 'a huge success with a crowd of painters to whom I've shown it recently'; it was their welcome attentions that he recorded, retrospectively, in *The Studio in* 45 *the Rue La Condamine,* where *View of the Village* is on the easel. When she saw it at the 1869 Salon, Morisot commented that Bazille had admirably succeeded in capturing the intense sunlight, in achieving what they had all tried to represent, a figure in the outdoor light.

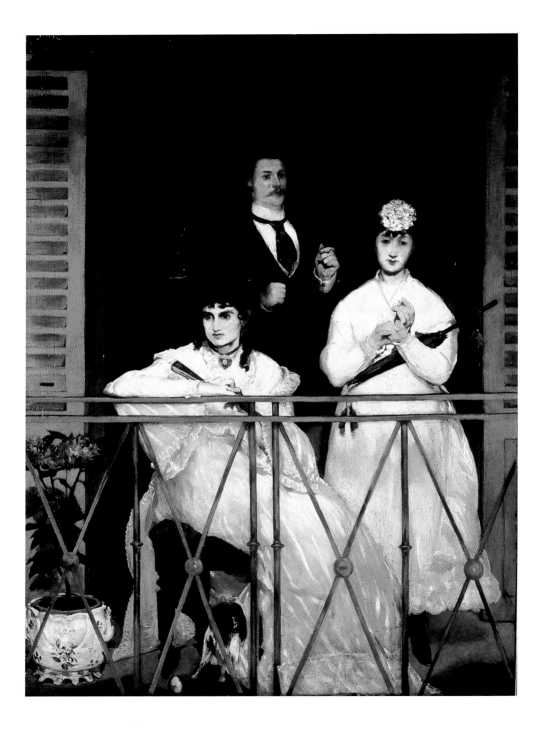

In a sense, Bazille had succeeded according to the terms that Manet's coterie had espoused as their primary goal in the mid-1860s – figures in the open air. In Manet's own Salon submission of that year, however, *The Balcony*, which provoked considerable mirth among Salon-goers, the artist remained true to his love of Spanish art and there is little sign of stylistic change. Although theoretically an outdoor Parisian scene, in reality Manet had staged it in the studio, as Morisot, who posed for the foreground figure in a white, light-catching dress, knew well. Moreover, he had borrowed the composition from Francisco Goya (1746–1828). The landscape painter Antoine Guillemet, also a former pupil of Corot, stands in the shadows behind. Morisot's dark brooding looks which, she was amused to find, led certain critics to use the epithet 'femme fatale', push the rather plainer featured Fanny Claus, a violinist, into a secondary role.

88
89

Bazille's *View of the Village* also succeeded in academic terms. It earned enough positive votes from the academic fraternity who made up the Salon jury to get accepted although it was hung in a poor position. A surprise supporter was Alexandre Cabanel (1823–89), a fellow artist from Montpellier, whose painting talents Bazille rated extremely low: 'He hasn't even got the strength to express the banality of his own intentions'! The reasons for the canvas's acceptability are clear, especially when one compares Bazille's precise and textural handling of paint with Monet's breadth and imprecision in *On the Banks of the Seine at Bennecourt*. Once again the canvases are superficially similar in size, date,

90

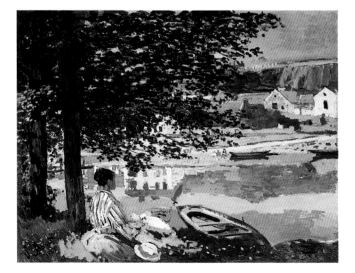

subject, even compositional arrangement, for both artists place their female subjects in light-coloured striped summer dresses in the foreground, with a placid riverscape and sunlit village in the background. Yet, where Monet's model, Camille, is reduced to a series of *taches*, Bazille clearly shows us the features, dark eyes and heightened colour of his quizzical young Italian girl. Monet's tree is just that, but Bazille's tree is clearly a pine, the crumbling greyness of its bark revealing the deeper reds of the trunk beneath.

Whereas Monet, by 1868, was already on the path to Impressionism – he was more and more drawn to nature's temporary aspects and light's constantly shifting appearances and had developed an approximate handling to stand in for it – Bazille was anxious about this tendency. He hankered after something more permanent: 'I would like to restore to every object its weight and volume', he wrote in 1868, 'and not only paint the appearance of things'. To judge from his own statements on the subject, his decision to paint modern rather than classical figures was taken relatively lightly, his commitment to new ways of seeing perhaps no more than skin deep. Behind it, Bazille's methods remained conventional, in much the same way as Caillebotte's would in the following decade. As Gary Tinterow put it recently: 'Bazille accommodated something of the novelty of Monet's method to the grand tradition of French painting.'

From 1867 onwards, Monet's career strategies and techniques changed rapidly. Although he still had the Salon in the back of his mind, Monet, staying at his father's house at Sainte-Adresse just outside Le Havre, was turning out a large number of smaller-scale paintings. He probably hoped to sell them to local clients rather than submit them to the Salon. Fresh, bright, broadly contrasted canvases such as *The Beach at Sainte-Adresse* date from this summer, when the key influences were Courbet, with whom he had worked in Trouville, and Boudin. Moreover a third, more exotic and highly significant stylistic element can be detected over and above these impulses from within French realism. As in Manet's marines of the 1860s, there is a distinctly Japanese feel to the flat bold treatment of the exquisite turquoise water, to the silhouetted shapes of sails, boats and figures and to the suppression of shadows. From this strange combination of influences, Monet's *Beach at Sainte-Adresse* achieves its own highly synthetic and fresh vision, whose extreme simplification contemporary viewers found bizarre and difficult to read.

Japanese art was a craze that swept Paris in the 1860s. In the wake of Japan's having opened up to Western trade in the 1850s,

several enterprising Parisian stockists were able to offer attractive Japanese porcelain and bibelots – much used by fashionable genre painters, such as Alfred Stevens and James-Jacques Tissot – and cheap colour woodblock prints, which were particularly prized by innovative artists. The work of oriental artists like Katsushika Hokusai (1760–1849), Torii Kiyonaga (1752–1815), Kitagawa Utamaro (1753–1806) and Andó Hiroshige (1797–1858) suggested a totally novel way of seeing the world and of organizing a two-dimensional composition so as to evoke three-dimensional space. Moreover they based their art on nature which, as Astruc was quick to point out, they held in similar reverence to the French realists. It was not surprising that an affinity was so quickly established.

By 1869, the year when Bazille's *View of the Village* won plaudits at the Salon, Monet was concentrating even more assiduously on working *en plein air*. That summer he joined Renoir on a stretch of the River Seine at Bougival which was popular with Parisian day trippers. The bathing place there was known as La Grenouillère, its purpose-built bathing platform dubbed, for obvious reasons, the camembert; it can be seen to the right of Renoir's picture. This naturally picturesque riverside setting, with its hive of modern, frivolous activity, offered possibilities which enthused and excited both artists. Much as they had done two years earlier in central Paris, they worked more or less alongside one another, sometimes from exactly the same viewpoint. As so often in the history of art, the close proximity of a rival encouraged them to push their stylistic experiments further; Monet, as ever, was the more radical, while Renoir was more tentative, experimenting with what for him was a new genre. Monet's painting recalls the Japanese way of conceptualizing a scene; his trees are reduced to massed shapes, their subtle contrasting hues assisting his spatial organization. Renoir's brushwork is more delicate and fussy, reminiscent of the elegant foliage of a pastoral idyll by Jean-Antoine Watteau (1684–1721) or François Boucher (1703–70). Monet places two women in garish costumes to the left of his composition, balancing them against two comical silhouettes of women in black bathing suits on the right. The latter are set starkly against a light expanse of water and their reflections extend down into the water in bold black steps. Renoir takes in more of the scene, giving his more numerous figures greater individuality, almost forming them into family groups; his handling of the water's ripples is bold, but less assured and schematic than Monet's.

86

93

94

93. **Auguste Renoir**,
La Grenouillère, 1868

94. **Claude Monet**,
Bathers at La Grenouillère, 1869

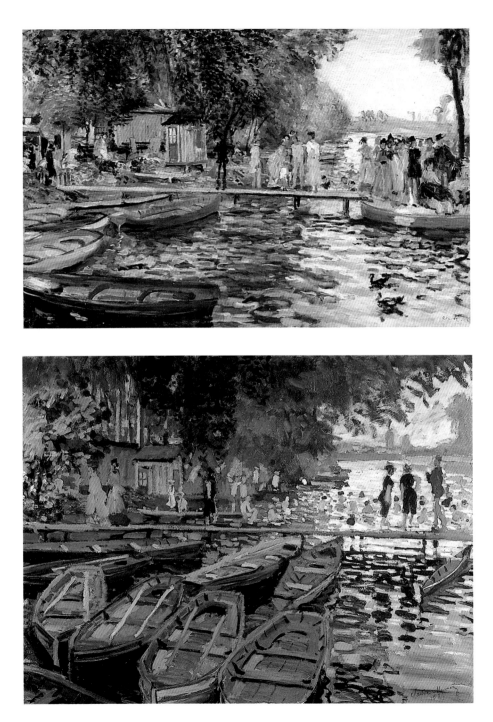

95. **Claude Monet**, *The Thames below Westminster*, 1871
During Monet's stay in London from 1870 to 1871 he exhibited at least two canvases from his recent Trouville campaign (ill. 96). The same concern for radical simplification carries over into this flat and limpid Thames view, which also suggests an awareness on Monet's part of Whistler's *Nocturnes*.

Both painters were still thinking in terms of studies for grander Salon machines, but circumstances and shortage of funds prevented their ever moving on to that final stage. From this date on, Monet began to consider his freely executed, light-toned outdoor work as exhibitable in its own right, particularly given the readiness of buyers to purchase such modest-scale, reasonably priced items.

By 1870, all the key elements of Monet's mature style were in place and honed to suit his preferred motifs, usually landscapes involving water. In fact, his development had come to a kind of plateau. Over the next few years, up to and beyond 1874, he worked prolifically and, with remarkable regularity, turned out canvases in which a balance is exquisitely maintained between spontaneity and control, colour and tone, observation and synthesis. *Beach at Trouville* is just one of a number of beach scenes that Monet painted during that summer on the Normandy coast which radiate the blond luminosity and informality only found by the sea. His example was a heady one, emboldening other landscape artists such as Morisot, Sisley and Pissarro to enliven their more subdued Corotesque colour range. It was not necessarily a helpful one for a mercurial artist like Renoir whose main efforts, hitherto, had been directed at portraiture, or for Manet, who would spend much of the next decade striving to infuse his own Salon-oriented art with the lighter touch and brighter colours of Monet.

If Monet's technical skill and rapid execution were well suited to nature's more evanescent effects, Pissarro's forte was his patient rendering of solid, earthbound motifs. This was recognized early on by Zola who in the 1860s had hailed Pissarro as his ideal landscapist. His 1860s paintings such as *L'Hermitage at*

96. **Claude Monet**,
Beach at Trouville, 1870

97. **Camille Pissarro**,
L'Hermitage at Pontoise, 1867
Pissarro had two landscapes hung at the Salon in 1868, of which it is possible that this was one. Their acceptance was due in part to the influence of Daubigny who was on that year's jury. They were admired for their strength, simplicity and sincerity, qualities which were consciously emulated by Cézanne.

95

96

97

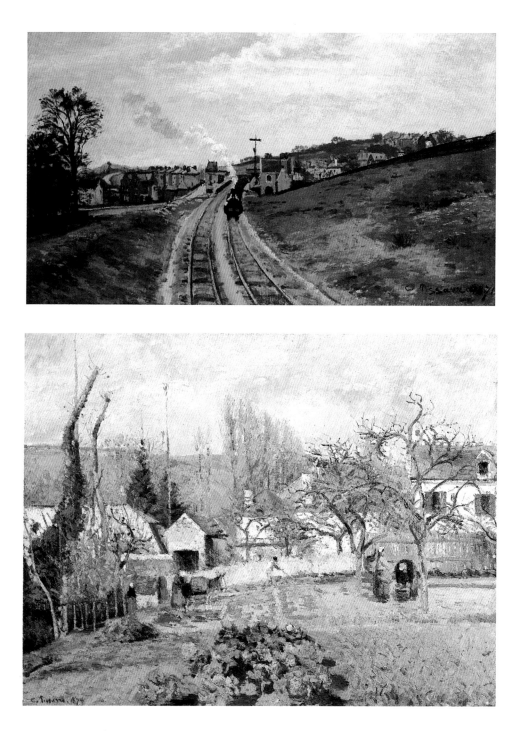

98. Camille Pissarro,
Lordship Lane Station, Upper Norwood, London, 1871

99. Camille Pissarro,
Kitchen Gardens at L'Hermitage, Pontoise, 1874

Pontoise, possibly shown at the 1868 Salon, were powerful Courbetesque compositions bound together by strong contrasts of tone and an interlocking structure of horizontals and verticals. In 1869, while living at Louveciennes, and in 1870–71, during his London stay when he saw Monet more regularly, Pissarro moved towards more informal and simpler compositions. No longer having the Salon in the back of his mind and, after 1871, with the new possibility of selling through Durand-Ruel, like Monet, Pissarro began to increase his rate of production and work on smaller canvases. Although he had the opportunity in London to look at the English landscape school, notably John Constable (1776–1837) and Joseph Mallord William Turner (1775–1851), it would be hard to claim that his painting owed anything to their example, beyond a general endorsement of the validity of landscape painting from nature. (Later, he would recall Turner's work when practising watercolour.) Rather, in several suburban scenes, he remembers the compositions and muted harmonies of Corot's earlier paintings of specific sites done from the motif, rather than the recent Corots of reverie and memory, with their soft-edged trees and monotonous grey harmonies. *Lordship Lane Station, Upper Norwood, London* has a Corotesque atmosphere and tonal simplicity, yet it is uncompromisingly modern both as a motif – the railway line had only opened a few years earlier – and in the way the bald curve of the embankment carves up the space, in stark denial of picturesque convention which required variety and irregularity. [34, 35] [98]

By the time Pissarro returned to Pontoise, to the views he had explored in the 1860s, his manner of seeing and representing the working landscape had changed markedly. Here he presents the scene from a high viewpoint and at close quarters. The palette is lighter in hue, the tones closer, a unity established by the use of a warm light putty-coloured ground. The paint is much drier in texture, the movements of the brush more evident. The vegetation suggests a day in late autumn although the sense of a specific moment is less strong than that of peaceable, routine activity. The need to cultivate the 'path of rustic nature' was pressed home to Pissarro at this important juncture by the critic Théodore Duret. Duret advised the artist against worrying what Monet, with his 'fantastic eye', was doing; nor for that matter should he try to emulate Sisley, whose 'decorative' appeal Pissarro lacked. Pissarro's special gift was his 'intimate and profound feeling' for nature. It was well-meant and sound advice, and Pissarro heeded it. [99]

Although a highly proficient technician, Renoir was something of a chameleon as a painter. He had the ability to work simultaneously in a number of different manners and genres and his stylistic development has none of the logic of Monet's. In fact, his periods of collaboration with Monet constitute breaks from his usual pattern of production, for he was more of a figure painter than a landscapist. Portraiture, which Renoir practised throughout his career, is a genre in which the artist is not a free agent and for his living Renoir depended upon the patronage of portrait sitters whose tastes were often conventional. His elder brother and sister-in-law were cases in point. Pierre-Henri Renoir, despite working as an applied artist (heraldic engraving and chasing), enjoyed an opulent lifestyle thanks to an advantageous marriage and to the high value placed on luxury goods by Second Empire society. Renoir's pair of pendant portraits, with their emphasis on expensive accoutrements, flattered the vanity of his sitters to perfection.

100

100. **Auguste Renoir**, *Portrait of Madame Pierre-Henri Renoir*, 1870

101. **Auguste Renoir**, *At the Inn of Mother Anthony*, 1866
The country inn at Marlotte, a hamlet in the Forest of Fontainebleau, was a favourite haunt of Renoir's circle. In this modern conversation piece, painted as a Courbetesque tribute, the models have been identified. Nana, the waitress, has the comely look Renoir would continue to celebrate throughout his career, Jules Le Coeur is standing, and, to the right, are a Dutch painter named Bos, Mother Anthony wearing a headscarf, Sisley in a hat and Toto, the watchful poodle. Renoir pointedly specifies *L'Événement*, the paper for which Zola was writing in 1866, as the artist's reading matter.

However, even in the field of portraiture, Renoir had different styles, according to whether he was painting friends like Bazille or Monet as an informal exercise, getting his friends to pose for a genre scene or as a tender engaged couple for a Salon submission, or working to commission, in which case he was beholden to the approval of his client. He was capable of producing a casual rococo grace, a Courbetesque robustness or a sensual and highly coloured exoticism reminiscent of Delacroix. But in his commissioned work we do not find him making startling stylistic innovations and his compositional arrangements tend to be more conventional. His handling of paint, after a brief experimental period when he tried the palette-knife technique of Courbet, generally consists of a more patient build-up of tones in a weave of fine parallel touches, a far cry from the risky shorthand technique of Manet. Renoir was more cautious about working in full sunlight than

102. **Auguste Renoir**,
Portrait of Claude Monet, 1875

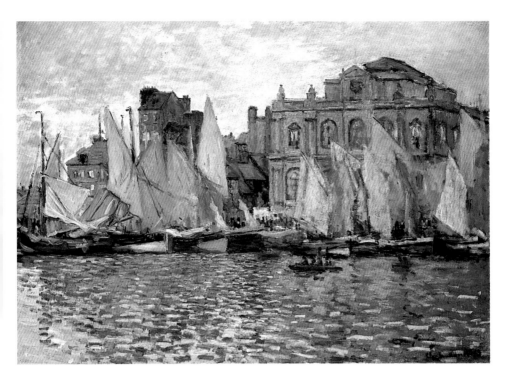

103. **Claude Monet**,
The Museum at Le Havre, 1873

Monet or Bazille; in 1868, when discussing a projected group portrait of his friends the Le Coeurs, he suggested they sat in the garden in the evening when the weather was grey, which seems to be the light he chose for *The Engaged Couple.* 73

If among the future Impressionists Monet represented the dominant force for stylistic change in the area of landscape, Degas was an equally potent instigator of change in figurative work. As we have seen, Monet was quick to discover his true *métier* as a painter of nature and was uninhibited by any undue reverence for tradition, an attitude encapsulated, surely unwittingly, in his harbour scene entitled *The Museum at Le Havre.* In yet another composition which gives a major role to water, the monumental classical facade of his local art museum (the building was destroyed in the Second World War) is half hidden behind a flotilla of sailing craft crowding the quay. For Monet, nature always took pride of place over the art of the past. When he travelled abroad, as, for example, when he went to London or followed Jongkind to Holland in 1871 in search of painterly motifs among its picturesque towns and waterways, the obligatory visit to the museum was never the first 80
item on his itinerary.

104. **Edgar Degas**,
Young Spartans Exercising, 1860

The contrary was true of Degas whose artistic formation had included spending the years 1856–59 in Italy, studying and copying the Old Masters. Following that stay, equipped and eager to produce a grand history painting, Degas encountered endless difficulties, partly because he set himself challenges that were impossible to fulfil. Technically ambitious, they sometimes combined ideas from disparate realms – mixing the Old Masters with the modern. His *Young Spartans Exercising* for example is still a history painting. Its frieze format is typical of neoclassicism which saw a revival in mid-century, notably among Ingres's pupils (Degas's main teacher, Louis Lamothe [1822–69], was one). It brings together figures posed from life yet arranged in groups inspired by Degas's earlier copies of works in Italy. Some of them still look like classical fragments and do not harmonize with the background landscape which vaguely evokes the sparse plains he had seen near Naples. Despite a certain incoherence to the story depicted, which may have prevented its passing the scrutiny of the Salon jury, these pubescent youths surely enact the timeless battle of the sexes. The figures have a rawness about them – the girls ahead of the boys in combativeness – which allows one to imagine the scene being played out in a teenage disco today.

Being steeped in tradition was both an advantage and a frustration for Degas. Some of his grander aspirations were out of step with the trends of the time, but the methods he had learned from the Old Masters allowed him to resolve complex spatial challenges when, later on, he tackled ambitious slice-of-life

104

105

105. **Edgar Degas**, *The Triumph of Flora* (after Poussin), *c.* 1860

compositions. Manet, who scorned Degas's late conversion to modern subjects, would have struggled to organize such a complex, multi-figure composition as *Orchestra Musicians*, with its 106 combination of men in close-up in the orchestra pit and gauzy ballerinas on stage. Degas's mastery of drawing gave him the confidence to explore the arbitrarily truncated, partial views suggested by photography, even if the snapshot as such had yet to be perfected. Nor was he afraid to turn to popular imagery or realist sources as a complement and counterbalance to his high-art training.

Apart from his history subjects, Degas devoted most of his efforts in the 1860s, under the watchful eye of his father, to family and other portraits. In fact this was the genre Auguste Degas urged his son to nurture in 1858, when he reported back favourable reactions to a recent double portrait Edgar had painted of two girls: 'It was done by the hand of a master and if you manage to fix your talent in that area and go on to perfect it further, you're launched.' Surely this advice was what spurred him on to expend

106. **Edgar Degas**,
Orchestra Musicians, c. 1870

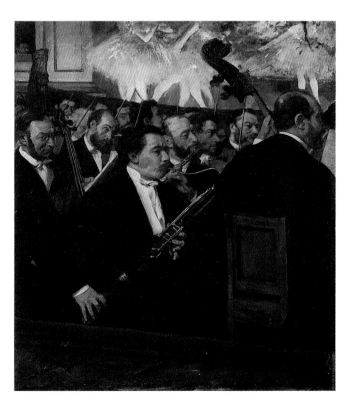

107. **Edgar Degas**,
The Bellelli Family, 1858–67

108. **Edgar Degas**, *Giulia Bellelli*,
study for *The Bellelli Family*,
1858–59

such energy on *The Bellelli Family*, begun in 1858 but not com- 107
pleted until 1867. Its size suggests he intended submitting it as a 108
major, unmissable Salon entry but events prevented him from
completing it to his satisfaction. In this protracted project, it was
essentially his aunt, Laure Bellelli, who held his attention. Her
haughty, distant yet vulnerable expression; her body language
(the black dress and outstretched arms create a solid presence
belying her doubtless slender frame); and the distance separating
her from her husband convey the bleakness and lack of communi-
cation that marred their marriage, which Degas himself had wit-
nessed. Although, at one level, Degas emulates the dignified
portraiture of such masters as Anthony van Dyck (1599–1641)
and Ingres, it has recently been shown that a Daumier composi-
tion prompted this unusual but powerful solution to the arrange-
ment of the figures.

Portraiture was the principle way in which Degas explored
modern life in the 1860s. Often he shows as keen an interest in the
setting as in the pose and characteristic gestures of his models, all

of which would become important features of his later modern-life work. Admiring the English sporting picture tradition which he came to know through his friends the Valpinçons, from as early as 1862, Degas also began to explore the racecourse as a distinctive 109 modern-life motif. Trying to capture in paint clutches of male jockeys in their colourful silks astride frisky thoroughbreds was a logical continuation of his interests in Italy, where he had carefully copied triumphal equestrian parades by artists such as Paolo Uccello (*c.* 1396–1475), Giulio Romano (1492/9–1546) and Benozzo Gozzoli (*c.* 1421–97).

Modern-life painting was not the discovery nor the exclusive prerogative of the Impressionists. By drawing on contemporary experiences, they were in a sense merely keeping up with the established trend of the times. But they concentrated on a specific, intimate, private world, an aestheticized version of modernity. Their paintings and graphic work tell us extraordinarily little about public affairs – the tumultuous events of the Franco-Prussian War and Commune of 1870–71, for instance – or the changing religious climate through which they all lived. There is something deliberate about this avoidance, particularly given the topicality and popularity of such themes among their Salon contemporaries.

Between 1867 and 1869 an uneasy attempt by Manet to combine painting and politics in a major Salon statement had failed to make its mark. It was government censorship rather than artistic disapproval that stood in the way when he tried to exhibit the most resolved version of his painting *The Execution of Emperor* 110 *Maximilian* at the Salon of 1869. Such was the nervousness of the imperial régime that the official censor even ordered that the lithograph he made of the same subject be destroyed. News of the assassination of Mexico's emperor had somewhat dampened the official mood during the 1867 Universal Exhibition, making a mockery of the Second Empire's foreign policy. Napoleon III had imposed the Austrian Maximilian on the Mexicans as a puppet emperor, but when local unrest erupted had shamefully withdrawn the support of his troops. Manet's stark and brilliant painting, inspired by Goya's *The Third of May, 1808* (1815) which he had recently seen in Madrid, rather too obviously casts the French military and the Second Empire régime in an unfavourable light; instead of making the firing squad identifiably Mexican, Manet gave them French uniforms.

109. **Edgar Degas**, *A Gentleman Amateurs' Race: Before the Start*, 1862, reworked *c.* 1882

110. **Édouard Manet**, *The Execution of Emperor Maximilian*, 1868–69

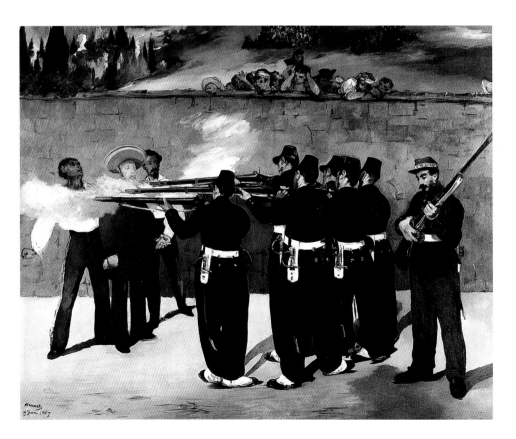

111. **Edgar Degas,**
The Pedicure, 1873

This political blocking of Manet's career and Courbet's exile during the 1870s surely served as cautionary tales to any radical elements within Impressionism. It may explain why Pissarro, having espoused the revolutionary ideas of Pierre Joseph Proudhon as a young man, and later become a convinced adherent of Piotr Kropotkin's anarchist philosophy, so studiously avoided direct political action or overtly political themes in his painting; in fact, he remained fearful of police surveillance throughout his career. It may also explain the uncontroversial modern-life themes associated with bourgeois leisure and domesticity which tended to characterize Manet and the Impressionists' subject matter after 1870. 113

The repertoire of modern themes that the Impressionists explored was more in line with Daumier, Paul Gavarni and other popular illustrators, who gently satirized the foibles of urban, domestic and bohemian life. Degas's own art collection, built up in the latter part of his career, boasted an enormous number of Daumier and Gavarni lithographs. Parallels can also be found in the themes of Japanese prints, where the private domestic world as well as that of the theatre and brothel were extensively explored. And there were also close connections and friendships, as we have seen, between the Impressionists and the fashionable modern-life painters Stevens, Tissot and de Nittis. Any of the Impressionists 112 could easily have gone down the same road of painting small pictures of social genre subjects, emphasizing intimacy and fashion.

112. **James-Jacques Tissot,**
Lady on a Couch, c. 1873–76

The commercial success that these genre painters enjoyed on both sides of the Channel would undoubtedly have been seriously tempting. In 1871, Morisot was already aware that Fantin-Latour and Tissot were making a good living in London and she would later be staggered to learn that Tissot could command as much as 300,000 francs for a picture when she visited him in London on her honeymoon in 1875. Manet and Degas were keen to explore London and Manchester as outlets, Degas seeing the dealers there as more likely than their French counterparts to take an interest in the modern-life genre paintings he had produced in Louisiana. What prevented the Impressionists from pursuing this fashionable vein? How do we account for the different direction their work took in the 1870s?

111

One reason may be that they were aware of the caveats that were increasingly being voiced by critics about painters of modernity not delving beyond the surface. Eugène Fromentin (1820–76), for example, a well-respected author and painter, wrote of Stevens, in around 1875: 'Of course one must paint one's own times… [but] one must render the manners, the feelings before the customs and the accessories. Such things play a role too, but an absolutely secondary role.' The Impressionists themselves recognized that an obsession with fashionable detail constituted a false artistic trail, that merely representing modern life was not the same as 're-creating nature touch by touch', as Mallarmé would later evocatively describe it. The true artist only took from nature that which properly belonged to art. Finally, in practical terms, what progressively drew the Impressionists away from the modern-life genre painters was the sense of group purpose that came about when they started to organize their own exhibitions in the 1870s.

113. **Claude Monet,**
Rue Saint-Denis Decked Out with Flags, 1878
A rare departure from the *parti-pris* of avoiding political and public themes was when Monet painted Paris streets decked out with flags in celebration of the Republic's declaration of 30 June 1878 as a new national holiday. This day encouraged the populus to forget France's recent defeat and to celebrate the triumph of the red, white and blue tricolour as emblem of Republican France. Memories were fresh of the Comte de Chambord, the last serious Bourbon candidate to the French throne, and his obdurate determination to bring back the old royalist flag with its symbolic fleur-de-lys. This had proved to be the fatal sticking point which effectively scotched the Comte's campaign to restore the monarchy in the early 1870s.

114. **Alfred Sisley**, *Early Snow at Louveciennes*, c. 1871–72 Sisley's composition here is extremely close to several works by Pissarro who was also then living in Louveciennes, while his bold touch perhaps owes more to Monet. One must assume that the freak weather conditions Sisley records here occurred in September or October since the leaves are still green.

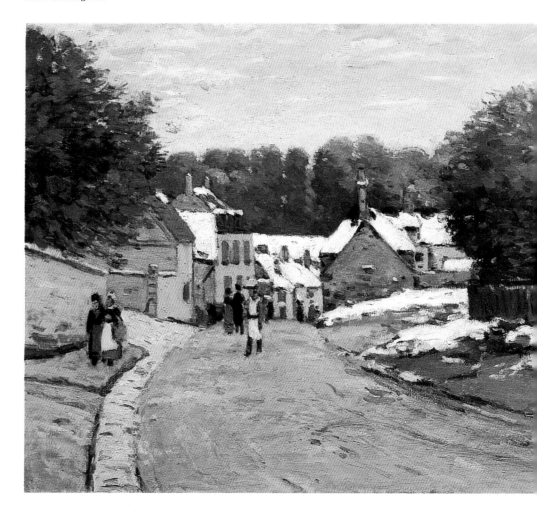

Part II

Chapter Five: The Exhibitions and their Critical Reception

The Franco-Prussian War of 1870–71 and the Siege of Paris in 1871 materially affected the lives of the Impressionists in different ways according to the individual's circumstances. Those with young families to consider kept their heads down or sought refuge in exile. Pissarro and Monet, as we have seen, went to London to avoid being called up, perhaps following the example of Daubigny. Cézanne returned to the south, where he holed up in L'Estaque, near Marseilles. Sisley, free from the fear of conscription as a foreign national, remained in Paris. In August 1870 Bazille had been repelled by and detached from the patriotic warmongering he witnessed in Montpellier, but spontaneously, and to the utter horror of his friends Maître and Renoir, he decided to join the Zouaves and was sent for initial training to Algeria. His sense of having a duty to serve his country seems to have been prompted by hearing of the rapidity of the Prussian advance and fearing for the safety of his relatives in eastern France. Renoir was called up into the cavalry and sent for training near Bordeaux. In October, with the situation for the French rapidly deteriorating, Manet and Degas, and their friends Tissot and Stevens, volunteered to help defend Paris against the Prussians. Morisot kept in touch with them, not leaving the city for the peace of her sister Edma's house in Cherbourg until May 1871.

For those in Paris the period was one of fear, food deprivation, bombardment and civil strife, which left them with feelings of cynicism about their fellow countrymen and political leaders. For those in exile, the momentous historic events were of less immediate consequence although they presumably feared for the houses and belongings they had left behind. Manet, staunchly republican in his views, became caught up in the emotions and politics of the times and recorded incidents of street fighting in a series of Goyaesque lithographs. For the rest of the future Impressionists, however, it seems clear that the Franco-Prussian War, the Siege of Paris and the bloodshed of the Commune offered little of relevance

115. **Édouard Manet**,
Civil War, 1873

to the artistic project on which they had embarked and did not deflect them from it. It simply put back the date of their first exhibition.

But of course the war took its tragic toll, with the appalling waste of talent of Frédéric Bazille who was killed in action at Beaune-la-Rolande in November 1870, picked off easily, due to his unusual height, by enemy snipers. His distraught father Gaston made an epic journey across battle lines and border crossings to recover his son's body for a funeral which was treated as a major local event in Montpellier. More than any other outcome of the war, the death of Bazille in a sense brought to an end the carefree romantic hopes and convivial bohemian camaraderie of the 1860s and signalled the beginning of a more pragmatic phase in the evolution of Impressionism.

With the return of peace, Parisians, although 'still mourning over... recent humiliations', as one fashion magazine put it, lost no time in getting back to normal life. Although it would take at least a decade to restore the capital to its former glory given the number of shattered buildings, the social calendar resumed in 1872, almost as though nothing had occurred. Trade was lively and the art market was buoyant. For the future Impressionists, regrouping after their eye-opening travels abroad, even if the cultural climate was conservative, the commercial prospects were good.

The Anonymous Society of Painters, Sculptors, Engravers, etc., who exhibited together in what came to be known as the First 116 Impressionist Exhibition was a thoroughly mixed group. *La Chronique des arts et de la curiosité*, in its January 1874 issue, was the first specialist journal to publicize the society's constitution; based on mutual financial contributions, sixty francs a year, the terms of membership had been drawn up by Pissarro on the model of a bakers' cooperative from Pontoise. *La Chronique*'s 'provisional administrators' included Pissarro (top of the list), Degas's friend Henri Rouart (1833–1912) and Monet, along with several other names, forgotten today; its 'provisional supervisory committee', responsible for the hanging arrangements, consisted of '[E.] Béliard, painter, [Léon-Auguste] Ottin, sculptor, and Renoir, painter'.

The exhibition opened on 15 April 1874 and lasted for a month; the entrance fee was one franc. It occupied airy premises at 35 Boulevard des Capucines, formerly the studio of the celebrated photographer Nadar, a location, as one critic noted, 'right on the boulevard, in the midst of the hustle and bustle of Paris'. Some of the artists showing, Boudin, Bracquemond and Adolphe-Félix Cals (1810–80) for example, were experienced professional

painters and etchers who regularly exhibited at the Salon; others were amateurs for whom painting was a relaxing pastime. Louis Latouche (1829–84), frame maker and art dealer, and Henri Rouart, industrialist, came into this category. Yet others were ambitious young professionals for whom the question of making their names and selling their work loomed large. It is the members of this last group, who had known each other and worked together since the 1860s, whom critics at the time – and history has subsequently – consecrated as the Impressionists.

The reasons for the artists organizing their own independent show were practical, economic, self-interested and only to a lesser degree ideological. Doing so enabled them to hang works sympathetically, which in turn gave the public the best chance of appreciating their merits. It was not a show of desperate rejects, as they were keen to prove by their contacts among the older generation, nor was it a show intended to demonstrate some sort of revolutionary intransigence. It did not pretend to offer a common stylistic programme and the identification of their 'Impressionism' was an unforeseen by-product. If Degas, who had done much of the behind-the-scenes organizing, was responsible for the presence of some of the more middle-of-the-road participants – many of whom would never appear again – he was also the one who persuaded Berthe Morisot to join. 'There are twenty to twenty-five of us, and we expect a few more participants', Degas explained in a decorous and charming letter to Morisot's newly widowed mother. 'I am not looking to establish in this way one of those major anti-academic enterprises [a reference, presumably, to the Salon des Refusés], but I do expect that this trial will be something we could repeat when we see that it has had some success. If we stir up a few thousand people in this way, that will be marvellous.... And besides, we consider that the name and the talent of Mademoiselle Berthe Morisot answer our purpose too perfectly to be able to do without her.' From this letter, for all its reassuring tone, we gain a valuable insight into how Degas conceived of the independent exhibition and its wider impact.

The presence of the older artists did not reassure everyone. When the painter Joseph Guichard had the shock of seeing works by his former pupil hanging in the exhibition, he lost no time in writing in his turn to Madame Morisot to express alarm: 'When I entered, dear Madame, and saw your daughter's works in this pernicious milieu, my heart sank.... Manet was quite right to object to her participation.... How could she exhibit a work of art as exquisitely delicate as hers side by side with *Le Rêve du célibataire*?

116. Title page of the catalogue to the first exhibition of the Anonymous Society of Painters, Sculptors, Engravers, etc., 1874

The two canvases actually touch each other!' He went on to scold Morisot for having had the audacity to try to say in oil what can only be said in watercolour, an error for which she would need to beg forgiveness on bended knee from Correggio (1494–1534). Although his disapproval of these technical flaws was clear, his outrage was couched primarily in social and moralistic terms: Morisot was lowering herself by associating with such a dangerous crew whose uncouthness was exemplified, for Guichard, by Cézanne. Although he did not name him, it was the latter's *A Modern Olympia*, judged by some to have been painted under delirium tremens, which must have been the work Guichard could not bear to see in the context of his pupil's exquisitely delicate *The Cradle*. As his reaction suggests, there were ruffled feathers in various quarters as a result of the exhibition. Unfortunately we have no documentary evidence of Gleyre's reaction to the work of his former pupils; he died during the exhibition's run.

117

118

However, to assert, as several writers on the subject have done, that the Impressionists instantly met a hostile press is a myth, which their defenders, and they themselves at times, contributed to fostering. Over recent years the validity of this claim has been rightly questioned. Thanks to Ruth Berson's invaluable two *Documentation* volumes (companions to the 1986 'New Painting' exhibition which charted the eight Impressionist exhibitions), we are now in a better position to be able to make a dispassionate assessment of the situation. Several important daily newspapers ignored the exhibition. It received no mention in the conservative and Bonapartist *Le Moniteur universel*, nor in the republican *Le Temps* and *Le XIXe siècle*, nor even in Zola's former paper, the republican and liberal *L'Événement*. However, a rough tally of the separate mentions of the show in different papers produces a provisional total of fifty-two, a remarkably high number which may in due course need revising upwards. Of these, nine were neutral (simple announcements of the dates, location and so on), twenty were favourable, eighteen were mixed and only five were openly hostile.

The first review appeared, the day after the opening, in the paper the republican politician and war hero Léon Gambetta had founded in 1871, *La République française*. Written by Philippe Burty, a friend and supporter of the artists and an expert on Japanese art, it naturally welcomed and applauded the enterprise. Indeed most critics congratulated the group on taking affairs into their own hands and avoiding the shambles that the Salon had become. Burty wrote a more extensive article on 25 April, isolating certain key aspects to the exhibition, such as 'the lightness of

colour, the breadth of vision, the quality of the impressions'. He continues: 'A second examination does not fail to upset all one's conventional ideas about level of finish, about chiaroscuro, about what makes an attractive site.' Jean Prouvaire's mixed and ironic review appeared in the more radical paper *Le Rappel* on 20 April and Armand Silvestre's favourable one in *L'Opinion nationale* on 22 April. Both, interestingly, latched on to the word 'impression', inspired by the title of Monet's *Impression, Sunrise*. Prouvaire, not the journalist's real name (the use of a pseudonym was common to several of the critics), saw it as granting the artist licence to play around with, even distort, reality. Not until 21 April do we find the first consistently hostile review, published in the Bonapartist *La Patrie*. Even here the anonymous reviewer, A.L.T., raises the spectre of an idea, only to dismiss it, that what he is mocking today may yet turn out to be 'the experiments of misunderstood geniuses, of bold innovators, of pioneers of the painting of the future'. Then, on 25 April, came two hostile accounts, penned by Louis Leroy and Pierre Véron in *Le Charivari* and *Le Journal amusant* respectively, journals specializing in satire. It was Louis Leroy who coined the term 'Impressionist' as a send-up of the new style of painting.

119

Leroy couched his review in the form of an imaginary conversation with a fictive, academically trained landscape painter called M. Vincent, a device which allowed him to articulate the most extreme conservative reactions against the new group through the mouth of his harumphing interlocutor. For Vincent, the show was an 'assault upon artistic high principles, upon the cult of form and the respect for the masters'. Pissarro's landscape *Hoar Frost* was the first item to arouse his ire. Try as Leroy might to persuade Vincent that it was a plausible impression of hoar frost on a deeply rutted field, the academician saw nothing but 'palette scrapings uniformly laid on a dirty canvas'. He could make 'neither head nor tail, top nor bottom, front nor back' of it. Vincent's visual confusion aptly conveys the unprecedented break Pissarro had made with the conventions of landscape painting. The canvas's choppy but relatively uniform brushwork and its barely differentiated tonality compound the difficulties of reading the picture. These are caused by the high horizon, the shallow depiction of space and the lack of repoussoir or other device by which the landscape artist usually assists the eye to make sense of linear and aerial perspective.

120

As the tour of the exhibition continues, other works by Monet, Cézanne and Morisot are subjected to the same ridicule. Then, as a final twist, Vincent is made to convert, in spectacular and maniacal

117. **Paul Cézanne**,
A Modern Olympia, 1872–73
For almost all the reviewers of
the 1874 show, Cézanne's
entries were beyond the pale.
Here he made pointed and
provocative reference to
Manet's iconic image of a
decade earlier (see ill. 48)
but departed from the latter's
dispassionate approach.
Instead, he handles the colour
feverishly, introducing himself
as artist/spectator in troubling
proximity to the now-cowering,
rosy-fleshed nude.

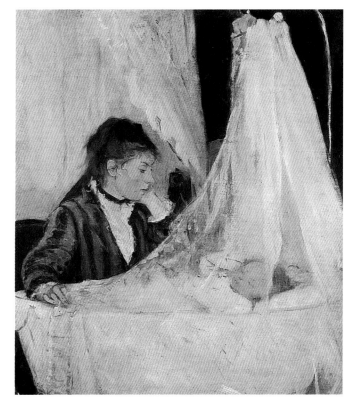

118. **Berthe Morisot**,
The Cradle, 1872

119. **Claude Monet**,
Impression, Sunrise, 1873
Monet exhibited two harbour
scenes in the 1874 exhibition;
his decision to entitle this, the
more schematic of the two, an
'impression' offered critics a
name for the group. Its limpid
atmospheric treatment of
Le Havre recalls Whistler's
Nocturnes – similarly
suggestive views of the
Thames in fog – which Monet
may have seen in London two
years before.

120. **Camille Pissarro**,
Hoar Frost, 1873

fashion, to the new Impressionist way of painting, whereupon he starts taking to task those painters like Sisley who displayed too much moderation. Even Monet, who was exhibiting the considerably more detailed interior scene *The Luncheon* (1868) alongside his *Impression, Sunrise* is all of a sudden, 'too finished, too finished, too finished!' The picture had in fact been intended for the Salon of 1870, but rejected by the jury.

If Leroy was the first to bandy the term about, on 29 April, just four days later, an authoritative endorsement of 'Impressionist' as a suitable name for the new style was given by the seasoned critic Jules Castagnary, an ardent republican, long-time supporter of Millet and Courbet and advocate of humanitarian and realist tendencies in art. Castagnary's piece, published in the republican daily *Le Siècle*, stands as one of the most sensible and informative accounts of the exhibition. He began by remarking upon the extraordinary range of art vying for attention that spring. The Impressionists' was one of many small private shows timed to coincide with the Salon, since late spring was the season when art was invariably on the agenda of the press. As a critic constantly on the lookout for signs that French art was in a robust state of health, Castagnary was enthused by the promise of what he saw on show at the Boulevard des Capucines: 'There is nothing tedious or banal about these young people's approach to understanding nature. It's lively, brisk, light – captivating. What a rapid grasp of the object and what an amusing facture. It's summary, agreed, but how spot on the marks are!'

Political analogies were frequently used about the new group; they were dubbed variously 'subversives', 'revolutionaries' and, by *Le Figaro*, 'intransigents'. There were similar, but more extreme reactions from the other side of the Channel. *The Times*, reviewing a show of French art held simultaneously in Durand-Ruel's London gallery, which included works by several of the same artists, concluded: 'One seems to see in such work evidence of as wild a spirit of anarchy at work in French painting as in French politics.' The explanation for the politicization of art language has more to do with France's recent history – particularly the Commune – than with the stated or implicit views of the artists themselves or with the pictures' subject matter.

Castagnary's piece, written in a calm tone laced with bathos and irony, poured oil on the troubled waters that had been whipped up by some of his more sensationalist journalist colleagues. He recorded how the new group had formed a cooperative with a board of directors of fifteen elected members, whose watchword

was egalitarianism in matters of exhibition policy. Admittedly they had been driven to take such independent action out of frustration and earlier 'persecution'; he laid the blame for this firmly at the door of the Salon administration which had systematically barred the artists' path to success. He underlined two further points. Firstly, only new, unseen works were on show, not rejects from former Salons (this was not strictly true given Monet's inclusion of *The Luncheon*). Secondly, the presence of established artists such as Boudin, Cals, Gustave Colin (1828–1910) and Félix Bracquemond – the latter showing a series of etchings of famous figures from history – was a sure sign of the new group's respectability. Incidentally the full list of participants in the 1874 exhibition contains names of artists who continue to elude researchers and several of the landscapes shown, for instance by artists such as Latouche, Jean-Baptiste-Léopold Levert and Ottin, remain unidentified. But it was not around these figures, Castagnary argued with considerable foresight, but around artists such as Pissarro, Monet, Sisley, Renoir, Degas, Guillaumin and Morisot, that any question of a new 'school' of painting needed to be raised.

Citing Pissarro's *Hoar Frost*, Castagnary feigned to concur 120 with those who objected to the artist's 'grave error' of incorporating in the picture the shadows of trees that were outside the field of vision and lamented the artist's 'deplorable penchant for market gardens', cabbages and domestic vegetables. He nevertheless urged such quibblers to acknowledge Pissarro's synthetic vision and skilful execution. He drew attention to Monet's extraordinary handling, Sisley's poetic grace, Renoir's audacity and modernity and Morisot's delicacy of feeling. Noting Degas's 'bizarre' fixation on the somewhat specialized modern themes of racehorses, ballerinas and laundresses, he lavished praise on his drawing and understanding of colour. What linked the various artists, in Castagnary's view, was their decision to cast aside their brushes once they had achieved a given overall effect rather than trying to reproduce with unnecessary exactitude what they saw.

Interestingly, he could recall the term 'Japanese' being applied to earlier exhibitions of these artists at Durand-Ruel's gallery. Precisely who had used the term about which pictures is unclear but one can well conceive its aptness to the abbreviated handling, stark oppositions of colour and daringly simplified compositions used by Monet in, for example, *Entrance to the Harbour of Le Havre* (1870) or *Hyde Park*, paintings which had certainly been shown at 121 different dates by Durand-Ruel in London and possibly also in

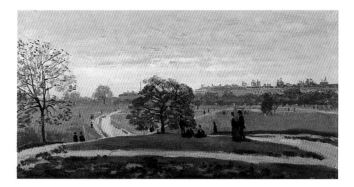

121. **Claude Monet,**
Hyde Park, 1871
The original title given to this work was *Kensington Gardens*; certainly the undulating lie of the land does not readily call to mind Hyde Park. Monet is thought to be looking in a northwesterly direction and he incorporates the terraced housing and churches on the Bayswater Road.

Paris. We know that Monet and Degas, among others, were attracted to the simple elegant forms and compositional boldness of oriental art. But Castagnary considered the term meaningless, in no way adequate to characterize the group as a whole. In the end, he agreed with Leroy: 'Once they've captured and fixed their impression, they declare their task done. If one wants to characterize them with one word that will explain them, it will be necessary to forge the new term of *Impressionists*.'

Castagnary concluded on a cautionary note. For him, the new art represented neither a revolution, since it had no more than modified art's existing procedures, nor a new school, since it lacked a guiding idea or principle. At worst, were its practitioners to follow the dangerous lead of Cézanne, they would lose themselves in an extreme, uncontrolled form of subjective romanticism. Alternatively, he predicted, those artists who took the trouble to perfect their drawing would soon drop Impressionism, finding it too superficial and restrictive; it would come to seem essentially a staging post on the way towards a more fully resolved style. How prophetic Castagnary's words would become in the next decade! First Pissarro, then Renoir and Morisot, would struggle to improve their techniques by strengthening their drawing. His forecast was extraordinarily close to the damning verdict on Impressionism delivered by Gauguin some twenty-five years later in jottings published posthumously as *Avant et après*: 'a purely superficial art, all coquetry, purely material. Thought is not to be found there.'

The 1874 exhibition had major repercussions both for the individuals taking part and for their public and critical profile. However, holding the group together around this tenuous concept, Impressionism, would prove an almost impossible task,

particularly given the lack of an obvious leader. In their reactions to the exhibition, most critics, like Castagnary, concentrated on the innovations of the landscape painters. Several critics wanted to see Monet as the group's captain, a notion that as the years went by became less and less apt. In terms of superior talent as a landscapist, the choice naturally fell on him and he had briefly played the part prior to the exhibition, rounding up signatories and writing to the journalist Paul Alexis welcoming his support of their cooperative venture. But just as much of this managerial responsibility had been and would continue to be undertaken by Pissarro and Degas. Monet lacked the conviction, social skills and broad political vision for the role of leader, too quick to put his own interests above those of the group. For some critics – notably Zola writing in 1875 – Manet, despite his refusal to take part, remained, paradoxically, the dominant personality behind the group. With such a charming and elusive deus ex machina it was perhaps difficult for an alternative leader to emerge.

Pissarro had an intelligent and broad vision of what the group stood for and could achieve. However, he was modest about his own work and would never have assumed a role of authority, partly no doubt because he was ideologically opposed to hierarchies, adhering to a Proudhonian notion of egalitarian democracy. His views, for some, were too revolutionary and his Jewish family background may have seemed too alien, despite his determined rooting of his art in the French countryside. Whatever the reasons, spoken or unspoken, Pissarro did not have what it took to head the Impressionist group. Instead he played a major role as a

122

122. **Camille Pissarro**, *Piette's House at Montfoucault*, 1874

teacher and theorist, drawing out the talents of both Cézanne and Gauguin, and influencing the developments of Impressionism when he urged the group to admit first Piette in 1877, then Gauguin in 1879, and lastly the younger generation centred around Georges Seurat (1859–91) in 1886. He is also thought to have largely dictated to Georges Lecomte the technical content of his *L'Art impressionniste* (1892), one of the first histories of the movement, based on Durand-Ruel's collection. For Cézanne, near the end of his life, Pissarro was the 'master of Impressionism'. But on Manet's death in 1883, Gauguin wrote to Pissarro: 'Manet had assumed the uniform of leader, now that he is dead Degas will inherit it and he is an Impressionist who draws!'

123

Degas was a suitable candidate in terms of education and range of contacts, but his particular talents were not at the centre of what seemed to be the group's main concerns, which crystallized, for the critics at least, around issues of perception and landscape. The reviewers who mentioned him in 1874 almost unanimously praised his obvious mastery of draughtsmanship, Burty even going so far as to predict he would one day 'become a classic'. Commercially, the show was a success for Degas, but how did it affect his position within the group? His initial determination to see his own brand of realism well represented had led him to urge such friends as Tissot and de Nittis, successful figure painters, to participate. Only de Nittis, who simultaneously exhibited at the Salon, agreed to take part, showing some minute landscape studies. He was initially optimistic about the outcome, writing a late review of the show for the Florence-based *Giornale artistico*. De Nittis's article interestingly reveals that one of the society's policies, and we can attribute this to Degas's influence, was the exclusion of all strictly commercial pictures, yet the

124

123. **Ludovic Piette**,
The Marketplace in front of the Town Hall at Pontoise, 1876
The works of Pissarro's friend Ludovic Piette, who, like himself, held firm republican and democratic political views, were seen at only one Impressionist exhibition, the third. He was singled out for having a 'predilection for markets', which he rendered with considerable attention to detail.

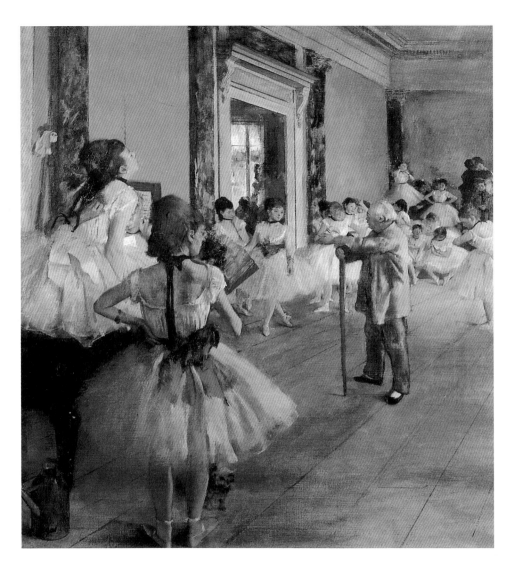

124. **Edgar Degas**,
The Dance Class, 1874–75
Between 1873 and 1876 Degas became
thoroughly absorbed in the dancer theme.
In this sophisticated composition, he shows
the distinguished elderly ballet master
Jules Perrot commanding the attention of
some, but not all of his pupils. By dint of
careful preparation, including drawings
of individual and group poses, Degas
achieved his desired effect of informality.

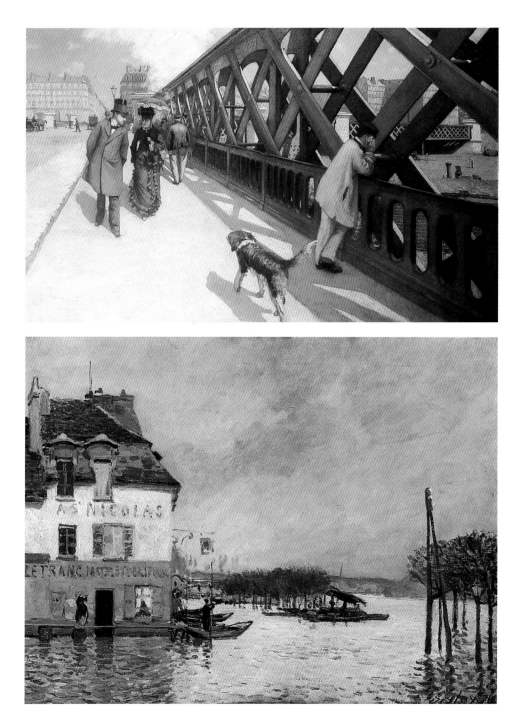

inclusion of all kinds of sketches and studies, as long as they contributed 'artistic notes'. Degas himself exhibited as many works on paper, including sketches in essence and pastels, as he did oils and Cézanne's problematic *A Modern Olympia* was described in the catalogue as a sketch.

The advantage of the open-ended situation over leadership was that it gave a number of members the chance to take centre stage at different moments. From 1877 on, for example, the wealthy artist Gustave Caillebotte, who had only joined the group the previous year, took responsibility for much of the behind-the-scenes exhibition organization. He also began to support some of the landscapists through his purchases and gave Monet offers of financial credit, in what proved to be a lean couple of years. In 1879 he had to work hard to secure Monet's participation, borrowing paintings from a wide range of private collectors. As a result, Monet's submission to the exhibition had something of the character of a mini-retrospective, incorporating works painted over the previous twelve years, with dates attached.

It was, in large part, the eagerness of certain critics to locate, define, almost conjure the long-anticipated new art out of the range of existing artistic tendencies that gave such immediate potency to the name Impressionism. By the time of their second exhibition, held in 1876 in the spacious Rue Le Peletier galleries which the artists had rented from Durand-Ruel, 'Impressionism' was circulating freely among the critics as the accepted designation of the new group. Indeed most of the artists themselves had come to accept it. The press may have been relatively charitable in 1874, but as the movement seemed to be taking firmer shape, so critics were inclined to deal with it more seriously and severely, especially the old-guard reviewers from the mainstream dailies who had yet to have their say. Albert Wolff, who had long waged war on Manet from the pages of *Le Figaro*, treated the Impressionists as madmen, charming young things as individuals, perhaps, but as artists, lost souls inflamed by misplaced ambition. After attacking Pissarro, for his violet trees and butter-coloured sky, and Renoir, for the putrefied tones of green and mauve he had introduced into the torso of a woman, he went on: 'There is also a woman in the group, as in all notorious gangs; her name is Berthe Morisot and she is intriguing to observe. In her case, feminine grace holds up in the midst of the excesses of a delirious mind.'

Even an earlier admirer like Armand Silvestre became more cautious and measured in his praise, liking the freshness and purity of their palette but calling the Impressionist school the

125. Gustave Caillebotte, *The Pont de l'Europe*, 1876 Of the six paintings Caillebotte exhibited in 1877, three were large, meticulously observed views of people negotiating the broad new spaces of Haussmann's Paris. To achieve this particularly daring perspective, Caillebotte rigged up a makeshift shelter in the Rue de Vienne, one of the spurs of the bridge crossing the railtracks entering the Gare Saint-Lazare.

126. Alfred Sisley, *Flood at Port-Marly*, 1876 When the Seine burst its banks in the spring of 1876, Sisley, living close by at Marly-le-Roi, painted several views of the flood and exhibited them at consecutive Impressionist shows. In this version, bought by the Rouen collector François Depeaux, he shows the improvised wharf set up for gaining access to the wine merchant's door.

127. **Auguste Renoir**,
Nude in Sunlight, 1875

128. Title page of
L'Impressionniste, with a drawing
of Renoir's *The Swing*, 21 April
1877

beginnings of a new tendency not yet fully matured or realized. 'Art', he wrote in *L'Opinion nationale*, 'could never be content with a series of impressions, however sincere these may be. Its goal is far more lofty and I cannot see in all of this anything but the very interesting starting point of new lines of research.' The painters were now more readily taken to task for perceived weaknesses, particularly when they used exaggeratedly crude colours, as though they wanted to 'unhook the rainbow', in the words of Baron Schop (a pseudonym for the poet Théodore de Banville writing in *Le National*, 7 April 1876).

The Third Impressionist Exhibition, held in 1877 in rooms in Rue Le Peletier, this time opposite Durand-Ruel's gallery, was the first to be announced by the artists themselves as an 'Impressionist' exhibition. The word Impressionist was also emblazoned on Georges Rivière's journal of the same name, 128 whose publication coincided with the duration of the exhibition. In a series of supportive articles, Rivière, a close friend of Renoir, took up the cudgels on behalf of both the group as a whole and its individual members. Unsurprisingly, Renoir's *The Ball at the* 129 *Moulin de la Galette* earned his glowing praise, but he also made a point of defending Cézanne, who had suffered the worst critical 130 attacks of all. He took to task the gentlemen of the popular press 131 for the prejudiced and easily dismissive tone they had adopted, which in its turn had predisposed many unthinking members of the public to come along simply to laugh. Rivière was in no doubt

129. **Auguste Renoir**, *The Ball at the Moulin de la Galette*, 1876
In Renoir's most important multi-figure composition of the 1870s, he deploys his new Impressionist technique of boldly broken brushwork and bright colour to translate the complicated effect of natural and artificial light. Many of his friends pose as dancers or drinkers; indeed, the painting, which was bought by Caillebotte, can be seen as a continuation of Renoir's earlier explorations of modern subject matter (see ills. 73, 101).

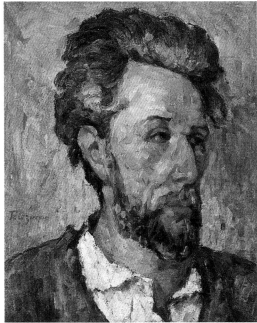

130. **Paul Cézanne**, *Head of a Man, Study* (Victor Chocquet), 1876–77
The critics mocked most of the works that Cézanne showed at the 1877 exhibition, particularly this portrait of his patron Chocquet; they attacked the violently heightened colour of the flesh tones.

131. **Cham**, *Madame! That Wouldn't be Wise. Keep Away!* Published in *Le Charivari*, 16 April 1877

that the Impressionists were about to triumph, that they were well on their way to making history. In one article, tellingly, he addresses himself to his female readers: 'For you alone have taste, you alone have no prejudices, and painters should address themselves to you alone.' He urged them to exert their influence on their husbands whose classical educations made them such conservatives in matters of artistic taste, even though they probably considered themselves progressives in other spheres. Why didn't these ladies ask to have their portrait painted in the charming new Impressionist manner, 'full of sun and gaiety'? By flattering women's idea of themselves as patrons and champions of art, Rivière encouraged them to come to the aid of the gallant young Impressionist painters.

It was a strategy that paid off in the case of Renoir, who was exhibiting recent portraits of three elegant sitters identified only by their initials: Jeanne Samary the actress, Madame Charpentier, wife of the well-known publisher of Zola and other naturalists, and Madame Daudet, wife of the novelist and a talented writer herself. Over the next few years, Renoir went on to garner numerous portrait commissions from the upper echelons of fashionable Parisian society, patrons such as the Bérards, Durand–Ruels, Cahen d'Anvers and Havilands. But the subtext of Rivière's

132

230

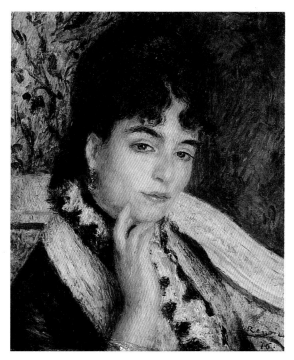

132. **Auguste Renoir**, *Portrait of Madame Alphonse Daudet*, 1876

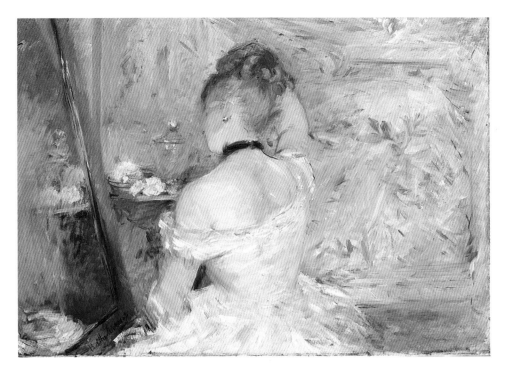

133. **Berthe Morisot**,
Lady at Her Toilet, c. 1875
This intimate study was shown at
the Fifth Impressionist Exhibition,
the first to involve all three women
Impressionists. Predictably, the
question of the feminine
contribution to the movement
was raised by critics. For Burty,
Morisot's distinction lay in her
delicate palette: 'Not since the
eighteenth century, not since
Fragonard [1732–1806], has an
artist laid on such blond colours
with such witty daring.'

article, underlining the feminine, light and accessible aspects of
Impressionism, its inheritance of an utterly French, rococo tradi-
tion – charms admirably embodied in Renoir and Morisot, whose
work rarely offended critics – can scarcely have delighted artists of
more classically educated and serious stamp, such as Degas or
Pissarro. With the best intentions, Rivière had laid the movement
bare to the attacks that would come with increasing frequency in
the next decade and that would make it more difficult for
Impressionism to be perceived as a serious, museum art.

Several authors have commented on the repeated use of the
political term *intransigeant*, roughly translatable as hard line, by
both approving and disapproving critics of the early Impressionist
exhibitions; it was used to refer both to the artists themselves and
to describe their realism. Certainly the choice of word is indicative
of the political and revolutionary tensions underlying the new
Republic, with the Left being fearful of the overly transigent ten-
dencies of the Marshal MacMahon's régime. But less interest has
been shown in the frequent use of religious metaphors. It was
probably Zola who had started this line of talk in 1867 in his
defence of Manet and, after 1876, numerous critics attempted to

133

134

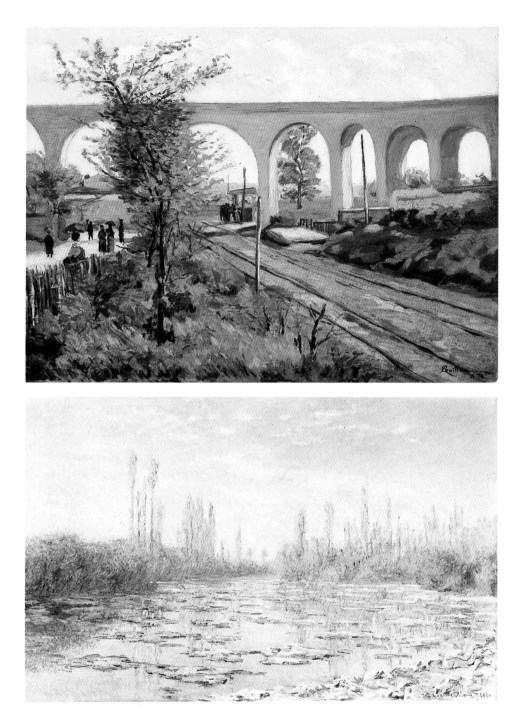

134. Armand Guillaumin,
The Arcueil Aqueduct at Sceaux Railroad Crossing, c. 1874
Despite the precision of its current identification, it is tempting to see this as the work exhibited in 1877 as *The Fleury Viaduct,* since no other Guillaumin corresponding to the title seems to have come to light. However, no contemporary critic left a description of the painting to clarify the question. In this thoroughly modern landscape, Guillaumin has road, rail and waterways intersecting.

135. Claude Monet,
Floating Ice, 1880
Following the great freeze of 1879–80, Monet painted several views of the break-up of the ice, a motif which oddly foreshadows the waterlily theme. He submitted this version to the Salon jury, a move which prevented him from exhibiting at that year's Impressionist show. It was rejected, although another more conventional riverscape was accepted. Bought by the Charpentiers, Monet showed it two years later at the Seventh Impressionist Exhibition.

explain the Impressionists' creed; warnings were given of the evangelizing zeal with which they threatened to make converts. Monet himself picked up the idea when he justified his return to the Salon in 1880: 'The little church has become… a banal school that opens its doors to the first dauber who happens to come along.' What fears lay behind this imagery? At one level, it was appropriate enough in a century of proliferating Protestant non-conformism. But one wonders whether the French, with their long heritage of Catholicism but increasingly secular tendencies, felt baffled by and anxious about the schismatic Protestants, whose enterprising businessmen were assuming such dominant roles around the world. (In the 1870s, following the loss of Alsace, the French Republic encouraged many of the territory's entrepreneurs to relocate to France.) In a similar spirit, critics struggled to explain the challenge to orthodoxy presented by the new, energetic and forward-looking Impressionist sect.

Giving any new artistic movement a name is tantamount to confining it to some sort of coherent shape. For Degas, the term Impressionism arguably distorted the diversity of the movement's overall aims, tending to marginalize his contribution. In 1878 a new condition of membership was introduced by Degas, in a somewhat contrary, possibly embittered spirit: henceforth one could not submit to the Salon as well as to the society's exhibition. Cézanne and Renoir immediately broke ranks, sending to the Salon instead, followed by Monet in 1880. In 1880 and 1881 Degas 135 succeeded in turning the show further in his direction, by involv- 138 ing newcomers like Mary Cassatt, Jean-Louis Forain (1852– 137, 140 1931) and Raffaëlli, all of whom specialized in figure work, not 139 landscape, with the result that neither Monet, nor Renoir, nor Sisley exhibited in 1880 or 1881. This irritated other members of the group, like Gauguin and Guillaumin, and generally confused 251 the critics.

136. Poster for the Fifth Impressionist Exhibition, 1880

(right)
137. **Mary Cassatt**,
Woman in a Loge, 1878–79

(below left)
138. **Gustave Caillebotte**,
In a Café, 1880

(below right)
139. **Jean-François Raffaëlli**,
The Absinthe Drinkers, 1881
When Raffaëlli showed this as *Les
Déclassés* (The Social Outcasts) at
the Sixth Impressionist Exhibition,
his pictures outnumbered those of
every other exhibitor. Such blatant
opportunism coupled with the
somewhat illustrative nature of his
work may explain his unpopularity
with some of the founder
members of the Impressionist
group, but naturalist writers
were attracted to his poetic
interpretations of the outer
suburbs.

(far right)
140. **Jean-Louis Forain**,
The Encounter in the Foyer
or *The Interval*, 1877

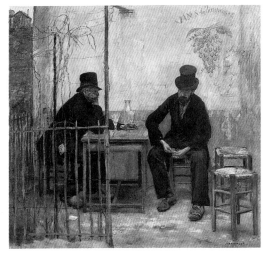

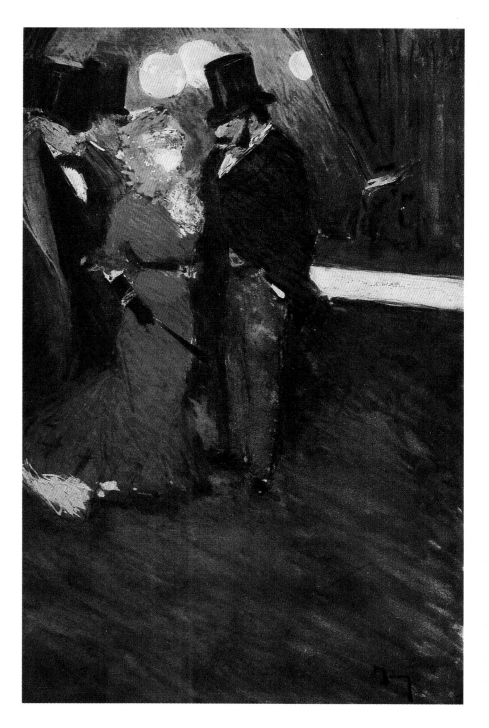

At the sixth exhibition in 1881, the word 'Impressionist' was once again replaced by the more neutral 'independent', reflecting Degas's personal antipathy to the earlier term. This gave certain critics the cue to question whether 'Impressionist' had had any validity. André Michel applauded the artists' apparent abandonment of a name which, he argued, they had usurped in the first place. It was by no means they alone who could lay claim to such a qualification, for 'Impressionists' had existed from the time of the sincere and naive masters of the fifteenth century right up to the time of Corot. However, Armand Silvestre repeated his earlier argument that, for him, the word represented, if not a fully developed theory, 'a perfectly determined order of ideas,… a certain community of aspirations and ideals… an aesthetic in the making'.

In 1882, Gauguin took an aggressive role behind the organizational scenes, determined to have Raffaëlli excluded. This piqued the pride of Degas who withdrew in protest. At such times, Berthe Morisot and her husband and Pissarro did their best to keep the

141

141. **Berthe Morisot**, *Nice Harbour*, 1882

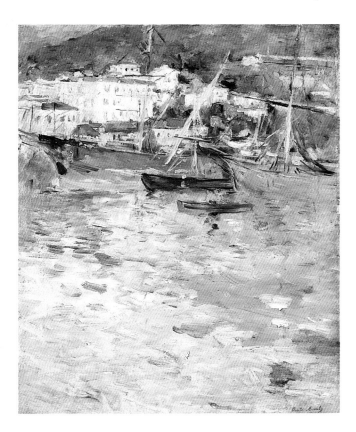

Draner, "Une visite aux impressionnistes," *Le Charivari* (9 March 1882)

peace between different factions, not always successfully. Monet, Renoir and Sisley were persuaded to return and thus the seventh show was dominated by landscape, which sparked a renewed critical evaluation of the term Impressionism. Incompletion and rapidity of execution were its essence for Jacques de Biez, writing in *Paris*, a definition which he saw reconfirmed in Monet's example that year. The latter was showing several repeated views of the same site – the Normandy cliffs – each one an attempt to capture a fugitive effect which, an hour after taking up his brushes, would already have been superseded by another.

142

143. Poster for the Eighth
Impressionist Exhibition, 1886

The Eighth Impressionist Exhibition did not take place until 1886. In the four-year interval, various developments had occurred in the art world which ensured this show would be the last. One problem was that Monet, Renoir and Sisley, because they were now in a position to have their work exhibited individually or in cosmopolitan contexts, were becoming less involved with the movement as such. So, notwithstanding the revival of the original Impressionist concept that had occurred in 1882, all three decided not to take part in the 1886 show. A new generation of artists had also appeared on the scene, led by the academically trained Georges Seurat, intent on developing Impressionist colour practice in a more scientific, systematic direction. This group – as yet including only Seurat, Paul Signac (1863–1935) and Lucien (1863–1944) and Camille Pissarro – had won a strategically important convert in Camille Pissarro who was able to argue for

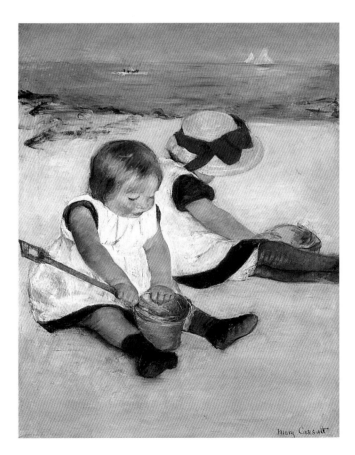

144. **Mary Cassatt**,
Children on the Shore, 1885

145. **Paul Gauguin,**
Near the Farm, 1885

146. **Armand Guillaumin,**
Twilight at Damiette, 1885

their inclusion in the 1886 exhibition. Their new, controlled divisionist canvases, dominated by Seurat's enormous *Sunday Afternoon on the Island of La Grande Jatte, 1884* (1884–85), decidedly stole the show. Identified by the symbolist critic Félix Fénéon, among others, as a sub-group of Impressionism, they earned the new designation 'Neo-Impressionists'. Other exhibitors included the ever-challenging Degas showing his suite of pastel nudes and his impressive ally Mary Cassatt, who, together with Forain, offered strong displays of draughtsmanship. The Impressionist style in its original form was represented solely by Morisot, Guillaumin and Gauguin. Even Gauguin embodied, in a sense, the stylistic difficulties and internal dissatisfactions that had characterized Impressionism throughout the early 1880s. Still trying to find his feet as a full-time painter, he had turned from the guidance of Pissarro and Degas to the paintings of Cézanne for an example of how to make a solidly constructed art. But Cézanne, since his bruising experiences in 1877, had had nothing further to do with the Impressionist exhibitions.

191
144

146
145

Chapter Six: The Impressionist Subject

147. **Paul Cézanne**,
Impression from Nature, c. 1877

There is a paradox to be addressed in relation to the Impressionist subject. Many early historians of the movement argued that, with Impressionism, the subject, as such, ceased to be of significance. Indeed they claimed that what made the Impressionists historically important was their indifference to questions of subject matter and readiness to paint just about anything that came to hand. More recently, art historians have been at pains to point out that, on the contrary, a particular slant towards modernity, especially urban modern life, lies at the very heart of the Impressionists' project and is in some sense inextricably bound up with their stylistic inventiveness. Many recent writers on Impressionism, influenced by the seminal work of T. J. Clark and Robert Herbert, have, in their different ways, made the social contexts of Impressionism and its thematic preoccupations the central issue to be addressed.

How do we reconcile such opposing positions? Was the choice of subject irrelevant or important to the Impressionist artist? There are occasional statements from the artists themselves which seem to lend support to the former view. Manet, for instance, is recorded as exclaiming, during a stay in Venice in 1874, 'They're so boring, these Italians, with their allegories, their characters from *Jerusalem Delivered* and *Orlando Furioso*, with all that showy bric-à-brac. An artist can say everything with fruit and flowers, or simply with clouds.' But rather than denying the relevance of subjects, Manet was essentially protesting against the nineteenth-century academic convention which persisted in categorizing art according to a hierarchy of genres that had been established in the seventeenth century. This hierarchy stipulated that the pinnacle of the artist's achievement and ambition was the representation of the human figure, with heroic historical compositions drawn from religion, allegory or myth taking precedence over portraits of living individuals. Further down the scale came everyday genre subjects, marines and landscapes, with imaginary classical landscapes with figures being rated above the painting of actual scenes; at the bottom of the gradation came animal painting and the humble still life.

Manet, to a certain extent, subverted these academic conventions; the Impressionists broke away from them more wholeheartedly. They not only avoided historical, literary and religious subjects to concentrate on the more lowly genres, but also kept their subject matter as neutral as possible. Cézanne's *Impression from Nature*, Morisot's *Head of a Young Girl*, Renoir's *Bouquet of Meadow Flowers* or Sisley's *Road, Evening* – to take a random sample of titles from the Third Impressionist Exhibition of 1877 –

147

seem designed to quell any specific narrative or anecdotal expectations on the viewer's part, expectations a title such as Raffaëlli's *Man Admiring His Newly Painted Gate* (1881, shown at the Sixth Impressionist Exhibition) sought on the contrary to arouse. This is not to say that all the Impressionists altogether dispensed with the narrative element in painting, but to varying degrees they played it down and kept their meanings ambiguous and open-ended. Cézanne was unusual in providing very few clues about the location of his landscape subjects. Pissarro, on the other hand, usually identified his landscape with a local name, such as Côte Saint-Denis, at Pontoise; Caillebotte was not averse to specifying street names as in *Rue Halévy, Balcony View*; and Degas, with his startlingly up-to-date study of a circus trapeze act *Miss La La at the Cirque Fernando*, tied down the subject to the circus located nearest to his studio.

17
148

The confusion over the importance of subject matter has largely persisted because of the historical role that Impressionism has been required to play within the twentieth-century modernist version of art history. Cézanne's suppression of his youthful romantic tendencies (literary themes haunted his work in the 1860s) to concentrate on landscape and still-life motifs can therefore be plotted within a perceived logical line of progression towards non-representational art. Similarly, his adoption of bland titles, such as *Impression from Nature* can be seen to lead ultimately, by a series of inevitable steps, to the open-ended *Untitled* used by so many abstract artists in the mid-twentieth century. *Untitled* is an aggressively obstructive way of denying the relevance of subject matter and of barring the intrusion of all literary or other non-artistic concerns into the specialist field of picture-making. As we shall discover, however, the Impressionists cannot be so readily forced into the straitjacket of 'pure painting'. Their subject choices were an important part of their innovativeness and the meaning of their work can often only be grasped if the social and cultural circumstances in which they lived and the kind of literature they read are understood.

Beyond their general commitment to nature and light, can we identify a typical Impressionist landscape subject? In selecting motifs, what part was played by happenstance or opportunity and what part by the painter's deliberate choice? When Monet discussed picture-making ideas with Bazille in his early letters, rather than referring to subjects as such, which would imply an element of calculated pre-planning, he tended to talk about his susceptibility to certain effects of season and weather and the

148. **Edgar Degas**, *Miss La La at the Cirque Fernando*, 1879

149. **Alfred Sisley**, *Barges on the Canal Saint-Martin*, 1870

natural motifs that enthused him. In August 1864, staying at the Saint-Siméon farm, he was seduced by the increasing variety of nature as the leaves started to turn yellow and by the marvellous motifs espied in Trouville and Étretat: 'Really now the country-side is at its most beautiful. We have wind, lovely clouds, storms; in short, it's the best time to see this landscape, there are many more effects.' For Monet, the readiness was all. Bazille, on the other hand, encouraged by his father, could still see the point of devoting a pre-planned painting campaign to a subject of historic and archi-tectural interest like Aigues-Mortes, with its picturesque med-ieval walls. This was a more traditional attitude to the landscape subject, typical of the Salon painter.

Monet's interest in harbours and working waterways, with their many different kinds of sail and steam craft, was a natural development of his experience of growing up in Le Havre. It was an interest shared to some extent by other Impressionist col-leagues: Guillaumin and Sisley in their paintings of barge traffic at 149 the hub of working Paris and Morisot, for instance, who painted at various times in the harbours of Lorient, Cherbourg, Fécamp and Cowes. It is significant that although Morisot exhibited the fresh study entitled *Boats under Construction* at the Second 150 Impressionist Exhibition, among a group of eleven similar land-scapes featuring harbours and boats, critics ignored them, focus-ing instead on her charming studies of women. Although an open-minded painter, she found herself increasingly stereotyped and confined to representing what was deemed appropriate for a painter of the feminine sex. Critics were similarly swift to pigeon-hole Mary Cassatt as a specially gifted painter of women and chil- 151 dren. Monet's sensitivity to nature's decorative effects, to the play of surface and depth in water, to soft-edged masses of flowers and foliage, links some of his earliest landscape motifs to his final vast

150. **Berthe Morisot**, *Boats under Construction*, 1874

151. **Mary Cassatt**, *Mrs Cassatt Reading to Her Grandchildren*, 1880

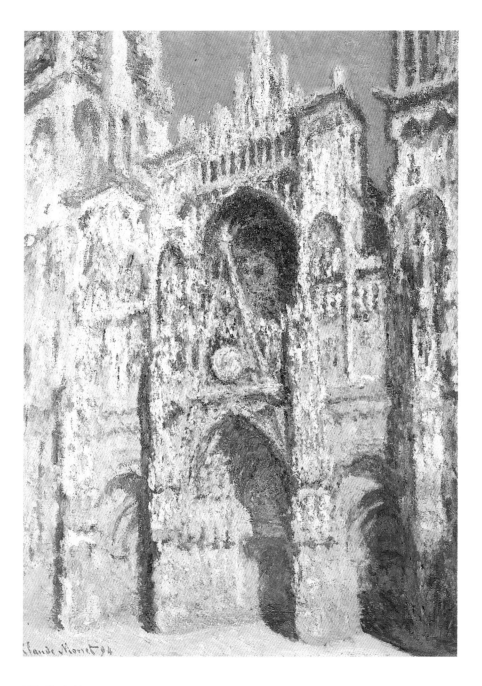

152. **Claude Monet**,
Rouen Cathedral, 1894

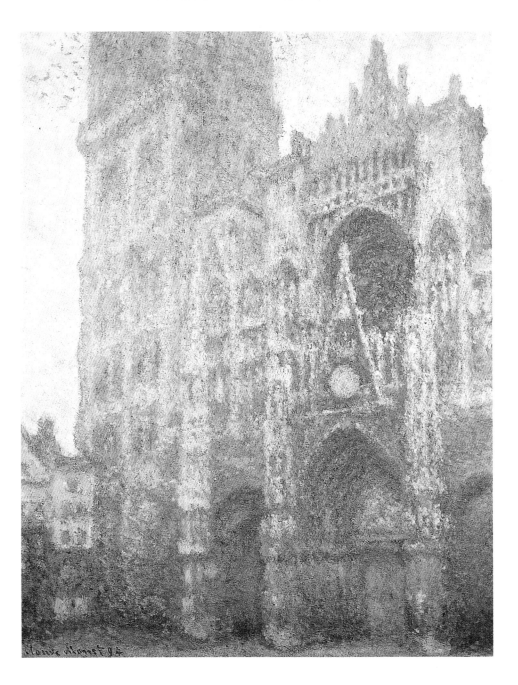

153. **Claude Monet,**
Rouen Cathedral, 1894

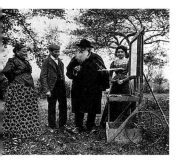

154. Photograph of Pissarro painting in his orchard at Éragny-sur-Epte, late 1890s. The artist is shown here with his wife Julie and children Paul-Émile and Jeanne.

155. **Camille Pissarro,**
Factory near Pontoise, 1873
Pissarro was almost the only Impressionist to deal directly with industrial subjects. He painted several views of the sugar-beet factory at Pontoise, which, in this placid and balanced composition, seems to pose no threat to the beauty of the natural surroundings.

156. **Camille Pissarro,**
Justice Path at Pontoise, c. 1872

canvases in which he explored his own garden at Giverny. Monet's rocks and cliffs invariably have a soft-textured, almost granular quality, the result of wind and water erosion. Indeed a similar fascination could be seen to lie behind his repeated paintings of the facade of Rouen Cathedral. Not for him the sparse and arid rocky structures of Provence that appealed to Cézanne. In the 1880s and beyond, a taste for elemental drama characterized Monet's more monumental motifs, which he travelled the length and breadth of France to find. He was no longer drawn to the workaday, unprepossessing themes that so consistently attracted Pissarro, however indicative they might be of modern times.

Whereas Sisley's interest in such sites as Louveciennes and Marly-le-Roi in the 1870s testifies to a lingering fondness for *ancien régime* elegance, a love shared with his teacher Corot, Pissarro seems to have had little taste for historical landscape motifs. Indeed, as Richard Brettell has shown, he took care to eliminate from his view the aqueduct of Louveciennes and the château of Pontoise and yet, for a newcomer to France, he showed a remarkable sympathy for the economic realities of this nation of 'cabbage planters'. This was, of course, not coincidental but a predisposition resulting from his radical political ideas. In a series of early Pontoise canvases he observed the way a sugar-beet factory made an impact on the surrounding landscape. He was a consistently keen observer of a wide range of farming practices – ploughed fields and cabbage patches became his stock-in-trade whilst living at Pontoise, arable farming when in 1884 he moved to Éragny-sur-Epte – and he studied the local markets at Pontoise and Gisors, perhaps in response to his friend Piette's interest in the theme. The market was not just a setting for social interaction, it also represented the weekly goal to which so much rural work was directed. It is worth remembering that it was essentially his wife Julie who gave the Jewish Pissarro access to this alien rural world with its enduring peasant values. Tending her vegetable patch, feeding poultry and shopping at the market were a way of life she had been brought up to understand. In so steadfastly making rural agronomy the mainspring of his art, Pissarro was discreetly paying homage to the role of Julie in his life.

Beyond such individual predispositions, their increasingly focused pursuit of light effects led all the landscape Impressionists to nurture certain distinct preferences when it came to selecting motifs, times of day and weather conditions. They tended to avoid the harsh clarity of the midday sun because it produced stark shadows like the one that divides the village street into deep shade and

152
153

19, 71
156

155

154

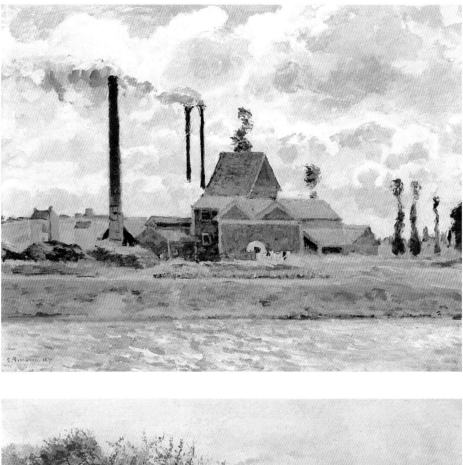

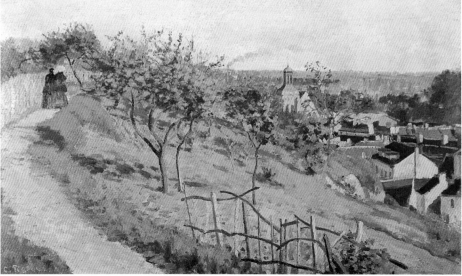

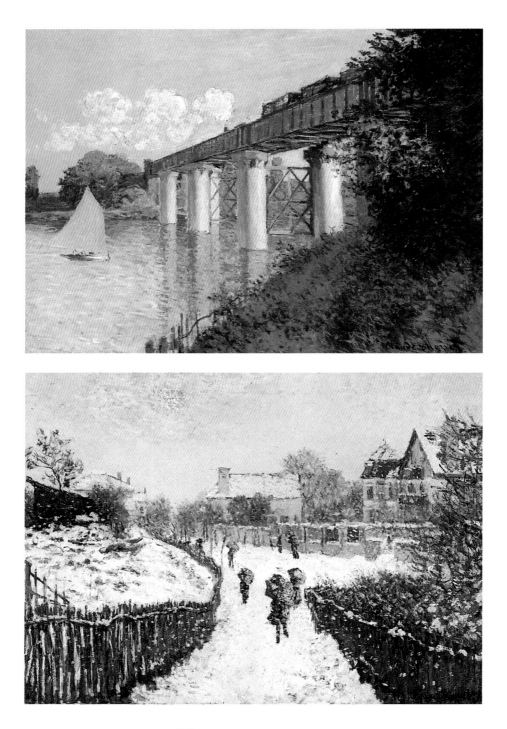

157. **Claude Monet**, *The Railroad Bridge at Argenteuil*, 1874
Around 1874 both Monet and Sisley went out of their way to paint striking compositions involving bridges. Here steam and sail are juxtaposed starkly, and Monet heightens the drama of his view by showing the underside of the bridge caught by the warm rays of a late afternoon sun. He must have stood on the shady bank near the water's edge to paint the scene, in an area of semi-industrial wasteland.

158. **Claude Monet**, *Boulevard Saint-Denis, Argenteuil, in Winter*, 1875

159. **Auguste Renoir**, *Woman with a Parasol in a Garden*, c. 1874

glaring sunlight in Monet's *Street at Honfleur* of 1864. They became more interested in the diffuse effects of light when it is broken by cloud or falls on reflective or absorbent surfaces. They gravitated towards scenes involving water with its ripples and reflections and, although they avoided the extremes of stormy and dramatic weather effects, they savoured the softening or erasing of contours produced by fog and snow. It was the billowing smoke and the filtered effects of light through glass that interested Monet more than the locomotives when choosing the Gare Saint-Lazare as a motif. The Impressionists were drawn to study gardens, the dappled shade cast by trees, and meadows of long grass and wild flowers whose surface was easily ruffled by breezes. In the woods and forests, it was the undergrowth with its complex web of vegetation, rather than the mighty oaks beloved of the Barbizon painter Rousseau, that absorbed their attention.

<div style="text-align: right">80, 94

157

158

1, 211

159

218, 219</div>

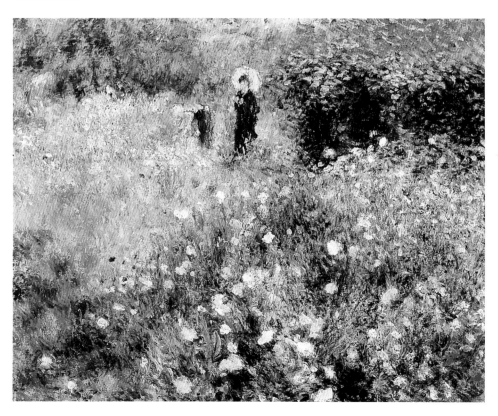

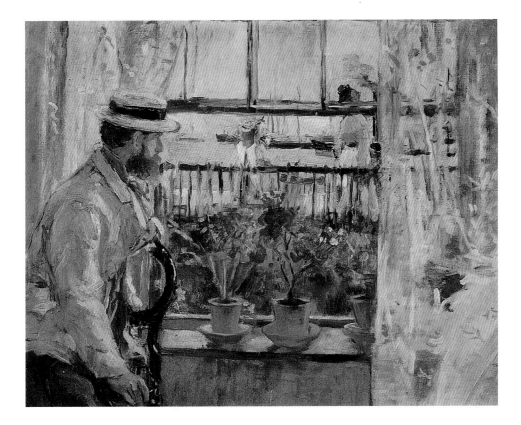

160. **Berthe Morisot**, *Eugène Manet on the Isle of Wight*, 1875

In interior subjects, the Impressionists favoured windows draped with sheer material, such as muslin and voile, which acts as a semi-transparent filter for sunlight, or white linen table cloths which offer a luminous foil for reflections and coloured shadows.

Over and above these interests in the special and ephemeral aspects of light, the Impressionist landscapists' distinctive concern was with modernity. This was apparent from their very first exhibitions. Indeed, as early as 1868, Zola, reviewing the Salon, had noted the modernity of Pissarro's landscapes and Monet's predilection for up-to-date subjects: 'Here's an artist who has drawn succour from our own age, here's one who has grown up and will continue to grow with an adoration of what surrounds him.... As a true Parisian, he transports Paris into the countryside, he cannot paint a landscape without placing fashionably dressed men and women in it. Nature seems to lose its appeal for him as soon as it does not bear the stamp of our contemporary manners.' In fact Zola placed Monet among a group he dubbed

160
161
162

161. **Edgar Degas,**
A Woman Ironing, 1873

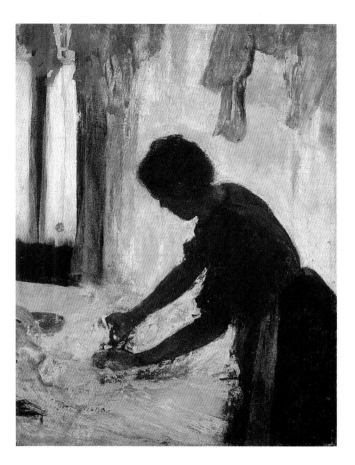

162. **Gustave Caillebotte,**
Still Life with Oysters, 1880–82

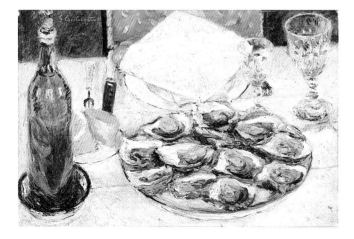

les actualistes because of their acute sense of modernity. Calling Monet a Parisian was of course not strictly accurate and one wonders whether the artist might not have come to feel the critic had overstepped the mark in making so much of his predilection for modern subjects. Although, in the 1880s, Monet would turn away from this somewhat circumscribed interest in signs of modernity in the landscape, Zola's description holds true for the Monet of the 1870s. On canvas after canvas, Monet painted the various ways in which city dwellers were taking possession of the countryside for their own ends, as a site for leisure. We see this in the paintings of Argenteuil, with its new railway and road bridges (which had been 157 destroyed during the Franco-Prussian War), and in the sailing 192, 203 dinghies, leisurely strollers and small regular suburban villas 205 springing up at the edge of open fields.

In 1874 Castagnary further developed the theme of the painters' relationship with modern life, by calling Impressionism an art that took its inspiration from 'contemporary manners'. Some commentators argued that Impressionism also addressed itself to a new audience – essentially to the smart and not-so-smart Parisians whose routines, interests and entertainments made up those contemporary manners. Such Parisians constituted an identifiable, albeit fluid, social group, which was well known to novelists, cartoonists and newspaper columnists.

The caption to Paul Hadol's cartoon of the First Impressionist Exhibition in *L'Eclipse* on 26 April 1874 reads: 'Boulevard des 163 Capucines – What could be more chic; here's an exhibition that

163. **Paul Hadol**, *La Semaine comique*. Published in *L'Eclipse,* 26 April 1874

dresses well!' Art and fashion have frequently been linked in the twentieth century, but the nineteenth-century critic who first

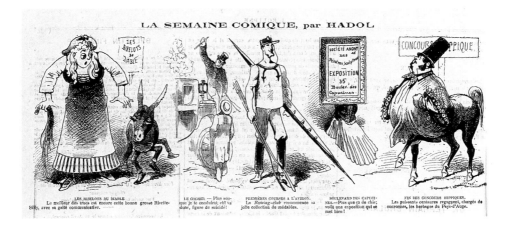

identified fashion as a locus for the very essence of modernity was Baudelaire. However, he made clear, as did Edmond Duranty in 1876, that modernity lay not just in the outward trappings of fashion and make-up, but in a certain look, gesture, movement. The Impressionists' choice of a smart commercial boulevard as locale not just for their first but also for their subsequent exhibitions brought together art and fashion in a significant and unprecedented way. One critic, Édouard Drumont writing for the *Petit journal*, gives a useful thumbnail sketch of the kind of viewer he believed might respond well to the work on show: 'The man who, throwing away his cigar at the door, pops up to see the show for a few minutes either during the day, or in the evening, since the exhibition is open until six in the evening, that man, I say, will not believe himself to be entering what people solemnly call a temple of art. He will rediscover the life he has just left behind, the spectacles he catches sight of at every instant, the exact look the countryside has when he chances to observe it.' Drumont seems to have in mind the busy man-about-town, broadly speaking the bourgeois, who has no time for High Art (perhaps lacking the education to appreciate it) but has his finger on the pulse of modern life and has an appetite for novelty. The link between the new art movement and fashion was made even more explicit by the subject matter of the works exhibited. The critic Jean Prouvaire observed ironically in 1874: 'One of the tendencies of this emergent school is to confront the charming artifice of the Parisienne with the charms of nature, or to mix up Worth and the bounties of God.' High fashion was noted in the paintings of both Morisot, whose women are recognized as having a specifically Parisian, albeit eccentric, chic, and Renoir.

The works Berthe Morisot exhibited in 1874 included a good number for which her sister Edma had sat with her children. Later, she had her husband pose and sometimes turned to professional models or her daughter's nursemaid. Several of her paintings – in particular the watercolour of an elegant mother and child on a raised terrace with railing, and the young woman and child on a [164] seaside balcony – carry echoes of the situations favoured by fashion-plate illustrators. Being a stylish woman who was accustomed to being admired, Morisot had good reason to be familiar with magazines such as *Le Moniteur de la mode* or *L'Illustrateur des dames*. [166] Whereas her male colleagues showed an occasional, but short-lived, interest in these colourful images (see p. 95), fashion plates [54, 83] provided nourishment for Morisot's art for much of her career, as Anne Higonnet has established. Her close friendship with

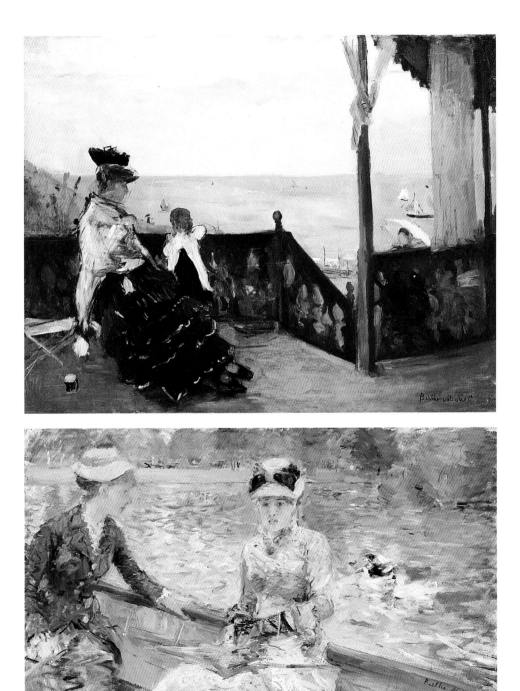

164. **Berthe Morisot**,
In a Villa by the Seaside, 1874

Mallarmé, a great admirer of her work, owed much to their mutual love of fashion; the poet embarked on a short-lived commercial venture editing a magazine called *La Dernière mode* in 1874.

Morisot's advantage over her male colleagues lay precisely in her experience of living in contemporary clothes. She knew the discomforts of corsets, the inconveniences of the crinoline and the restricting effect of tightly swathed skirts. She also understood the relative irrelevance of looking immaculate when sitting on the grass or playing with young children. Although the settings are similar, her pictures differ from the detailed staged vignettes of fashion plates; rather, Morisot adapted ideas from the realm of fashion to the intimacy of the domestic interior. With a combination of careful observation and an ability to make rapid notations of effects with swift, long and nervous brushmarks, she achieved the artless, unposed look she wanted. Where Alfred Stevens's fashionable subjects somewhat resemble clothes horses, Morisot's women get on with their lives, often with the ribbons on their bonnets adrift. Instead of fanning themselves flirtily, or holding their parasols above their heads as Tissot's women do, they constantly discard such encumbrances. Morisot, like Renoir, not only animated her landscapes with such figures, but also regularly alternated her studies of landscape with figure work. In considering the subjects of the figure artists, the Impressionists' commitment to modernity comes even more forcibly to the fore.

165. **Berthe Morisot**,
Summer's Day, 1879
Exhibited at the Fifth Impressionist Exhibition, Morisot's charming loosely worked painting records two elegantly dressed ladies enjoying an outing in a rowing boat. The setting is the artificial lake in the Bois de Boulogne, remodelled by Haussmann during the Second Empire and, by this date, a popular park among fashionable Parisians.

166. Fashion plate from
L'Illustrateur des dames, c. 1872

Writing about Impressionism in 1876 for *The Art Monthly Review and Photographic Portfolio*, Mallarmé's vision of the new art's character and potential audience was broad in scope. He went so far as to describe it as 'a democratic art for a democratic age'. Linking it to the French Republic's recent introduction of universal male suffrage, he saw in Impressionism the seeds of a whole future artistic era when painting and literature would forget the imaginative dreams of the past and address the experience of the 'energetic modern worker'. He continued, 'Today the multitude demands to see with its own eyes.' From our perspective, it is more striking that the Impressionists' subjects seem more limited, essentially drawn from the domestic, private bourgeois sphere rather than from the experience of the multitude or the grand themes of public life. As it turned out, with the exception of paintings such as Caillebotte's *The Floor-Scrapers* (1875) or

167
168

167. **Marie Bracquemond**, *Teatime*, 1880
Marie Bracquemond showed work at three of the Impressionist exhibitions and this was possibly the painting shown in 1880 as *Study from Nature*. The artist's sister posed and the hilly verdant setting is Sèvres, just outside Paris. Although seeking to render the effect of dappled shade, the artist retains a high level of characterization and incidental detail.

168. **Mary Cassatt**, *Susan on a Balcony Holding a Dog*, c. 1883

certain Guillaumins, the experience of the male 'energetic modern worker' occupied a relatively small space in the art of the Impressionists.

The critic Camille Lemonnier was probably nearer the mark when he wrote, in 1900: 'It will be the characteristic mark of the art of this century that it has approached contemporary life through woman. Woman really forms the transition between the painting of the past and the painting of the future.' Lemonnier reached this conclusion in a review of the work of Alfred Stevens, but it seems just as apt a verdict if one applies it to the subject matter of Impressionism as a whole. In Lemonnier's view, the Millet woman – the honest rural peasant – and the Stevens woman – the over-refined decadent Parisienne – were the century's two prototypes, or polar opposites. Where do the Impressionists' representations of women stand?

The debates over the painting of the female nude during the 1860s, highlighted by the furore over Manet's *Olympia*, were not 48 only a telling indication of the contradictory tastes and moral dualism of the Second Empire, but also of the difficulty of devising a plausible modern nude. Courbet's nudes frequently got him into trouble on grounds of propriety. In 1864, his large painting on a spurious mythological theme, *Psyche and Venus*, was rejected by the Salon jury, presumably because it represented an intimate moment between two very real fleshy nudes. His fellow painter Jean-François Millet's response to this rebuff is interesting: 'I have not seen the picture and cannot form any judgment of the jury's decision, but I find it very hard to imagine that any picture of Courbet's could be more improper than the indecent works of Cabanel and 169 [Paul] Baudry [1828–86] at the last Salon, for I have never seen anything that seemed to me a more frank and direct appeal to the

169. **Alexandre Cabanel**, *Birth of Venus*, 1863

passions of bankers and stockbrokers.' The acceptable nude of the mid-nineteenth century was a confection, masking her pornographic purpose in flawless surface finish and mythological or exotic guise.

Renoir's early nude figure paintings, particularly the robust fleshy handling of his *Diana the Huntress*, completed in Bazille's 41 studio, recall Courbet in their frank and sensual approach. Courbet's candour undoubtedly troubled the imagination of Cézanne too and set Bazille standards to emulate. In the 1870s, Manet increasingly rejected the nude as a subject, preferring instead to depict the semi-clad figure, which had both more erotic 170 piquancy and could be executed with a greater degree of modern verisimilitude. He made a few informal pastels of women in the tub, however, which can be compared with Degas's later systematic exploration of the subject. Cézanne and Renoir, on the other hand, persisted with the theme (as seen in Cézanne's *Three* 172

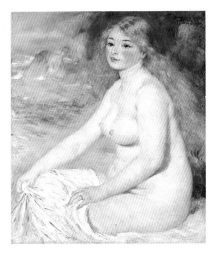

171. **Auguste Renoir**,
Blonde Bather, 1881

172. **Paul Cézanne**,
Three Bathers, 1879–82

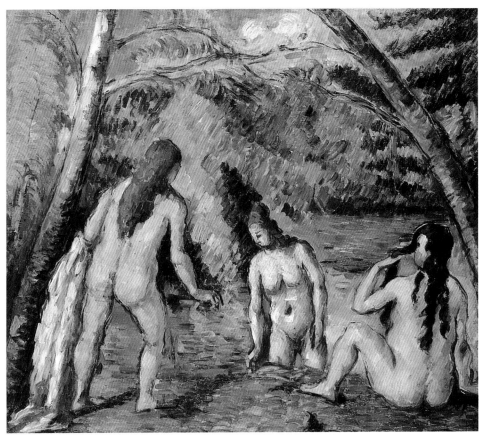

Bathers and *The Battle of Love*, and Renoir's *Blonde Bather* and *The* 241, 171
Bathers), but they quite rapidly gave up trying to devise plausible 222
modern contexts for the nude and resorted instead to locating
them in non-specific landscape settings. By denying particularity
of time and place, such compositional solutions inevitably hark
back to the classical tradition. Renoir's *Blonde Bather*, painted in
1881 in a new, more generalized, monumental manner, shows evi-
dence of his recent studies of Raphael's Farnesina Villa frescoes in
Rome. In the 1890s, Pissarro too had a brief dalliance with this
theme, but his nudes are more specific to place; they are the peas-
ants whom he usually showed working in the fields having 174
stripped off to cool down in a shady stream. Other Impressionists
flirted with the nude subject. Caillebotte, having painted a rather
awkward female nude on a sofa, executed an arresting composi-
tion of a male figure drying himself after a bath. In 1880 Gauguin
devised a modern solution to the subject which earned him the 175
glowing praise of Joris-Karl Huysmans. But, as we shall see, it was
Degas who, having been painstakingly trained in the study of the
human form early in his career, returned to and obsessively
worked away at the theme of the female nude in the 1880s and
1890s, devising plausible, albeit schematic, modern settings –
either in the bedroom or bathroom. 173

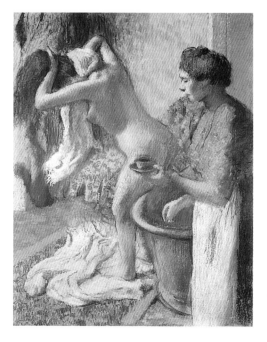

173. **Edgar Degas**, *Breakfast after the Bath*, c. 1895–98

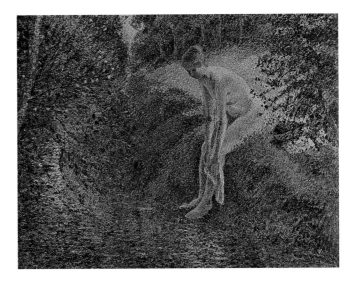

174. **Camille Pissarro,**
Bather in the Woods, 1895

175. **Paul Gauguin,**
Suzanne Sewing, 1880
Shown at the Sixth Impressionist
Exhibition of 1881, as part
of a varied group including
landscapes, still lifes, figure
studies and sculpture, this
painting was singled out for
praise by Huysmans who felt
its candour and realism revealed
the 'incontestable temperament
of a modern painter'.

The nude motif had of course belonged since time immemorial to the domain of the visual artist and enjoyed a long history within the Western pictorial tradition. However, in the search for specifically modern genre subjects involving more than one figure, subjects which caught 'the exact physiognomy of an epoch', to use the words of the writer and librettist Ludovic Halévy, there was considerable overlap between the themes of writers and painters. Moreover, given that the overriding area of common interest was the modern woman, and that the writers and artists were almost invariably male, there was also, despite a certain mutual hostility or suspicion, considerable scope for interplay between the fields. Several novelists and poets – Zola, Duranty, Huysmans, Théodore de Banville, Mallarmé – turned their hand to art criticism; some were outspokenly keen to draft the painters into their own literary crusades. When one looks more broadly at the work of the naturalist generation (writers such as the de Goncourts, Maupassant and Daudet), it is clear that they were fascinated by the same worlds of popular entertainment – theatre, café, circus, brothel, restaurant, Sunday outings on the river – that the Impressionists and other modern painters were exploring on canvas. But how closely did painters read the new writing of their literary contemporaries and was it of specific use and relevance to them?

As their early champion, we might expect Zola to be the novelist most responsive to Impressionist ideas. However, as his own career advanced, he became less and less sympathetic to the

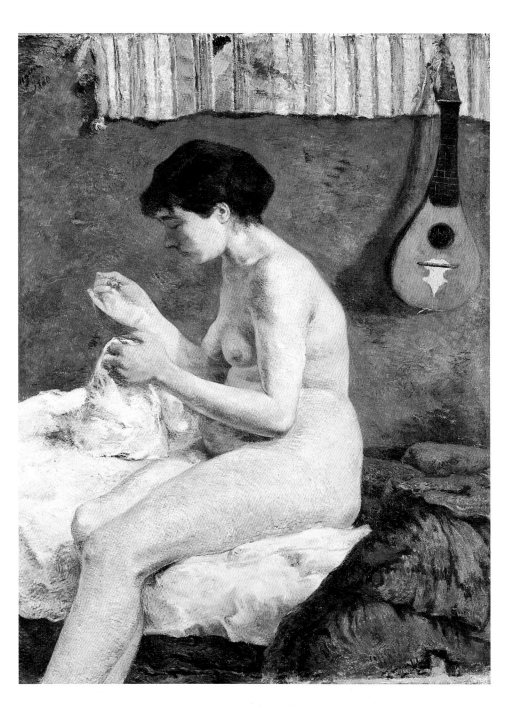

original Impressionists' work, preferring the more resolved modern paintings of their Salon contemporaries. In 1880 he complained that they were only able to produce incomplete fragments and lacked a truly capable master. Zola's novels about the Rougon-Macquart family, widely read though they were, essentially served as vehicles for their author's political and social views rather than for subtle social interplay. Each documents a given milieu exhaustively, the plots following determinist and sometimes melodramatic lines. He had a love of set-piece descriptions involving cumulative concrete details and, for these, his imagination was certainly nourished by painting, sometimes by specific Impressionist canvases. A passage in *A Love Affair* of 1878, for example, was directly based on an idyllic garden scene by Renoir. In Zola's earlier novel about working-class Paris, *L'Assommoir*, he based some of his descriptions of the communal laundry on the evocative studies of laundresses by Degas. However, it was the de Goncourt brothers whose writing style, in the opinion of the French literary historian Gustave Lanson, came closest to the Impressionists. 'They really created the *impressionist* style; a highly artistic style which sacrifices grammar to the impression, which, through the suppression of all the colourless, inexpressive words required by the conventional rules of grammatical construction, through the elimination of all merely syntactic and conjunctive parts of the sentence, leaves only the terms which produce sensations, juxtaposed in a sort of *pointillism*.' The de Goncourts and Degas were the direct equivalents one of the other, in the opinion of Huysmans, who was himself a disciple of Edmond de Goncourt's, the nervous qualities of their writing matching his rare colour combinations and mesmerizing handling of pastel. But despite a mutual investigation of the brothel as a subject in the late 1870s, no truly productive collaboration ensued.

176

It was Renoir who, after the success of *L'Assommoir*'s serialization in *Le Bien public* in 1876, was invited by Zola to provide drawings for an illustrated edition of the novel which the publisher, Georges Charpentier, planned to bring out. Renoir was fast becoming the Charpentiers' official painter. He executed the family's portraits and carried out decorations for their Paris salon. Through them he got to know Alphonse Daudet, his exact contemporary in age. Renoir not only painted a fine portrait of Madame Daudet, but was also invited to illustrate a series of Daudet articles on contemporary literary salons. Daudet's most successful urban novel, the title that had greatly boosted the Charpentier publishing house's fortunes, was *Fromont jeune et*

179

177, 178

132

176. **Félix Bracquemond,**
Portrait of Monsieur Edmond de Goncourt, 1880

177. **Auguste Renoir,**
Man on a Staircase, c. 1876

178. **Auguste Renoir,**
Woman on a Staircase, c. 1876

179. **Auguste Renoir,**
*Madame Charpentier and Her
Children,* 1878

Risler aîné (translated into English as *Sidonie*), published in 1874. Its eponymous heroes are the proprietors of a wallpaper factory based in the working-class east of Paris. Despite certain exaggerations to the storyline, it is a telling study of contemporary society and particularly of social mobility. Daudet excels in contrasting the pleasures of the Parisian working classes, who, to escape the city on Sundays, head out by train to the suburban villages, with the stiffer rituals of the *nouveaux riches* in their over-furnished apartments and country retreats. In Sidonie, his principal female character, we meet the kind of ruthless working-class *arriviste*, or go-getter, who became a leitmotif of naturalist literature in the 1870s. We encounter a more extreme form of her in Zola's Nana.

Certain of Renoir's women seem to come from the pages of such novels; indeed, taken together, his modern-life paintings can be read as explorations of petit bourgeois or nouveau riche mores, although Renoir viewed his characters' social interactions in a more benign light than Daudet or Zola. The critic Prouvaire, in his review of the 1874 Impressionist exhibition, went so far as to read Renoir's *The Parisienne* and *Avant-scène* or *The Loge* as representing successive stages in the social advancement of the same young and unintelligent, but pretty and ambitious, Parisienne, whose promising teenage début could be seen in his standing *Ballet Dancer*. Renoir's essays in social observation culminated in the large multi-figure compositions *The Ball at the Moulin de la Galette*, set in Montmartre, and *The Luncheon of the Boating Party*, which takes place in the Fournaise restaurant at Chatou. During this same period, his friend Caillebotte was turning a more critical gaze on the stiff and stuffy world of the nouveau riche bourgeois, to which his own family belonged. In this world, modernity is conveyed by chilly non-communication rather than by figures conjoined in vibrant, palpitating colour.

The experience of pleasure, coquetry or contentment so frequently evoked in the paintings of Renoir was on the whole alien to Degas's women. Was this a question of class or of temperament? Probably of both. Unlike the upper-middle-class Degas, the tailor's son Renoir was on familiar terms with the 'coarse type of working-class girl' he so often, according to Rivière, chose to paint. Although we are unlikely to be beguiled into accepting Renoir's beautiful visions as truthful, and may even find them unacceptably rosy, we can respect his refusal to condemn the working classes through his art and his wish to perpetuate the idylls of his beloved eighteenth century. Degas does not directly condemn either, but the vision he presents of the working-class

180

129
234

181

180. **Auguste Renoir**,
The Loge, 1874

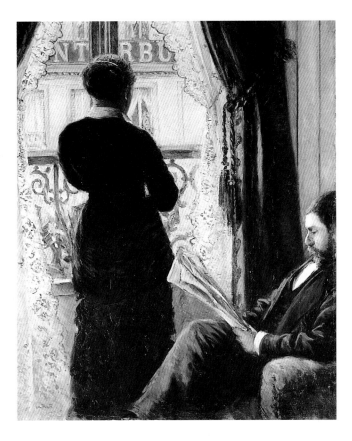

Parisienne is a more jaundiced one, the reverse side of the secure but confined world of the bourgeoisie which he knew best.

The shift that occurs in Degas's subject matter around 1874 – from portraits of family and friends and meticulously observed bourgeois genre subjects to motifs inspired by the lower depths of Paris, by the 'vulgar' women who laboured and performed in the public sphere – was a bold, combative and intriguing career move. It was signalled by the range of works he chose to show in the 1874 exhibition; as well as racing subjects, there were ballet scenes, in rehearsal and backstage, laundresses and a single bather. This move transformed him from the curious, highly talented but essentially unassuming minor master of modern life to the extraordinary grand master whose breadth of vision and incisive insights continue to amaze the world today. How do we account for it? Does the puzzling *Interior*, also known as *The Rape*, which Degas referred to later as 'my genre painting', give us any clue? 182

178

Interior depicts, in precise detail, a young woman's bedroom into which a bourgeois man seems to have intruded. What has happened between the two protagonists is eloquently indicated by their body language, the gulf between them and the poignant inclusion of a discarded corset. It was painted at the end of a decade in which Degas's exploratory attempts at history painting, beginning with *Young Spartans Exercising* and *The Daughter of Jephta* 104 (*c.* 1859–61), and continuing in *Scenes of War in the Middle Ages* (1865), had shown a singular preoccupation with the theme of the antagonism between the sexes. The uncomfortable rift at the heart of *Interior* also recalls the apparent remoteness of *The Bellelli* 107 *Family*. Taking these works together, we can begin to see the problems of gender difference as a defining theme for Degas, one that would have long-term implications in his oeuvre. The setting and figures in *Interior* correspond closely in certain respects to a similar scene in Zola's novel *Thérèse Raquin*, published in 1867, which does not, however, involve a rape. But might the choice of subject also have a more personal resonance? Does it at some level embody some shameful personal experience? Is Degas conveying a rueful acceptance or a more bitter assertion of the exploitation of working women by bourgeois men that lay at the heart of modern French society?

182. **Edgar Degas**,
Interior or *The Rape*, 1868–69

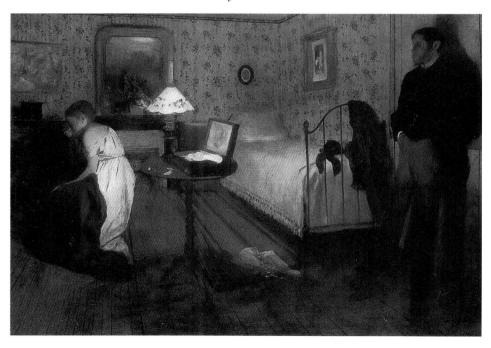

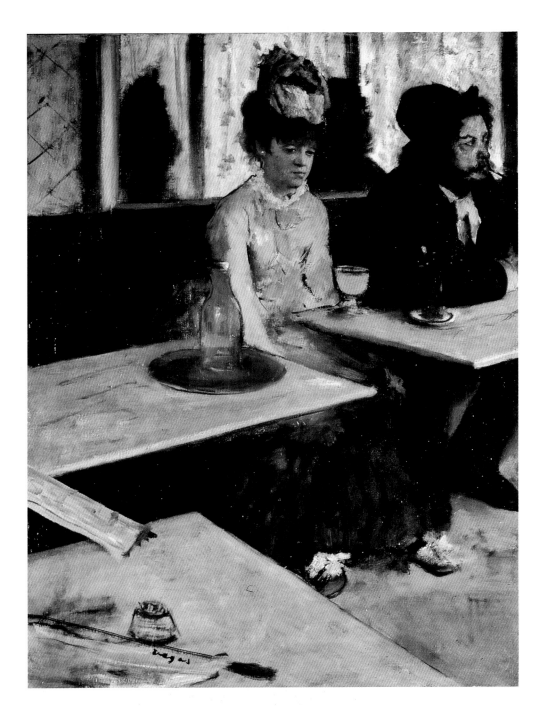

183. **Edgar Degas**,
Absinthe, 1875–76
To achieve the authentic look of
low-life Paris, Degas had two
friends, the actress Ellen Andrée
and the artist Marcellin
Desboutin, pose in the roles of
streetwalker and dissolute drinker.
Intended for exhibition in 1876,
this carefully contrived modern
genre painting went on view late
during the run of the 1877 show.

Degas had been brought up in a highly cultivated family in which he enjoyed convivial and equal relations with women of his own class, for example, the Morisots or his upper-crust friends the Valpinçons, whom he regularly joined on their country estate, le Ménil-Hubert. Is it pure coincidence that it was after the death of his father, in 1874, and when mopping up financial difficulties and shameful behaviour on behalf of his feckless and reckless brothers, the younger of whom had abandoned his invalid wife to take a mistress, that Degas turned his back on his own society? He set himself instead to explore the exotic, vulgar and colourful worlds of the dance hall and café-concert. This was unquestionably 'slumming it', although the amount of time he spent in field research is debatable since his working practice thrived on minimal direct input from life. Nevertheless, from 1874 on, Degas seems to have been fascinated by the extremes of dress and comportment characteristic of women outside his social sphere. Often what seems to have attracted him to a model was the uniqueness that set her apart from the crowd, an oddness that others found merely ugly. 183

At one level, certainly, his images are observations of movement. These women are shown performing a variety of tasks or actions: laundresses ironing with the full force of their tensed arms; dancers reaching round to adjust their shoulder straps or 184
bending to lace their pumps, exercising or stretching their highly

184. **Edgar Degas**, *Dancer
(Adjusting Her Shoulder Strap)*,
1895–96
Throughout his career Degas
had an alert but wary interest
in photography. His own
experiments in the medium,
which mostly continue the
preferred thematic interests of
his paintings, served as direct
models for numerous drawings
and pastels.

developed leg muscles in order to perform ballet steps; chanteuses bellowing out songs with exaggerated accompanying gestures, hoping to raise a glimmer of interest, perhaps even a laugh, from the audience; more crudely, prostitutes lining up their flaccid bloated bodies for inspection on the sofas of a brothel; and finally anonymous women, soaping, scrubbing and rubbing themselves dry, performing implausibly energetic bathing rituals. Unlike so many painters of women at work, including Millet, Degas does not embellish his models with graceful rhythms, encouraging the viewer to believe they take pleasure in the task for its own sake; on the contrary, he stresses the awkwardness of the bodies and the strain they are undergoing.

But there is more to these images than a draughtsman's technical fascination with specialized movements and gestures. Another common factor implied by his choice of subject is the male client towards whom all these forced, painful, unnatural efforts are being directed. Sometimes he is merely a suggested but unseen presence, signified, in the laundry pictures, by the piles of starched white shirts. In some of the ballet scenes, however, a miserable-looking bourgeois male is introduced, waiting in the wings to catch his protégée, and, in the brothel monotypes, he is shown lasciviously watching the obscene commodified antics of the whores. In his café-concerts, Degas frequently shows the heads of the predominantly male audience, enslaved, in a way that opera-goers were not, by the coarse blandishments of the performer in the spotlight.

Being an *abonné* or subscriber at the Opéra gave one a pass to go behind the scenes, a well-established way for a gentleman of means to experience an erotic frisson. Degas's friend Ludovic Halévy subscribed and Bazille was offered this privilege in 1868. He took care to behave himself, or so he assured his parents, but was nevertheless shocked, on talking to the dancers, by their mercenary attitudes and complete lack of interest in the ballets in which they performed. In 1874, the venality of the backstage world was alluded to in Prouvaire's comment on one of Degas's exhibited ballet scenes, now apparently lost: 'The old habitués of the Opéra foyer, passing this canvas, will smile, with a sigh.'

Halévy was one of Degas's oldest friends, a former schoolmate, and his perception of Paris concurred in many respects with the artist's. I would argue that the economical wit of the *Cardinal Family* stories, finally published as a volume in 1883 but available separately at earlier dates, had a greater resonance for Degas than has previously been acknowledged. Although Halévy himself felt

185
186

187

185. **Edgar Degas**,
Café-Concert Singers, 1877–78

186. **Edgar Degas**,
The Song of the Dog, c. 1876–77

187. **Edgar Degas**,
Three Prostitutes Seated, c. 1879

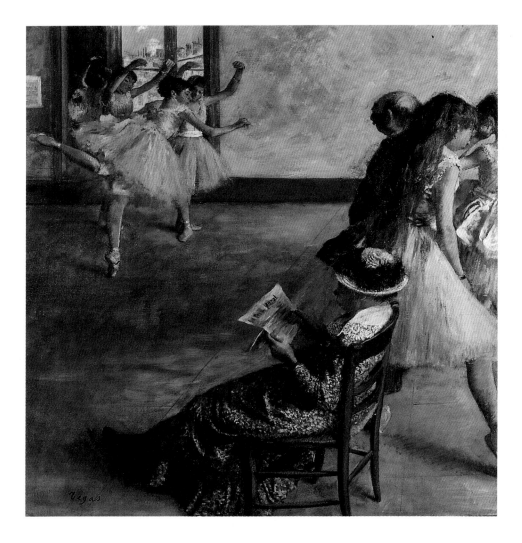

188. **Edgar Degas,**
The Dance Class, c. 1880

189. **Edgar Degas**, *The Famous Good Friday Dinner: The Scene of the Quarrel between Virginie, the Cardinal's Protector, the Marquis Cavalcanti and Monsieur Cardinal*, 1876–77

these stories to be 'dry little things, satirical, sceptical, ironic, without heart, without feeling', their concise Parisian wit seems to have sparked Degas's own unique gift for visual humour and narrative economy. In 1877, at the Third Impressionist Exhibition, Degas showed a few of the monotype drawings from the enormous series of illustrations he had made to accompany this work. It was his most thorough attempt at translating into images the subject matter of contemporary literature – an abortive attempt because it failed to please Halévy. But he did not stop there. Why else, for example, does Degas place *Le Petit journal* in the hands of the priceless little woman stolidly seated in the foreground of *The Dance Class?* Surely because Halévy had made this popular daily paper, which sold for only a sou and had the largest circulation figures in France, the favourite reading of Madame Cardinal, who liked it for 'the novels, the crimes and the accidents'. Reading it filled the time while she sat waiting at rehearsals for her daughters whom, with knowing ambition, she has enrolled in the corps de ballet.

One might point to two other summarily treated episodes in the book which seem to contain the germs of two of Degas's most important thematic obsessions in the 1880s: milliners and women in the bath being attended by a maid. Having engineered a reunion between the wayward Pauline Cardinal and her mother, Halévy has them visit a hat shop where Pauline, accustomed to dressing

189

188

190
173

190. **Edgar Degas**,
At the Milliner's, 1882

extravagantly at her lovers' expense, is amazed by the fanciful hats to be had at absurdly cheap prices. Later, helping her daughter undress in her old bedroom, Madame Cardinal claims she wants nothing more than to act as her daughter's chambermaid, assist at her toilette and tuck her up in bed. Through such intimate glimpses at the private world of women, Halévy surely prompted Degas's own intimate yet non-specific exploration of similar themes, the first images in which he began to exclude the male and envisage a world of women pleasing each other or themselves. But here, too, to judge from the reactions of contemporary critics, the male spectator felt implicated, just as he had done in confronting Manet's *Olympia*.

48

At the Eighth Impressionist Exhibition of 1886, Degas, who was showing nothing but pastels, stood out, according to the reviewer for the *Moniteur des arts*, from the rest as one who was 'committed, sincere, the leader of the Independents'. He alone of the original group gained new stature from the show, counteracting his already much-talked about reclusiveness. In exhibiting his suite of 'nudes of women bathing, washing themselves, drying themselves, wiping themselves, combing their hair or having it combed', Degas was renewing and giving a contemporary frisson to the traditional nude subject. At about this time, although he refused to perpetuate such age-old Biblical themes as Susanna and the Elders or Bathsheba, Degas acknowledged, perhaps regretfully, that he would have painted such stories had he lived in another era. Instead he showed real, not fictive or Biblical, women at their most intimate yet chaste and self-absorbed toilette; he refused any comforting transference of moral blame, putting the ball firmly back in the court of the spectator. It forced some male viewers into an uncomfortable awareness of their own positions as voyeurs. Their retaliating with invective against the women depicted contributed to the myth that was already building up of Degas's misogyny.

Take Octave Mirbeau writing in *La France* on 21 May 1886. Midway through his description of the nudes, he remarks: 'There is… a ferocity here which speaks loudly of disdain for women and horror of love. It's the same bitter philosophy, the same proud vision one finds in his dancers.' Gustave Geffroy, whose review came out on 26 May, was the first to draw the analogy of looking through the keyhole; he did so simply in order to point out that Degas's woman 'is unaware she is being watched'. But the idea seems to have taken off. Henri Fèvre, writing for *La Revue de demain* of May/June, is fairly crude in his identification of the

women in terms of 'the puffed up, pasty and modern flesh of the public whore'; his choice of words suggests his review appeared in time for it to have been read by Maurice Hermel, who proceeded to write a blistering defence of Degas in *La France libre* on the 27/28 May. Hermel expressed unreserved admiration for Degas's monumental artistic achievement, sounding a note which is more in tune with today's reverence for the artist. He defends Degas stoutly against the accusation of misogyny and is solely impressed by his finesse, his inventive use of colour and the accuracy of his observations of the precise and strange contortions to which the human body can turn. 'And that one there, leaning right forward, her left elbow on her knee, soaks the sponge with her right hand. The spine and hips form a sinuous and angular arabesque, exquisite in its slenderness. It has a muted, amber harmony, crossed by

191

191. **Edgar Degas**, *Woman Bathing in a Shallow Tub*, 1885

greenish reflections, against which one sees charming colour notes, the faded pinks and lilacs of a rough wool dressing gown.' He ends his piece by lamenting the many misguided readings of these women he has come across: 'Whatever the subject, treated by a true painter, it speaks only to the artistic sensibility. The only way of being moral in art is by painting well. What really is immoral and despicable is duping people with intentions that are cunningly sentimental and discreetly pornographic.'

The confusion of critical responses to Degas's nudes and the heated debates about their morality or immorality continue to this day, demonstrating that there was nothing haphazard, neutral or innocuous about his choice of theme. Indeed, the ambitious project to translate the essence of modern life into visual form required conscious and calculated effort. One thinks of Renoir and Degas getting friends to pose in tavern, dance hall and café to produce their seemingly effortless slice-of-life tableaux, *At the Inn of Mother* 101 *Anthony*, *The Ball at the Moulin de la Galette* and *Absinthe*. Clearly 129, 183 the decisions they took about who and what to paint were central to their purposes. Similarly the move on the part of the landscapists to rid their pictures of the dramatic, sentimental or heroic content inherited from the past was a considered and deliberate one. Writing about Monet in 1898, Gustave Geffroy was determined to quash the myth to which the chance label 'Impressionism' had given rise: namely these artists' non-choice of subjects. On the contrary, he argued, a 'reflective and single-minded' artist, like Monet, sought out, 'with infinite patience and care, the aspect of nature best suited, through its arrangement, its form and its horizon, to the play of light, shadows and colour effects'.

Chapter Seven: Questions of Style

In this chapter I want to consider whether the critics' ascribing a name, a shape and some sort of an aesthetic purpose to the Impressionists, in 1874 and at each successive exhibition, impinged upon, or even materially affected the painters' stylistic decisions. If so, in what ways? Was it liberating or limiting to be increasingly written about? Given that critics were often damned by artists as misguided fools meddling in affairs they could not understand, were their reviews merely dismissed? In that case, should matters of style be seen as solely the outcome of personal experiment and discovery, stimulated perhaps by emulation and rivalry between artists? Or did artists sometimes pay heed to what was being said and in part evolve in response to public and critical opinion, just as they had to take note of what dealers and buyers were telling them? These are almost impossible questions to answer definitively, one way or the other, and would be different for each artist. Nevertheless they are important questions to bear in mind.

The emergence of Impressionism coincided with the advent of the mass popular press. It was the first art movement in history to be given such wide press coverage and the range alone demonstrates the extraordinary expansion that had occurred, particularly during the Second Empire, in newspaper publishing. Today, artists learn the skills of self-presentation and media exploitation as part of their training; by comparison, the Impressionists entered the public fray unarmed and ill-prepared.

It is of course essentially artificial to separate form from content, style from subject matter. Hardly surprisingly, the journalists given the job of writing about the Impressionist exhibitions often confused the two issues; at times it is virtually impossible not to. In some instances formal matters, because less easy to write about, eluded these inexpert critics, who may have been quite happy discussing questions of content. Indeed the very reason critics and caricaturists so frequently resorted to making fun of a painting's subject may have been because this was an area they felt competent to address. Perhaps one may see the exaggeratedly outraged response to the immorality of Manet's *Déjeuner sur l'herbe* as 46

an example of the uninitiated critic, disconcerted by the painting's novel forms, displacing his anxiety on to its degraded content.

Writing about pictorial form, on the other hand, involves grappling with an alien language, a specialized vocabulary. Often what betrayed the writer struggling to describe an unfamiliar painting style was the tendency to reach for a metaphor. A good example is the satirical Bertall writing about Monet's 'Impressionalist' landscapes in 1876 for the new popular dailies *Paris-Journal* and *Le Soir*. Faced with Monet's alarming technique of distinctive brushstrokes and bright, unattenuated colours, he was reminded of coloured wools. After describing a Monet snow scene as 'a tapestry of white, blue and green wool', he elaborated his theme: 'The riverbank at Argenteuil, [Monet] knows full well, 192 was never knitted in wool and cotton of five colours. But that hasn't stopped him rendering his so-called impression in that way.' The accusation that they were madmen, suffering from eye disorders which made them paint everything blue, sheep and landscape alike, was bandied about by other critics with reference to Renoir and Pissarro. A partial explanation lies in the Impressionists being quick to avail themselves of the more intense new blue

192. **Claude Monet**,
The Seine at Argenteuil, 1875

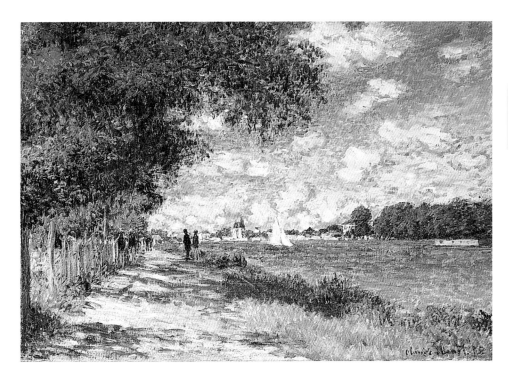

pigments now commercially produced for artists' use, both the costly cobalts and cobalt compounds and the cheaper synthetic ultramarines.

We see the telling use of metaphor again a year later in the review by Baron Schop for another recently founded daily newspaper, *Le National*. Searching for a suitably witty image to describe the new style, he came up with, 'that tub of soapy water in which the Batignolles school drowns everything indiscriminately, male portraits, female figures, snow effects, genre pictures'. Soapsuds (which almost certainly had a bluish tinge at the time) were a convenient shorthand for the pale harmonies and blurred effects of the Impressionists' colour and brushwork, which Schop, and many like him, found unnatural and disconcerting. Quizzing the artists about their approach to technique, Schop discovered they had no fundamental theory linking them together and over the question of drawing or not drawing, he found 'scarcely any agreement among the Impressionists themselves'. Here Schop had identified an underlying problem which was already effectively separating the movement into two camps, around the draughtsman Degas and the colourist Monet.

There is also indeed confusion surrounding any attempt to explain Impressionism's essential theory, which is compounded by the fact that the artists themselves were disinclined to write about such matters. Their apologists did not always clarify matters; from Zola onwards, supporters tended to claim that what united them was a shared wish to be true to nature. Thus, in 1876, Mallarmé, defending his friends' work in the English *Art Monthly Review*, went so far as to claim each Impressionist endeavoured 'to suppress individuality for the benefit of nature'. And yet Zola, that same year, writing for *Le Messager de l'Europe*, a St Petersburg journal to which Ivan Turgenev had invited him to contribute, maintained that a show of individual temperament was precisely what made an artist interesting, criticizing Caillebotte for doing no more than 'photographing reality'. And from a modern-day perspective, one is surely more inclined to see the Impressionist technique, or, more correctly, what Anthea Callen has aptly called their techniques, as means whereby artists asserted their distinctive hand and stressed their individual personality.

In a broad sense, the barrier that prevented or impeded the ordinary spectator from seeing clearly the objects which the artist purported to represent was what one might call Impressionist 'style'. And as the artists gained in confidence and maturity, the idiosyncrasies of their individual styles became more, not less,

pronounced. Whereas a viewer might have been forgiven for mistaking a Monet for a Manet in 1874, or indeed a Sisley for a Monet, a Pissarro for a Sisley or a Cézanne for a Pissarro, a decade later there was no excuse for such confusion. Of course what the artists were seeking to translate was not so much an externally verifiable standard of truth to appearance as their own subjective response to an aspect of nature at a given moment. The term the artists themselves used for this was 'sensation'. In their parlance, sensation came to mean more than just a physiological response to visual stimuli; it became a highly personal response to a particular effect.

The dissimilarity of manner and the assertion of the individual's subjective vision which characterize Impressionism in the 1870s and 1880s are all the more salient when one compares the work of the Impressionists' contemporaries. Many academically trained artists who exhibited regularly at the Salon seemed intent on playing down their personalities and producing a quasi-objective, unmediated, styleless version of reality, corresponding in its precise detail to the experience of the man in the street, or to photography. This could be as true of an artist who specialized in modern-life scenes, such as Jean Béraud (1849–1935), as of one who preferred anecdotal archaeological reconstructions, like Jean-Léon Gérôme (1824–1904), or representations of life in the Islamic world, like Charles Bargue (d. 1883). Their styles of painting indeed might be mistaken one for the other, but there was no confusing either of them with Cézanne.

However, the most informed and forward-looking art critics acknowledged that the changing reality of the later nineteenth century demanded its own new modes of representation. One of the most vocal on this point was the writer Edmond Duranty who, in 1876, identified the Impressionist group as having given birth to just such a novel style. Duranty, who had contributed in the 1850s to formulating the realist aesthetic in literature and had written extensively on physiognomy, caricature and characteristic gesture in painting, eschewed the label Impressionist, when he entitled his article 'The New Painting'; it was published in the form of a pamphlet at the time of the group's Second Exhibition. Duranty begins with a broad-ranging retrospective analysis of the recent ructions between academic and innovative art, citing such authoritative writers as Eugène Fromentin, Paul-Émile Le Lecoq de Boisbaudran, Denis Diderot and John Constable, championing fresh and independent initiatives. Without mentioning their names, he welcomes the new group, with their novel

193

194

193. **Jean Béraud**, *Avenue des Champs-Élysées, c.* 1885

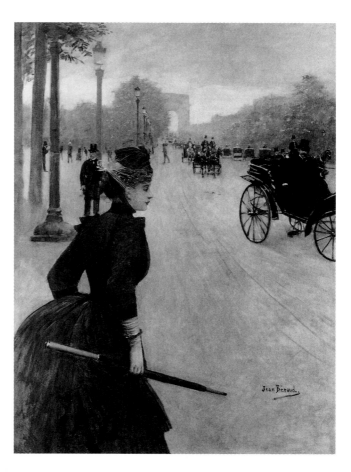

194. **Jean-Léon Gérôme**, *Phryne before the Areopagus*, 1861

analytical approach to colour; with their sweeping away of dark bituminous tones beloved of romanticism; and with their ability to paint landscapes that convey the vibrations and palpitations of light and heat. Yet although he purports to be writing about the whole group, the article mainly focuses on Degas. It celebrates his acute vision of the modern figure through draughtsmanship and innovative points of view, referring obliquely to some of his recent paintings such as *The Cotton Office, New Orleans* and *Place de la Concorde*.

195
199
197

Duranty offered artists an inventory of methods for capturing modern life in all its unexpected and arresting forms. In fact, with its sentences beginning 'what we need is…', his pamphlet was a rallying cry, an optimistic projection forward into the future. It is clear that 'The New Painting' was informed by long discussions with Degas, if not, at times, actually a record of the latter's views. It called for painters to join forces with realist writers like himself in the only aesthetic mission that was worthwhile, namely to express the habits, costumes and settings of one's own times, to represent one's personal life, to record the epoch.

In a number of different ways, artists like Degas, Caillebotte and even, to a lesser extent, Renoir and Morisot were already recording the epoch and their experiments were carried further by such artists as Cassatt and Gauguin. Degas's compositional strategies in his portraits already involved placing the sitter in a characteristic setting, viewing him or her from an unexpected

195. **Edgar Degas**, *The Cotton Office, New Orleans*, 1873

196. **Edgar Degas,**
Yellow Dancers (In the Wings),
1874–76

197. **Edgar Degas**, *Portrait of
Edmond Duranty*, 1879

oblique angle, maybe off-centre and partially cropped. When Degas invites us to watch the ballet, we are often required to make the best, as in life, of obstructed visibility, rather than afforded an ideal, central viewing position. Caillebotte's scenes of Paris draw attention to viewpoints, as Duranty prescribed, from the windows and balconies that framed people's communication with the world outside their apartment.

196

18, 198

What Duranty's article did not fully explain was the artifice involved in painting modern life convincingly. Degas's recently recovered masterpiece *Place de la Concorde* is a highly sophisticated and arresting achievement, the result of ingenuity and not just of direct observation from life. Degas asked his friend Vicomte Lepic, with his daughters and dog, to pose for the figures in the

199

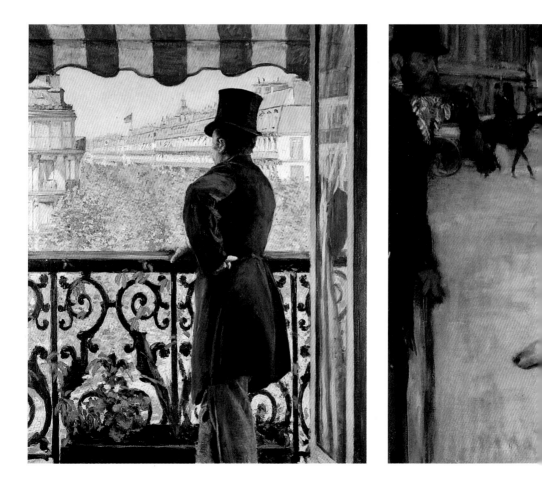

foreground; their disunity as a family group typifies the irresolution and conflicting movements of modern pedestrians marooned on a traffic island. To achieve that result, Degas left an enormous gulf just where one's eye expects to find the focus of attention. The canvas, although painted in a relatively smooth, unemphatic manner, has been folded several centimetres above the bottom edge, which shows that he revised his original idea about where to crop the figures. Indeed his canvas sizes frequently underwent modification as he worked. The overall effect is of a cameo scene glimpsed in passing, as if through a carriage window. Through pondering the problem of seizing life on the move, Degas had in effect stolen a march on the photographers who could not yet, as Duranty conceded, capture instantaneity.

In the later 1870s Degas introduced something of the classic simplicity, born of repetition and refinement, that he admired in Millet whose work was much in evidence around 1875, the year he died. In the last years of his life Millet had sold most of his production to Durand-Ruel; in addition he had produced a body of work in pastel for the collector Émile Gavet, for which he had been paid in monthly instalments, an enviable arrangement. This collection was put up for sale in June 1875. It was at about this time that Degas seriously began to concentrate on pastel. Indeed, Degas, who left a quantity of projects unresolved, is remembered as much for the brilliance of his preparatory work – his drawings in charcoal, pastel, or essence on coloured paper and his extraordinary pastels over monotype – as for his complete paintings on an exhibition scale. Did Degas's urge to concentrate on selected themes and to work repetitions on poses not begin about this date also? And could Millet's example have prompted this development?

One critic who identified strongly with Degas's attempts to forge a new visual language, as he put it, was Joris-Karl Huysmans. He was another writer closely identified with Zola's naturalist school of literature, who emerged as a critic in 1879; a number of his articles on the Salon and on the Impressionists' exhibitions were collected together and published as *L'Art moderne* in 1883. Huysmans neatly formulated the new school's credo in the phrase: 'New methods for new times' (*À temps nouveaux, procédés neufs*). In Huysmans's view, the times were characterized by movement and bustle and, just as architecture in the late nineteenth century needed to dispense with eclectic excrescences in stone in favour of functional simplicity (iron and glass), so art needed a flexible manner that could keep pace with the speed and pressures of modern living. Huysmans hailed Degas and Caillebotte as prime exemplars of this adaptable style, with their abrupt, dynamic and cropped compositions and, in Degas's case, the startlingly experimental juxtaposition of vivid colours. Huysmans seems to have been less appreciative of the nervous, flickering, palpitating brushstrokes that characterized the handling of a Monet, Manet, Renoir or Morisot. In his review of the Impressionist exhibition of 1880, Huysmans considered Caillebotte superior to Monet, arguing that one of Caillebotte's chief merits was the fact that he had 'rejected the Impressionist method of strokes which compel the eye to blink before it can restore people and objects to their correct position'. He had adopted instead 'the traditional method of the artists of the past', which he had 'adapted to the demands of modernity'.

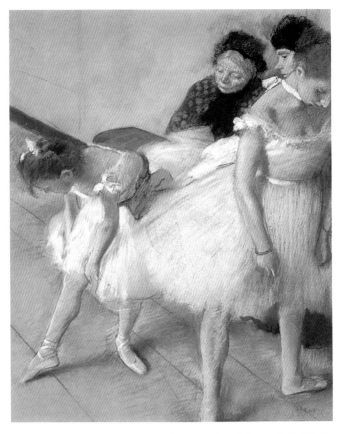

However Huysmans certainly appreciated the technical brilliance of Degas's handling of pastel. Writing about *The Dance* 200 *Exam*, he observed: 'the redhead who leans her eagle beak over her throat has a neck shadowed in green and the twists of her calf outlined in violet; from close to, the tights are a crush of pink chalk; from a distance, we see cotton stretched over a flexed leg muscle.' Although Huysmans could recognize a distinction between the achievements of a Degas or a Caillebotte and the minutely detailed illustrative approach of such chroniclers of Parisian life as Jean Béraud, who was enjoying considerable success at the Salon, he did so on the basis of a false premise: that of the greater or lesser truth to nature of the artists concerned. His main complaint against Béraud was that his naturalism was 'false, absolutely false', his figures insufficiently readable as social types. What he failed to understand was the transformation of the real through artifice that Degas's art involved.

But if these naturalist writers were adept at pinpointing the areas in which an urban figure artist such as Degas or Caillebotte was in touch with the pulse of the times, generally speaking they were less interested in or skilled at diagnosing developments taking place in landscape. It is understandable that, on due reflection, Impressionists like Pissarro and Gauguin decided that Huysmans had never really understood Impressionism but had judged it from within the limited purview of the naturalist aesthetic. Just as the domain chosen by Caillebotte or Degas came at times uncomfortably close to that of a chic urban realist like Béraud, what distinguished Impressionist landscapes in the 1870s from the more conservative ones that were acceptable to the Salon cannot be explained in a few words, nor by divorcing questions of content from questions of technique. As John House's exhibition 'Landscapes of France: Impressionism and its Rivals' in 1995 showed, there were set conventions within landscape that the Impressionists generally discarded. They turned their backs on the picturesque, the historical, the topographical, the dramatic

201. **Charles Busson**,
The Village of Lavardin, c. 1877

202. **Paul Cézanne**,
Small Houses at Auvers,
c. 1873–74

and the sublime (which is not to say that such descriptions are never applicable to their works) in order to cultivate instead the humdrum, non-descript corners of nature. But the distinction does not solely lie in the attitude to the motif, for there can be extraordinary congruences in this respect.

The view of *The Village of Lavardin* by Charles Busson (1822– 1908) has the same constituent elements as any number of views of Pontoise by Pissarro; in particular it recalls *L'Hermitage at Pontoise* painted for the Salon a decade earlier. Both artists use a high horizon and break up the predominant greens in the middle ground with a horizontal arrangement of blocklike houses. Two later canvases, Cézanne's *Small Houses at Auvers*, executed while under Pissarro's tutelage, and Pissarro's *Landscape at Chaponval*, follow the same basic compositional layout. But whereas in the latter examples a high-keyed, close-toned colour range is used to translate the single overriding effect which initially arrested the artist's interest, Busson adopts a dramatically wide tonal range, passing from steely dark greys and blackish browns, for overcast sky and shadowy water, to bright yellowish sunlit areas. Busson also uses a fine brush to pick out incidents, such as ducks and reeds in the foreground, thereby creating a readily acceptable, indeed beguiling, degree of anecdotal verisimilitude, just as Daubigny had done eighteen years earlier in his highly naturalistic *The Banks of the Oise*. Busson's whole compositional arrangement is brought into greater relief by the use of varnish, which pushes the houses back into a clearly articulated space. On the contrary, in Pissarro's

201

canvases, particularly the unvarnished *Landscape at Chaponval*, the simple shapes of the houses appear to be on almost the same plane as his summarily painted foreground meadow. The whole arrangement, indicated with repeated flecked brushstrokes, interlocks on the canvas in a way which minimizes the illusion of depth. This tendency to reduce anecdotal detail and simplify basic shapes reaches a more extreme stage with Cézanne. The most salient difference, finally, is size. Busson's painting is over two metres in width, inviting the spectator to lose himself in the illusion of an unmediated nature. Although in the 1860s Pissarro worked on a large scale for the Salon, the relatively small-scale formats and undisguised brushstrokes he and Cézanne used from the 1870s onwards proclaim the pictures for what they are.

203. **Édouard Manet**, *Argenteuil*, 1874
Monet in His Studio Boat is considerably more sketchy in appearance than *Argenteuil*, where Manet constructed a tight-knit composition and deployed a more conventional level of finish suitable for the Salon. For this, one imagines he reverted to his usual practice of working in the studio. However, the level of intensity of the blue he used for the water led to a stream of abuse from the critics.

From 1874 onwards, Manet's name was frequently linked with the Impressionists despite the firm stand he took on showing his work only at the Salon or in his own independent exhibitions. He continued to have close personal contact with members of the group and when his younger brother, Eugène, married Berthe Morisot, Manet inevitably found himself intimately involved in their cause. Indeed, when he could, he promoted their interests. In a sense the tables had turned, partly perhaps as a result of the First Impressionist Exhibition; certainly now it was Manet who actively took up the stylistic challenge presented by his more youthful colleagues. A degree of reciprocity with the younger landscape painters also governed Manet's later work. This had already been hinted at in Bazille's *The Studio in the Rue La Condamine*, where the stance given to both Manet and Monet suggests admiration of Bazille's achievement as well as critique. With *The Railroad* (1872–73), exhibited in the Salon of 1874, for which Victorine Meurent posed, and *Argenteuil*, painted that same summer, both of which involved a measure of *plein-air* work, Manet achieved arresting results. The summer of 1874 saw a fruitful and convivial three-way collaboration in Argenteuil between Monet, Manet and Renoir and one senses that Monet, now on his home turf, was the focus of attention. Indeed, that summer, Renoir and Manet painted valuable documentary records of Monet's working practices, both of them stressing the image of Monet as the *plein-air* painter. In Renoir's portrait, Monet stands at his easel in the

45

203

68

garden; in Manet's, he is seen working, like Daubigny before him, 204 from his bespoke studio boat. Monet is engaged on one of the yacht basin motifs that were fast becoming his trademark. Sailing was an increasingly popular pastime and Argenteuil, easily reached by 205 rail or road, was a great draw for Parisians with a few hours' leisure time to fill.

The studio boat portrait is a vivid document of the typical working practices of the 'Impressionist', as Monet had just been dubbed, in the 1870s. The new breed of painter went about his task in so frank and transparent a way compared with the mysterious alchemic practices that were supposed to go on behind studio doors. Firstly, Manet notes the direct, unceremonious way in which Monet attacks a subject, dispensing with the usual preliminary underdrawing and preparatory sketches. He paints with brushes on a small, pre-stretched canvas, supported by a convenient portable easel. The canvas has been primed with a white ground. (The colour of the ground was crucial to the look of the resulting picture as it was often allowed to show through the layers of paint, establishing a luminous, warm or cool tonality.) The Impressionists generally bought their materials and ready-primed canvases from colour merchants in Paris, accepting their standard-size stretchers. Later in their careers, when financial worries were behind them, it was more usual for them to commission non-standard canvas sizes. They also availed themselves of the commercially produced tube paints. Gone were the days when artists spent years mastering the craft of preparing their own colours in the studio. Indeed some of them, notably Renoir, lamented this lost understanding of their materials and took steps to try to relearn it in later life, poring over the Renaissance colour

205. **Édouard Manet**, *The Seine at Argenteuil*, 1874

treatise of Cennino Cennini. The metal tube was only introduced as a more convenient form of packaging in the 1850s. Such technical improvements naturally facilitated the practice of painting in oils on canvas out of doors, where previous generations had tended to rely on watercolour sketching or confined their oil studies from nature to paper supports.

Manet's use of broken brushstrokes to stand for the fitful sunlight on the water and its reflections; the lack of precision he gives to the face of Camille seated in the doorway of the cabin (the only area of definition is Monet's face); the bright colour range; and the alternately long and short, highly visible strokes of paint all denote Manet experimenting with technical features of Monet's Impressionist style. Here then was an experienced and accomplished artist – grounded in the bravura techniques of the Old Masters of the Spanish and Dutch schools and a virtuoso of the studio-based full-length portrait – showing his readiness to submit to the discoveries of his younger peers and follow their lead.

Portraits such as this did much to entrench the popular, but misleading, notion that the Impressionist went about constructing his picture without thought, mechanically and with unseemly haste. Émile Porcheron, writing for the monarchist paper *Le Soleil* on 4 April 1876, derided the obviousness and easiness of their methods. He incited his reader to buy 'a box of paints, a canvas and the necessary accessories, sit yourself in front of some landscape or other, put down as well as you can what you see, and Impressionism will have a new recruit'. Accounts of Manet's working methods, which frequently stressed his total dependence on the motif in front of him, contributed to the same mythology. 206

In the impressive sequence of exhibition canvases Manet painted between 1873 and 1882, although figures dominate, the specific modern setting – urban garden, suburban riverscape, skating rink, café or café-concert – becomes progressively more prominent and public. This series includes *The Railroad*, *Argenteuil*, *Skating* and the two segments of *At the Café* (1878–79). 203, 208 Manet's starkly frontal compositional solutions were a useful example for the younger Impressionist figure painters as they gave equal value to figure and setting. One could see Renoir's *The Loge* as a more close-up and informal version of Manet's 180 *The Balcony*: in both, people assembled to take advantage of an 88 elevated viewpoint become themselves the objects of our scrutiny. Manet's *The Railroad*, *Argenteuil* and *Skating* may have inspired the similar arrangements Renoir adopted in his series of paintings of rowers relaxing at the Fournaise restaurant at Chatou, 234

206. **Mars**, *An Impressionist about to Begin a Painting*. Published in *Le Journal amusant*, 30 April 1881

UN IMPRESSIONNISTE DEVANT LE TABLEAU À FAIRE (Saint-Ouen).
— Est-ce posé ça ! Combien d'minutes?
— Une et demie ; mais, à mon avis, c'est encore trop tourmenté !

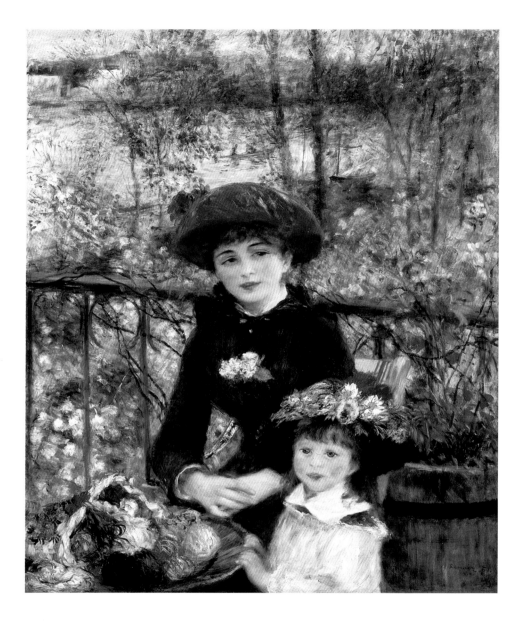

207. **Auguste Renoir,**
Two Sisters (On the Terrace), 1881

which includes the charming composition of *Two Sisters (On the Terrace)*. Here, instead of figures on the ice, the screen separates the foreground figures from the shimmering decorative backdrop of the river. Manet's boating pictures, with their stark contrast of blue water and life-size figures, were unquestionably emulated by two academically trained painters, Gustave Caillebotte and Mary Cassatt (the latter, like Manet, exhibited in the 1874 Salon).

More importantly, thanks to Manet's stature, his practical endorsement of Impressionism ensured that the new movement created stylistic reverberations within the Salon and beyond. Manet could command attention at an international level, long before the Impressionists proper. In the 1880s and 1890s, his example became important for, among others, the Swedish painter Anders Leonard Zorn (1860–1920), and the international portraitists John Singer Sargent (1856–1925) and John Lavery

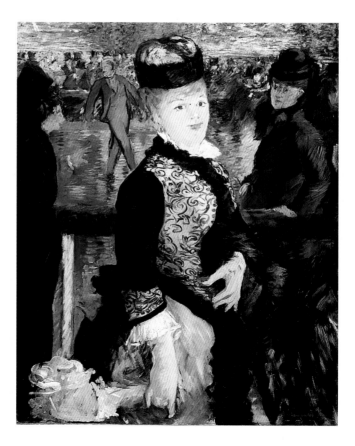

208. **Édouard Manet**,
Skating, 1877

(1856–1941). In 1878, the year he was elected President of the Royal Academy, the English painter Frederic (later Lord) Leighton (1830–96) made a point of visiting Manet's studio at the time of the Paris Universal Exhibition. He was struck by the flickering brushstrokes that Manet had employed in *Skating*, painted in 1877, and is supposed to have remarked: 'It's very good, but, Monsieur Manet, don't you think that the outlines are not well enough defined and that the figures dance a bit too much?' Manet countered, 'They're not dancing, they're skating; but you're right, they do move and when people are moving, I can't freeze them on the canvas.' It is intriguing to imagine the effect upon Leighton of this exchange and the impact of the uncompromising modernity of an artist who was his direct contemporary in age. Despite their common beginnings under the tutelage of Couture, himself a firm believer in outlines, in terms of technique and approach, Manet was now worlds apart from his own classicizing grand manner. 208

The ambitious and sizeable *Bar at the Folies-Bergère* was Manet's culminating masterpiece. The painting explores the motif that had consistently engaged his interests, the young, 209 210

209. **Édouard Manet**,
A Bar at the Folies-Bergère, 1882

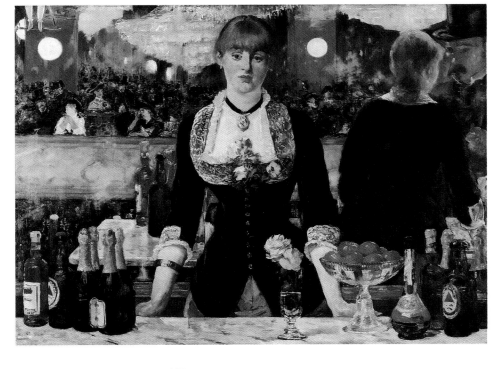

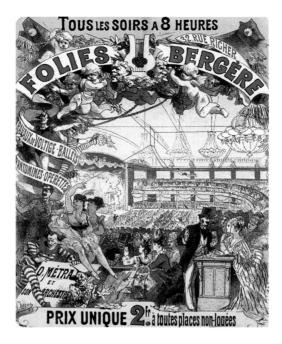

210. **Jules Chéret**, *At the Folies-Bergère*, 1875
Chéret's poster, despite its somewhat rococo flourishes, documents in a useful way the complicated layout of the famous café-concert. As in Manet's *Bar*, our viewpoint is from the upper-level promenade. An encounter across a bar, similar to the one Manet painted, occurs to lower right, while a trapeze artist can be glimpsed below the level of the chandeliers just right of centre.

comely woman seen face on, starkly confronting the spectator. The impetus to tackle increasingly modern subject matter probably came from Degas, who, in the late 1870s, was using café and café-concert themes for a series of technically adventurous experiments, combining the media of print and pastel. It may even have been an idea of Degas's that led Manet to experiment with such a complex arrangement of lighting and mirror reflections. One of the many unrealized ideas Degas toyed with in his journal was just such a combination of a woman's head set against the reflected brilliance of a chandelier. Not only was Degas nearest to Manet in age, background and education, he was also his closest friend and rival within the Impressionist group. Manet's final attempt at a modern history painting succeeds; it brings together his lifelong interests in still life and figure and, although completed under trying circumstances when Manet must have known he had not long to live, it demonstrates his sheer enjoyment of the act of painting. After his old sparring partner's death in 1883, Degas was left feeling somewhat rueful about some of his past unkindnesses, particularly when he and his contemporaries had the chance to contemplate the sum of Manet's achievements in a retrospective exhibition held in his honour in 1884: 'He was greater than we thought, that Manet!'

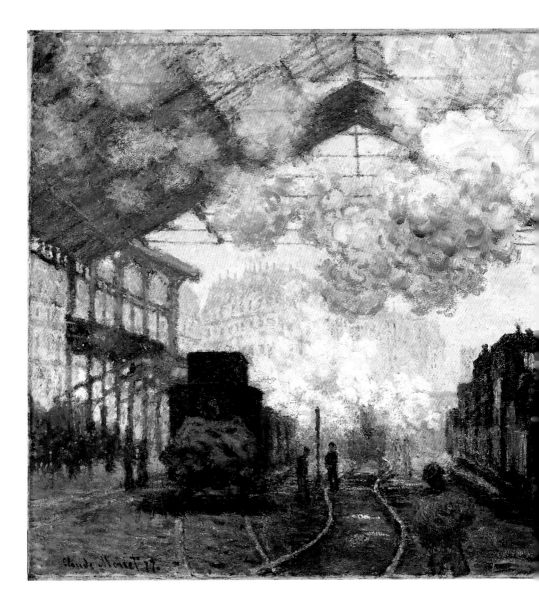

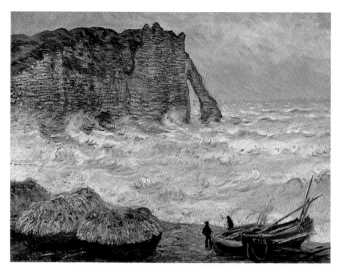

When one looks at the parallel development of Monet's technique during the late 1870s and into the 1880s, it is apparent that he made efforts to change his style at various junctures, often coinciding with shifts in his subject matter. In his landscape motifs, he leaves less to chance, increasingly paring down his viewpoint to encompass no more than a simple combination of monolithic shapes. Paradoxically, given the modernity of the subject, we can see signs of this tendency in his sequence of Gare Saint-Lazare 211 paintings of 1876–77. The awe-inspiring locomotives and the bustle and noise of passengers on the platform were themes which contemporary naturalist writers loved to describe. But Monet's attention was caught by the overall effects of varying light on billowing smoke in lofty engine sheds, or by the strange hallucinatory effect of signal discs emerging from a cloud of steam. 1

Pointing the way forward to a major preoccupation of the mid-1880s were the explorations of beach and cliff views, in Monet's native Normandy, at Fécamp and Étretat. Here, as a painter, he 212 was more concerned with the textural and colouristic variations, which translate changes in atmospheric weather effects, than with the chance incidents and human activity that had animated his earlier work. After 1880, more and more of Monet's paintings eliminate the human figure; later they even cut out such solid reminders of human existence as bridges, houses and boats. One wonders what part the early death of his wife Camille, his favourite model, played in this renunciation. He had recorded her last minutes on

her deathbed, not an uncommon thing for artists of the nineteenth century to do, but in his case it was as though even death took the form of evanescent colour harmonies stealing across her features.

In paintings such as *Lavacourt under Snow*, the brushstrokes take on more of a repetitive rhythm; often the whole canvas seems animated by their movement. Dark colours, particularly black and earth tones, which had been progressively banished from his palette, have by now completely disappeared, replaced by blues and violets. An overall harmony of tone is achieved by means of colour alone, the rationale for accents appearing at different points on the canvas being the pursuit of a unified surface, rather than of strict truth to appearance. In the early 1880s, Pissarro, for one, was critical of what he saw as Monet's edging towards romanticism in his colour practice, particularly in the work he brought back from Ventimiglia and Antibes in the Mediterranean. In Pissarro's terms, stalking reality had to be done more doggedly; any display of bravura, facility or prettiness smacked of a slippery slope towards commercial sell-out.

Sisley's style was at its most forthright and varied around 1874. Soon after the First Impressionist Exhibition closed, he had the chance to spend a few months in Richmond-upon-Thames, to

213

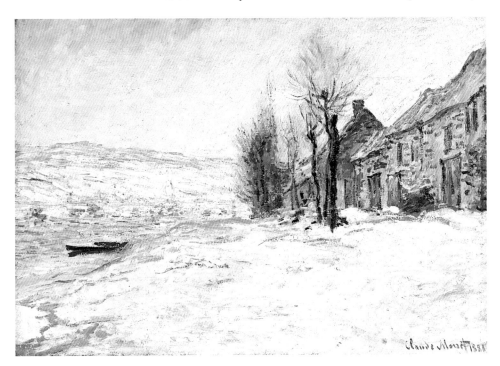

214. **Alfred Sisley**,
Molesey Weir, Hampton Court,
1874

the west of London, paid for by an admiring patron, Jean-Baptiste
Faure. The suburban site offered the same sort of riverside motifs
as his colleagues were exploring in Argenteuil: bridges, buildings,
flagpoles, canoeists and people strolling on the picturesque banks.
It was a productive period. Sisley devised arresting compositions
and confidently handled the range of different elements before
him, adjusting his brushwork accordingly. In *Molesey Weir,* 214
Hampton Court, apart from the sky, there is no overall directional
pattern to his brushstrokes; he juxtaposes bold horizontals and
diagonals for the smoother surfaces of the water with shorter,
drier, more curving impastoed strokes for the frothy turbulence
created by the weir. Although such a canvas appears to have been
painted spontaneously in a single sitting, closer examination
reveals the figures standing to the left were painted by applying
wet strokes over dry ones. This suggests that Sisley allowed at
least forty-eight hours for the underlying paint surface to dry
before adding them. In another view, taken from directly under the
span of Hampton Court bridge, he outdoes Monet in composi-
tional daring. Sisley, like Morisot, on the whole managed to escape

215. **Alfred Sisley**,
Boatyard at Saint-Mammès,
1885

the critics' attacks in both 1874 and 1876 (when he showed his limpid *Flood at Port-Marly* canvases). But early praise and a modest temperament may have encouraged a certain innate tendency to conservatism. The basic compositional ingredients of his landscapes, once established, would not vary greatly; he refined but did not extend the possibilities of Impressionist naturalism. While keeping a weather eye on Monet's later work, Sisley's style, after his move in the 1880s to the picturesque town of Moret-sur-Loing, remained consistent with, but less adventurous than, his earlier work.

Pissarro was far more varied in his approach, more inclined periodically to reinvent himself as an artist. Perhaps this was due to a temperamental restlessness. He worked simultaneously in a range of media, notably around 1879–80 when he experimented with etching and aquatint, sharing discoveries with Degas and Mary Cassatt. The subtle range of effects he achieved in black and white probably encouraged the increasing complexity and subtlety of his handling of oil too. His large and imposing landscape, *The Côte des Boeufs at L'Hermitage*, painted in time for the Third Impressionist Exhibition, shows his paint handling becoming

126

215

216
217

218

216. **Edgar Degas,**
Mary Cassatt at the Louvre,
1879–80

217. **Mary Cassatt,**
Interior Scene, 1879–80

218. **Camille Pissarro**, *The Côte des Boeufs at L'Hermitage*, 1877

219. **Camille Pissarro**, *Wooded Landscape at L'Hermitage*, 1879

more dense, choppy and deliberate. This intimate undergrowth motif, found more or less on his doorstep in Pontoise, was one he painted several times. The main framework of vertical tree trunks, solidly built up with superimposed layers, supports an inner mesh of criss-crossing brushstrokes, approximations of the blur of leafless branches and twigs seen against a backdrop of cottages or sky. The overall effect produced by the myriad small touches of yellows, creamy whites and blues is somewhat muted and the viewer needs time to discern the two indistinct figures emerging from the undergrowth. Some critics complained that Pissarro's density of touch and his over-fondness for blue were monotonous; others appreciated these evident signs of serious, painstaking work. 219 Pissarro made a point of cultivating a matt surface, refusing to use varnish which was known to darken with age. In one instance, he left clear instructions on the subject for posterity; on the reverse of his *Landscape at Chaponval*, he wrote: 'Please do not varnish this 220 picture.' The same recommendation should have applied to many Impressionist paintings and has all too often gone unheeded.

220. **Camille Pissarro**,
Landscape at Chaponval, 1880

221. **Berthe Morisot,**
Copy of Detail from Boucher's
'Venus at Vulcan's Forge', 1884
Morisot reverted to her student
practice of copying in the Louvre
in order to execute this free
copy of a lighthearted rococo
decoration by Boucher. She
installed it as an over-mirror panel
in her new apartment. She later
substituted the decorative panel
on the subject of Bordighera
which Monet had painted at
her request.

It is clear, even from these examples, that while theoretically
united by their devotion to nature, the Impressionists had no one
definitive way of painting it. Most of them evolved different tech-
niques year by year and, periodically, forced themselves to take
stock and work on areas of weakness. This was true of both Renoir
and Morisot; dissatisfied with painterly effects that had perhaps
come too easily, they felt the need, in the early 1880s, to strengthen
the structural element of their work. Both went back to drawing
and studying the Old Masters with that aim in view. Morisot,
acknowledging a very real affinity between her work and the
rococo masters of the eighteenth century, much played upon by
critics at the time, made a copy of a couple of naiads from Boucher's 221
Venus at Vulcan's Forge (1757). As we have seen, Renoir's new man-
ner developed as a result of his travelling to Italy to study Raphael 222
and spending more time in the Louvre. Thereafter, both artists
often reintroduced a traditional preparatory stage of red chalk

drawings, a medium much favoured in the eighteenth century when preparing a complicated composition or important portrait commission.

An interview by Pierre Bonnard (1867–1947) provides one of the most insightful accounts of how, at a technical level, the Impressionist programme evolved into the twentieth century. Bonnard, who had come late to a form of Impressionism in the mid- to late 1890s and in many ways perpetuated its ethos late into the following century, was able to speak authoritatively about it in 1943. He knew the methods of Pissarro, Renoir and Monet from first-hand observation; all of them had offered him advice at one time or another. His knowledge of Cézanne's working practice was more likely to have been gleaned from his close friends Ker-Xavier Roussel (1867–1944) and Maurice Denis (1870–1943), who had watched Cézanne at work near Aix at the end of his life. Bonnard explained that painting in front of the motif or with the

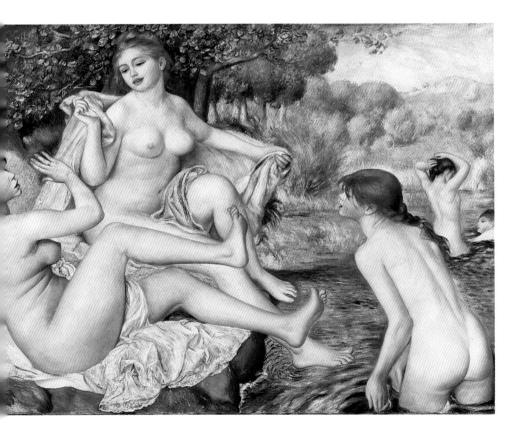

object in view was something he personally found treacherous; too easily he lost control of his all-important initial idea and found himself led astray by the tyranny of accidental details. It was vital he argued, paradoxical as it might seem, for the Impressionist painter to be able to dominate nature.

The painters who have been able to work directly from the motif are very rare – and those who've managed to get away with it had their very personal defence mechanisms. Cézanne in front of the motif had a solid idea of what he wanted to do, and only took from nature that which corresponded to his idea. Often he would stay out there, warming himself like a lizard in the sun, without even touching his brush. He was able to wait until things went back to how they were when they had first entered his conception. Of all painters he was the most powerfully armed against nature, the most pure, the most sincere.

Before all else Renoir painted Renoirs. He often had models with grey, not pearly skin yet he painted them pearly. He referred to the model for a movement, a form, but he did not copy, he never lost sight of the idea of what he could do. I was out walking with him one day and he said to me: 'Bonnard, one has to embellish.' Embellish was his way of explaining that initial portion that the artist must put into his picture.

Claude Monet painted on the motif, but only for ten minutes. He didn't allow things time to take hold of him. He came back to work when the light corresponded to his first vision. He knew how to wait – he had several pictures on the go at a time.

…In the case of Pissarro, it's even more visible, he arranged things – system plays a more important rôle in his painting.'

And in a single sentence Bonnard in a sense sums up the special nature of the Impressionist style: 'The Impressionists worked on the motif, but they were better defended against the object than others by their very procedures, their manner of painting.'

Chapter Eight: The Impressionists and the Art Market

The Second Empire had seen an extraordinary expansion of the art market as an intrinsic feature of its developing capitalist economy. Paintings were treated as commodities to be bought speculatively for investment purposes and sold at a profit. The Hôtel Drouot, Paris's main auction house, which opened in the early 1850s, was in the same street as the major banks and a short step away from the stock exchange. Sales of art collections were reported in the press and watching artistic reputations rise and fall at auction became a riveting pastime. For an artist like Meissonier who had secured Salon popularity, the sky was the limit as far as potential earnings were concerned. By the 1860s, it required a considerably greater outlay to purchase a major work by him than to buy a work by an esteemed Old Master. The Old Master trade had in any case been compromised by a series of notorious fakes. It was hardly surprising that the young Impressionists, embarking on their careers in the 1860s, had set such store by gaining a reputation at the Salon.

The art-dealing firms, like those of Paul Durand-Ruel, Adolphe Goupil and Louis Martinet, which came to prominence during the Second Empire were also to be found in the heart of Paris's financial district. In 1869 the Durand-Ruel firm opened new galleries in premises that had separate entrances on Rue Le Peletier and Rue Laffitte. Such firms had their roots in allied trades, also selling stationery or prints. Less prominent dealers like Alphonse Portier and Père Martin worked alongside them, while Louis Latouche and Julien-François Tanguy were colour merchants who subsequently turned art dealers by dint of offering credit to artists in exchange for paintings. Usually dealers took care to corner the market in a particular specialism: in the late 1860s, the Durand-Ruel firm was particularly linked to the Barbizon School, while Goupil made its name through reproductions of Salon favourites, such as Gérôme. Similarly, they tended to encourage artists to find their own market identity and niche.

The dealer whose name is most closely linked with the Impressionists' fortunes is Paul Durand-Ruel. Despite initial reluctance, he joined the family business in the late 1850s, learning the trade through extensive travel and first-hand acquaintance

223. **Auguste Renoir**, *Portrait of Paul Durand-Ruel*, 1910

223

with artists such as Millet and Daubigny. He first encountered Monet and Pissarro in London, where all three had taken refuge during the Franco-Prussian War. For the young painters, the meeting was timely. Durand-Ruel took an immediate interest in their work thanks to the warm recommendation of Daubigny, also in London. During the early 1870s he bought large numbers of their pictures and occasionally inserted them into the various mixed shows of French art he held in London, shrewdly seeing the English market as a promising outlet. There the future Impressionists were presented in the august and reassuring company of older Barbizon and realist painters like Corot, Rousseau, Millet and Courbet for whose works there was by now a regular clientèle.

Their period of exile therefore freed Monet and Pissarro briefly from the routine of working towards the next Salon. As discussed in Chapter Four, Monet's major shift around 1867 towards working on a smaller scale was prompted in large measure by his desperate need to sell. He could no longer afford, as Bazille or Manet could, to stake everything on the time-consuming and risky business of producing a monumental canvas for the Salon when it could so easily be rejected or badly hung. At that date, and at later stages in his career, his marketing strategies and techniques changed in unison.

In the immediate post-war period, the Paris art market was buoyant. For the future Impressionists, the fact that Durand-Ruel bought over 51,000 francs worth of Manet's paintings in the early part of 1872 gave good reason for optimism. Sales of their works were going well and buyers abroad as well as in France could be hoped for. By early 1874, Monet and Pissarro could expect their landscapes to fetch five hundred francs, while Degas's ballet subjects were selling for over a thousand francs. The commercial prospects were favourable when they mounted their first group exhibition.

The recognition that came with selling their work was vital to the Impressionists. Although not all the artists went through such desperate periods of penury as Monet, for most of them, selling pictures represented food on the table. Even Degas, who had been comfortably off during the 1860s, for family reasons found himself needing to sell his work during the mid-1870s and early 1880s. And for artists like Berthe Morisot or Mary Cassatt, who were cushioned from financial need, selling constituted a welcome affirmation of their professional status and a boost to their self-esteem, the more so because they were making their reputations in a man's

224

world. Were selling as unimportant to Morisot as some have claimed, it seems odd that she subjected herself to what proved to be the humiliation of having her works auctioned, along with her colleagues Renoir, Monet and Sisley, at the Hôtel Drouot in 1875. And why did she take such an envious interest in the fees Tissot could command in London? Cassatt for her part was thrilled by the substantial success of a show the Durand-Ruel gallery held for her in 1893, immediately ploughing the proceeds into property.

When in June 1874 de Nittis heard reports of healthy takings from the First Impressionist Exhibition, he was quick to broadcast the news. His verdict was over-optimistic, however, for the commercial side of the show had in fact been a failure, leading to the premature winding up of the Anonymous Society. It was on these grounds that de Nittis declined to take part again. Yet even if their financial projections went awry, from the outset the Impressionists were keen to demonstrate that they were not a band of desperate rejects; on the contrary, most of the works they chose to exhibit were not up for sale but lent by private collectors. This fact did not escape the attention of certain critics who singled out a well-known name, the operatic baritone Jean-Baptiste Faure, as one of the lenders to the show. 'Buying Cézannes is as good a way as any of drawing attention to oneself', quipped Émile Cardon.

Faure first came to the aid of the Impressionists through his association with Manet, whose work he enthusiastically began

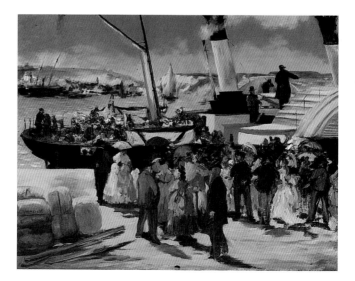

224. **Édouard Manet**,
Departure of the Folkestone Boat, 1869
This painting, the most resolved of Manet's two versions of the subject, was bought by Durand-Ruel in 1873. It dates from the summer of 1869, which Manet spent in Boulogne.

buying in 1873. He had already amassed a collection of works by Corot, Delacroix and Barbizon artists, which he sold at considerable profit that summer in order to release funds to devote to the younger generation's painting. At first he bought through Durand-Ruel's London branch, since he performed regularly at Covent Garden, but soon began dealing directly with the artists. He was an important supporter in the mid-1870s, when adverse economic conditions forced Durand-Ruel to curtail his purchases. But he proved not to be the easiest of patrons as far as Degas was concerned, partly because Degas himself was slow to fulfil undertakings. When a catalogue of Faure's collection was drawn up in 1902, it no longer comprised a single Degas, but numbered two Caillebottes, twenty-one Manets (including the *Déjeuner sur l'herbe* and *The Railroad*), thirteen Monets (in 1876 he had lent eight Monets to the Second Impressionist Exhibition), twenty-four Pissarros and twenty-two Sisleys (among them the series of views of the Thames he had financed). 46 225

Another important collector at this time was Ernest Hoschedé, a nouveau riche cloth merchant and owner of a large drapery store. He bought and sold with equal rapidity in the 1870s as his fortunes fluctuated. His first sale of Impressionist pictures in January 1874, when Durand-Ruel had stepped in to sustain the prices, brought in huge sums, the highest price of 950 francs being fetched by Pissarro's *Factories and Barrage at Pointoise*, of 1872. It would be many years before the artist could count on earning a similar sum. Hoschedé's finances were on a far from sound footing and he lacked all prudence in business affairs, yet his family lived lavishly, particularly at the Château de Rottembourg in Montgeron, his wife's inherited property. When in 1876 Monet, who had been desperate to find wealthy patrons in order to meet his mounting debts, was invited to paint decorative panels at Montgeron, he must have felt his prayers had been answered. However, the following year a drastic reversal of Hoschedé's fortunes meant that bills were left unpaid and his collections were once again thrown on the market. This time they failed to make at auction anything like the sums Hoschedé had invested. The twelve Monets sold on average for less than two hundred francs apiece. These events intimately affected Monet's life. In 1878 the now-destitute Hoschedé family moved in with the Monets to a house on the outskirts of Vétheuil. Alice Hoschedé, with whom Monet may already have been having an affair, would eventually become his second wife, after Hoschedé's death, in 1892. It is worth noting that marrying into the solidly bourgeois Raingo 226

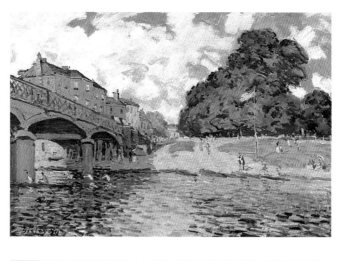

225. **Alfred Sisley**, *The Bridge at Hampton Court*, 1874

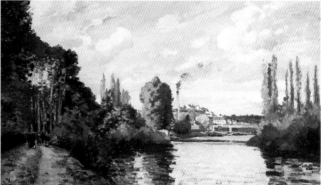

226. **Camille Pissarro**, *Factories and Barrage at Pontoise*, 1872

family to which Alice belonged represented a form of social advancement for Monet, effectively reversing the situation of his first marriage.

For all their prodigal generosity, the Impressionists' bruising experiences with speculative collectors from the worlds of business and entertainment might have made the patronage of professional men – like the doctors Georges de Bellio and Paul Gachet or the retired customs official Victor Chocquet – all the more attractive. Although such men's incomes were restricted, their support was steady and reliable. Chocquet fitted the category of the eccentric, obsessive collector (like Degas would become), who neglected his own appearance but lived for beautiful objects. He was the most important early collector of Cézanne, to whose work he was introduced in 1875 by Renoir. Both artists painted sympathetic 130

portraits of their patron, Renoir showing him in front of one of his prized possessions, a sketch by Delacroix. Chocquet's wife, too, was posed strategically in front of an oil sketch by Delacroix for the Bourbon Palace ceiling decorations. The fact that Delacroix was an artist admired fervently by both Renoir and Cézanne no doubt cemented their working relationships. There were also artists who bought pictures: Caillebotte, whose purchasing power was formidable and a lifeline in the 1870s; Gauguin, who bought cheaply for both economic and artistic investment; but also more conventional Salon artists, such as Ernest Duez (1843–96). In general, with the help of critics like Duret, Zola and Burty and a dealer like Durand-Ruel, from a relatively early date the Impressionists were able to attract a modest circle of buyers from diverse social backgrounds. If they had periods of intense hardship, it was never simply because they were misunderstood; it had much more to do with the fluctuating economic climate.

27, 227

1, 88,
127, 129

228

227. **Auguste Renoir**, *Portrait of Madame Victor Chocquet,* 1875

228. **Auguste Renoir**,
A Girl with a Fan, 1881
The successful actress Jeanne
Samary posed several times for
Renoir between 1877 and 1880.
He exhibited her sumptuous full-
length portrait at the Salon of
1879, but it was poorly hung
compared to *Madame
Charpentier and Her Children*
(see ill. 179). In this more
contrived genre image, for which
she is thought to have posed,
Samary wears a tartan day dress
and holds a Japanese fan.

Working hand in glove with a dealer not only brought the
artist material advantages and freedom from the constant anxiety
over money, but it also obviated the need to negotiate with clients.
However it could also entail drawbacks and a mutual dependence,
which was not always beneficial. It was imperative that a trusting
understanding be built up. Durand-Ruel generally succeeded in
developing good personal relations with his artists. He did not
issue formal contracts but worked on the basis of gentlemen's
agreements. In the early 1870s, he earned the implicit trust of
Pissarro, Monet and Degas who used him in lieu of a banker.
However, whereas Pissarro and Monet kept in close touch with
the dealer, constantly informing him of progress and often plead-
ing for more time to finish work in hand, Degas's relations were
kept on a more business-like footing. Some of the letters Durand-
Ruel received from Degas were curt to the point of rudeness. The
idea of mutual trust worked most successfully in the case of Renoir,
since Durand-Ruel's monarchist, conservative and traditionalist

outlook came close to matching the artist's. Indeed, in the still politically charged atmosphere of the 1870s Durand-Ruel was a useful ally. In Renoir's view: 'We needed a reactionary to defend our painting which the Salon crowd saw was revolutionary. He [Durand-Ruel] was one person at least who didn't run the risk of being shot as a Communard.'

But the enduring relationship was not always plain sailing; in 1882, after a particularly bad patch, it had to be tactfully rebuilt. Renoir was courting the wealthy diplomat Paul Bérard at the time and feared that Durand-Ruel, who had major funding difficulties of his own, was about to desert him. Stirred up by his journalist brother, Renoir had determined to resist showing his work at the Seventh Impressionist Exhibition which Durand-Ruel was helping to organize; he planned to show at the Salon instead. He only conceded because Durand-Ruel owned the works concerned. That summer, to appease the artist, the dealer commissioned a series of portraits of his children, effectively drawing Renoir back into the fold. Monet had clear views too of what constituted good and bad exhibition policy and his reasons for threatening defection in 1882 were spelt out clearly to Durand-Ruel: 'Now for this exhibition, I can tell you that my ideas are very firm on the subject. At the stage we are at now, an exhibition must be really well done or not done at all, and it is imperative that we be seen by ourselves, and there must not be a single stain to compromise our success.' The 'stain' he had in mind was probably Raffaëlli, who in the end withdrew.

In 1883 Durand-Ruel began showing certain of the artists' work individually, in recognition of their growing reputations. Monet, Renoir, Pissarro and Sisley were favoured in this way. The development was not unanimously applauded even by the artists involved. Some felt it smacked of commercialism and would sound the death knell of the movement; others probably felt slighted. Gauguin, who was yet to make his mark, still cherished the notion of a united group and suspected this new development would thwart his ambitions. However, given the near impossibility the previous year of uniting the group despite his best efforts, Durand-Ruel's preference for one-man shows is understandable.

These years were the hardest Durand-Ruel ever endured. In 1882 there had been a crash of the Union Générale bank, Durand-Ruel's chief funder, which had serious repercussions on his firm's viability and hampered his business activities for several years. It was presumably for this reason that he did not buy more aggressively at the posthumous Manet auction held in February 1884, where, despite press interest, several works looked like selling for

229. **Hugues Merle**, *Portrait of Paul Durand-Ruel*, 1866

230. **Auguste Renoir**, *Alice and Elisabeth Cahen d'Anvers*, 1881

disappointing sums, forcing the Manet family to step in and buy them back. In 1884 the dealer struggled to retain the fidelity of his stable of artists, finding himself unable to help them. Meanwhile Monet, Renoir and Sisley were also finding a profitable outlet in the dealer Georges Petit's gallery, where their work was shown in an opulent setting and assimilated into an eclectic and international context. None of these artists took part in the last Impressionist show of 1886.

In his memoirs, Durand-Ruel portrayed himself as the saviour of the struggling Impressionists, helping incidentally to fuel the myth of them as misunderstood artists. It has tended to be forgotten, however, that it was the popular Salon painters William Bouguereau (1825–1905) and Hugues Merle (1823–81) who were the mainstays of the Durand-Ruel gallery until 1865 when they were poached by the Goupil firm. Their sentimental subjects and polished techniques were admired by Durand-Ruel himself but also appealed to the tastes of the first-time American buyers, who were an increasingly significant sector of the art market after 1867. Durand-Ruel would scarcely have switched to backing such different artists as the Impressionists had he not been convinced that they too represented a sound business proposition.

The Impressionists did not deny their debt to Durand-Ruel whose support sustained them at critical moments, particularly early on, but they were under no illusions that it was a business relationship. Even Renoir, fond as he was of Durand-Ruel and his family, realized the dangers of a dealer taking on one's whole production. For this reason, he made sure that he retained a measure of personal freedom and continued to deal directly with his portrait clients. Monet was more ready to let the market, and speculators, decide upon his work's value, but he, too, particularly in the later 1880s, played off Durand-Ruel against his rivals Georges Petit and Theo van Gogh, the keen young agent for Boussod, Valadon & Cie, successors of Goupil. Gauguin's own experience of the stock market and of dabbling in the art trade (he bought pictures cheaply for himself and negotiated certain sales for Pissarro) led him to believe he understood marketing better than the dealers. This was probably one of the reasons why Durand-Ruel was unwilling to take him on. Yet Gauguin would certainly learn in his own practice to distinguish between works done primarily for sale and those that would challenge the buyer.

Pissarro was sympathetic to Durand-Ruel's difficulties, but conscious also of their fundamental ideological differences. Stirred up by Gauguin in part, he too, like Renoir and Monet, was

229

230

231, 232
233, 239

231. **Mary Cassatt**, *At the Theatre, c.* 1879
Mary Cassatt made her début with the
Impressionists in 1879, exhibiting a strong
group of portraits and modern figure studies.
Gauguin, another newcomer that year,
may have acquired this delicate study by
exchange; he would later experiment with
the same mixture of media – pastel,
gouache and metallic paint.

232. **Armand Guillaumin**, *View of the Panthéon from a Window on the Île Saint-Louis*, *c.* 1881
For this dense vertical view of Paris, Guillaumin painted what he could see from his window on the Quai d'Anjou, intriguingly incorporating still life and cityscape within a single frame. It was bought by Gauguin, at a time when the two artists were close, and taken by him to Denmark in 1884, where it remained.

233. **Camille Pissarro**, *Slopes at Chaponval*, 1878–79
Pissarro exhibited a dozen fans, including this one, at the Fourth Impressionist Exhibition. Durand-Ruel encouraged him to pursue this saleable line.

highly dubious of Durand-Ruel's new marketing strategy: the dealer had decided actively to cultivate the American market and organized the first Impressionist show in New York in 1886. Although this was a far-sighted and logical move on Durand-Ruel's part, which ultimately confirmed his flair and business acumen, the Impressionists were afraid that if he neglected the Parisian market he would miss his target. We can perhaps detect other reasons for Pissarro's concerns. His doubts coincided with Durand-Ruel's expressing grave reservations about the new turn his own work was taking and urging him to paint 'in the old style'. Did he feel ill-equipped to cater to the uncharted market represented by the New World? Did he fear for the new pressures such a market would open up?

It was part of the dealer's job to understand the elusive public and the tastes of buyers. In later years, when the American market was his primary outlet, Durand-Ruel tried to steer his artists in certain directions. He encouraged particular themes, by funding Monet's painting campaigns in Rouen, Venice and London for instance, or Pissarro's in Paris, Rouen and Dieppe, but also tried to divert them from blind alleys. The painters knew it was in their

234. **Auguste Renoir**,
The Luncheon of the Boating Party, *c.* 1881
Aline Charigot posed as the woman with the dog in this painting which was judged 'absolutely superb' by Armand Silvestre at the Seventh Impressionist Exhibition. Durand-Ruel, who bought the work, steadily enhanced its masterpiece status by continuing to exhibit it, first at his Renoir one-man show and then in Boston (1883), New York (1886), London (1905) and elsewhere. When the Washington collector Duncan Phillips finally persuaded the dealer to part with it for the sum of $150,000 in 1923, the story hit the American headlines.

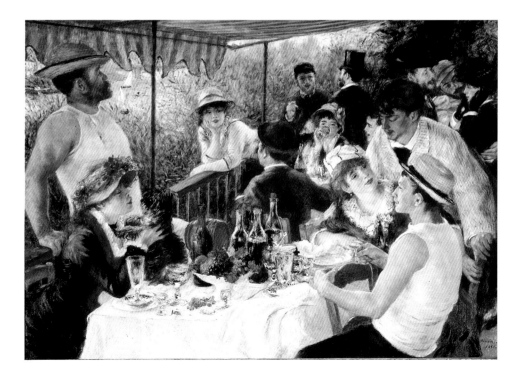

235. **Auguste Renoir**,
The Umbrellas,
c. 1881 and *c.* 1885

Due to the discrepancies of fashion and paint handling – for example, the children on the right are much more softly treated than the rest of the figures – it is thought that Renoir began this canvas before and completed it after his trip to Italy. Although he acquired it in 1892, Durand-Ruel discouraged the new tendency towards dull, grey tones and harder-edged forms evinced by such paintings.

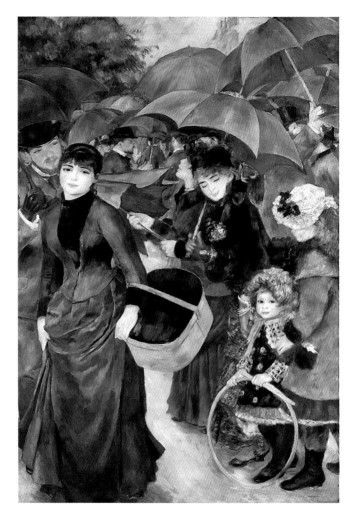

material interests to produce saleable work, yet, preoccupied with their own researches, they usually resisted such advice. Renoir was somewhat more amenable. He was well aware that his experiments with a more hard-edged style in the mid-1880s had disconcerted Durand-Ruel, but in 1888 he could write reassuringly: 'I think this time you will be happy. I have gone back for good to my old, sweet and light way of painting.... It's completely different from my last landscapes and the monotone portrait of your daughter.... It's nothing new, but a continuation of the paintings of the eighteenth century... so my new and definitive facture is roughly like Fragonard only less good.' In 1892, when Renoir was enjoying

235

a family holiday in Brittany, Durand-Ruel urged him to persevere in this direction: 'Make the most of the children on the beach for as long as you can and paint them as fresh and pink as your old off- 236 spring. Once and for all get rid of that grey which haunted you for a time and never be in a sombre mood.'

A dealer could sell paintings more easily if the product was unique and had a distinctive market identity, but also if it was of reliable, predictable and consistent quality. When a formula proved successful the temptation was always to press the artist for more of the same. Gauguin warned of this in 1881 when he complained to Pissarro about the repetitive nature of the landscape Impressionists' subjects: 'The way Durand-Ruel is operating with Sisley and Monet who are churning out pictures at top speed, he will soon have four hundred paintings which he will not be able to get rid of. Dash it all, you can't flood the place with pictures of rowing boats and endless views of Chatou, it'll become a dreadful trademark.'

Gauguin's pinpointing the issue of repetition was a valid point. On occasion, in his early career, Monet painted a subject twice over, the two versions showing only the most insignificant differences of size, handling and level of finish. One such pairing is a view of a street in Honfleur probably painted in 1866. It is sometimes suggested the paired works are in fact the preparatory study and finished painting he referred to when he wrote in 1864 to Bazille; it seems more plausible that he simply repeated a successful composition to satisfy a client. Certainly following his success at the 1866 Salon with his enormous *Camille*, Monet was commis- 54 sioned to paint a smaller replica for private clients, the print dealers Jules Luquet and Alfred Cadart. Had they perhaps suggested a reproductive print would follow? If so, it seems not to have materialized. As Patricia Mainardi has recently argued, the exaggerated emphasis on originality that characterizes modernist art history has glossed over the practice of repetition. Yet Courbet and contemporary Salon artists frequently resorted to it. Repeating successful compositions remained an expedient for certain Impressionists, chiefly for market reasons. Later in his career, near repetitions or variations on a theme would once again become central to Monet's practice when he painted in series. This way of working made practical sense as he grew older, enabling him to husband his resources. But, like a musician, he made it work to the benefit of his subtle aesthetic preoccupations: his attempts to distil the essence of time on the wing and what he called the 'envelope' of atmospheric light.

236. **Auguste Renoir**,
Young Girls at the Piano, 1892

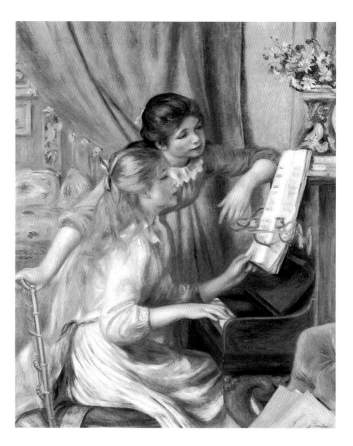

237. Photograph showing the
interior of the Durand-Ruel gallery
in New York, 1894

If Renoir had always gravitated towards the French rococo tradition, it is clear that Durand-Ruel, by the later 1880s, was encouraging him in that direction. And it must have been abundantly clear to his sons, Joseph, Charles and Georges Durand-Ruel – who between them took responsibility for the firm's New York branch on Fifth Avenue after 1888 – that the same collectors who had developed a taste for French eighteenth-century painting and furniture could be encouraged to become equally enthusiastic about purchasing Impressionist painting. For Maurice Denis, writing about Impressionism during the First World War, the rococo and Impressionist periods represented the high points of French culture and complemented one another, in an aesthetic, colouristic sense, to perfection. It is no coincidence that one of the finest collections of French rococo masters, that of Henry Clay Frick, now open to the public in New York, terminates its chronological sweep with representative examples by Degas, Manet, Monet and Renoir.

Monet had a loyal American following in his lifetime, notably in Mrs Potter Palmer in Chicago and Juliana Cheney Edwards in Boston, who often bought pictures as soon as they went on show. It is worth remembering that several American painters had close relations with Monet – both Theodore Robinson (1852–96) and John Singer Sargent had sought him out and benefited from his advice and Theodore Butler (1861–1936) married first one, then another, of his stepdaughters. One of America's most discriminating, although not its largest, collections of Renoirs was formed by Sterling Clark, heir to the Singer sewing machine fortune, aided and abetted by his French wife Francine; they bought regularly from the Durand-Ruel galleries between 1916 and 1950. Their chief rivals for Renoirs in the decades following the artist's death in 1919 were Duncan Phillips, Chester Dale, John Spaulding and the insatiable Dr Albert C. Barnes. Assessing the Renoirs housed in the Clark Art Institute in Williamstown, Steven Kern suggested recently that Renoir, during the first half of the twentieth century, was 'perhaps the most successful artist in America'. After the Second World War, however, that honour may have passed to Monet, whose late decorative work, after a period of disfavour, earned new support in the context of abstract expressionism with its emphasis on huge scale and open-ended structure.

Robert Herbert, reflecting in 1998 on the extraordinary success of the 'Monet in the Twentieth Century' exhibition in Boston, offered some challenging explanations for the artist's enduring appeal in the States. He recalled that in 1894 one of the first

homegrown enthusiasts for French Impressionist art, Hamlin Garland, had characterized the Impressionist as an artist who 'loves nature, not history'. This thinking, Herbert felt, explained why Monet appealed more readily in the New World than his more tradition-bound contemporaries Degas and Cézanne. American buyers were prepared to accept Monet, however challenging he was in a technical, iconoclastic sense, because his art was emphatically of the democratic present and future, unburdened by Europe's perennial absorption in history and the classical tradition. It could be argued that the way in which American audiences embraced Impressionism bore out Mallarmé's earlier definition of 'a democratic art for a democratic age'.

Seen in the light of America's characteristic enthusiasm for Renoir and Monet, the collection formed by the Havemeyers in New York was untypical. Closely guided in their buying by Louisine Havemeyer's old school friend Mary Cassatt, they specialized in the figurative tradition. Having first laid the foundations of an Old Master collection, they then added examples of recent or contemporary French art in the form of Courbet, Cézanne and Degas. It took the experience and inside knowledge of Cassatt to nurture this more learned, educative approach to recent French art. Through this carefully garnered selection she

238. **Sahib**, *La Belle Olympia au Louvre*. Published in *La Vie Parisienne*, 22 February 1890

was clearly following her own predilections, validating the tradition that had sustained her own art. But, just as Degas was doing in France, might she not also have been seeking to counterbalance the bias of her contemporaries towards Impressionist landscapes?

Happily the far-sightedness of Gustave Caillebotte, who drew up a will almost as soon as he began collecting in the 1870s, ensured that Paris retained some of the most important examples of High Impressionism. The Musée d'Orsay's wealth of Impressionism was founded upon Caillebotte's generous bequest to the nation, which encouraged further collecting and bequests in its wake. However, by the date of his unexpectedly early death, 1894, the taste of officialdom had by no means unanimously come round to the new art and there were protracted wrangles involved in the state's acceptance of the legacy, which had to be whittled down by half.

Of course, in 1894, memories were still fresh of the debates surrounding the purchase of Manet's *Olympia*, just twenty-five years after its scandalous début at the Paris Salon. The prime mover behind this manoeuvre, an expression of loyalty and long-standing admiration, was none other than Claude Monet. In his campaign to get the state to buy *Olympia* for France, he met with almost unanimous support from his old comrades and supporters, with the surprising exception of Zola, who disapproved of what he called 'forcing the pace', and of Mary Cassatt, when she learned that the campaigners' chief objective was to prevent the painting going to an American buyer.

By the time most European collectors and curators were belatedly waking up to the need to protect their Impressionist heritage, it was already too late to stem the tide of pictures going straight to wealthy American collectors. The result, today, is that Renoir's work of all periods and Monet's later series paintings can only be fully appreciated by visiting the major American museums of Boston, Chicago, New York, Philadelphia and Washington, D.C.

48
238

Chapter Nine: The End of Impressionism and Its Legacy

In recent decades it has become standard to describe the Impressionist movement as undergoing some sort of a crisis in the early 1880s, a crisis more apparent with hindsight than it was at the time. The increasing reputation enjoyed by the group as a whole did not prevent the individual originators of Impressionism from continually reviewing their manner of working. In some cases this involved reducing the time they spent on *plein-air* work and reverting to more traditional practices. We saw in Chapters Six and Seven how Monet was shedding his commitment to modern subjects and conceiving nature in broader, more simplified terms and how Renoir was determined to go back to drawing. Mid-career, Renoir made the conventional student trip to Italy, which he had missed out on as a young man, with the express purpose of learning from the Old Masters and filling an embarrassing lacuna in his education. Others in the group, particularly Pissarro, were beginning to question where their art was heading, in response perhaps to the criticisms of allegedly unfinished, sketchy painting which resurfaced around this time. He paid renewed attention to drawing from the figure and tried to vary his landscape practice by giving greater prominence to the figures engaged in working the land. He also executed his canvases to a higher level of completion, as we see in *Man Sawing Wood*, cutting 239 out the sky, that keynote of 1870s Impressionist luminosity, in order to concentrate more effectively on the variegated and muted harmonies of the sloping bank. By the end of the decade, following his experiments with the Neo-Impressionist touch, he was prepared to acknowledge that achieving the right harmonic balance could best be done in the studio. Therefore, while a work like *The Gleaners* would have been inspired by a harvesting scene near 240 Éragny-sur-Epte, it was under studio conditions that Pissarro achieved the calm and unity he was after; the result, in his view, was unquestionably 'more artistic and more thought through'.

Cézanne had first adopted a quasi-Impressionist practice in the early 1870s, working from nature at Pissarro's side or indeed copying the latter's paintings. At that time, although he lightened his touch and brightened the tonal range of his palette, he nevertheless always sought landscape motifs that offered pictorial

239. **Camille Pissarro,**
Man Sawing Wood, 1879

strength and order. It was in Cézanne's temperament to make things hard for himself. He avoided the potential distraction of working figures, preferring instead the empty, elemental aspects of nature. By the later 1870s, after he had renounced the painful business of exhibiting with the Impressionist group, part of him longed to show at the Salon instead and he finally succeeded, with Guillemet's backing, in 1882; however, he was acutely conscious that he did not have the ability to finish work in a way that pleased the Salon jury and public. He was struggling to devise a method which accorded with his beliefs about the importance of form; although convinced that he was in the right, he was frequently beset by a sense of frustration and inadequacy in the task. Some of this doubt stemmed from the fact that geographically he was so isolated from his former Impressionist colleagues, although in 1881 he had brief spells painting with Renoir in the south and with Pissarro and Gauguin in the north. He had developed a new, more systematized technique involving a rhythmic web of evenly weighted brushstrokes (visible in *The Battle of Love*), a way of achieving 'luminosity while respecting the integrity of forms', as Douglas Druick in his recent monograph on Renoir described it. It proved an object lesson, not just for Gauguin who bought several key works by Cézanne, but for Renoir too. A distinctly Cézannesque weave of parallel diagonal strokes characterizes Renoir's *La Roche-Guyon*, a site on the River Seine where Cézanne and Pissarro had painted before him.

241

242

240. **Camille Pissarro,**
The Gleaners, 1889

241. **Paul Cézanne,**
The Battle of Love, c. 1880

Degas meanwhile was pursuing experiments of his own into colour and form and, in the process, honing his range of subjects, endlessly working variants on old themes. He returned in the early 1880s to his earlier motif of the racecourse. His extraordinary practice of refinement and repetition, in which he frequently used tracings, led to strikingly simplified, monumental compositions. He now favoured pastel over and above all other media, a neat solution to the problem of uniting drawing and colour. In *Jockeys in the Rain*, Degas dispenses with the particularities of setting; there are none of the onlookers, chimneys and other topographical markers that featured in his earlier racecourse scenes and the horizon line is placed high as though to obliterate all distractions. Nothing impedes our eye from being drawn along the broken diagonal line of horses and jockeys impatient to start their race. Since Degas worked at such a remove from specific visual experience – many of the horses here, for example, had featured in earlier compositions – we are not tempted to read the image as a record of an actual rainy day. But it is difficult to say whether he introduced the rain effect as an acknowledgment to Japanese prints, as a way of further variegating the broad surface of the grass which he had already enlivened with textural markings, or out of sheer virtuosity, since the mere addition of five or six light blue slanting lines suffices to indicate a sudden shower.

A similar concentration on broad shapes characterized his later female figure subjects, where the observed bodies tend to appear closer to the viewer and enclosed within heavily textured and decorative colour areas. In *The Morning Bath*, a majestic composition dating from the early 1890s, the nude is isolated, seen only in fragmentary form, hemmed in by textures of contrasting complexity. Our viewpoint is one of disconcerting intimacy: all that separates us from her as she steps into her bath is the rumpled surface of her unmade bed which is seen as though from the depths of an alcove.

After 1886, with the exception of a one-man show of landscapes in Durand-Ruel's gallery in 1892, Degas no longer executed works with the intention of exhibiting them. Occasionally Durand-Ruel was allowed an example of the artist's recent work to sell to a persistent collector. In general, however, when Degas needed to raise funds to buy more items for his own collection, he would sell an earlier work that he had kept stored in his studio. His commitment to and solidarity with the Impressionist group dwindled and his circle of friends closed in once more around those who shared his background and tastes. Thus, while he saw little of

242. **Auguste Renoir**,
La Roche-Guyon, 1885–86

243. **Edgar Degas**,
Jockeys in the Rain, c. 1883–86

243

244

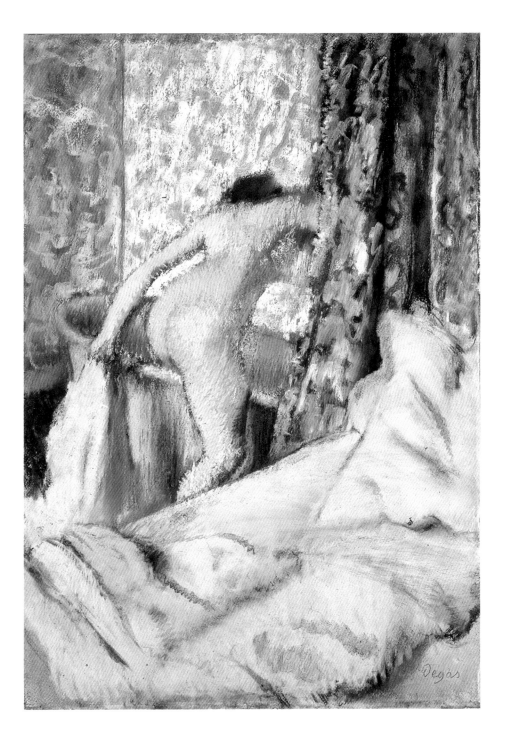

244. **Edgar Degas,**
The Morning Bath, c. 1892–95

Monet or Sisley, he remained in close contact with Berthe Morisot. The reactionary position he took over the Dreyfus Affair would further limit the number of people he was prepared to see, Pissarro being one of those he dropped. An exception to his general disenchantment with the younger generation was Morisot's daughter, Julie Manet, through whom he kept in contact with Renoir and Mallarmé. The elderly Degas paid kindly avuncular attentions to her when, aged fifteen, she was bereft of both her parents. He doubtless felt he had fulfilled his duties to both Manet and Morisot when he succeeded in arranging her engagement to the eligible Ernest Rouart, son of Henri, one of his best friends.

245
246

The many ties that in the 1870s had united the Impressionists to the naturalist movement in literature began to loosen in the 1880s. Their eloquent defender Duranty had died in 1880. It was clear that the Impressionists could no longer count on Zola's support, particularly after he published a Salon review in 1880 in which he expressed a certain disappointment in their collective achievements, their seeming inability to produce a solid masterpiece. He had higher hopes instead for such Salon naturalists as Alfred Roll (1846–1919) and Henri Gervex (1852–1929), who shared with the Impressionists a broad touch and bright colour range but still had the history painter's appetite for tackling major social themes on a grand scale. He also admired the peasant naturalists, the well-established Jules Breton (1827–1906) and the young Jules Bastien-Lepage whose influence would increase over the course of the decade. In 1883, in a letter to Huysmans about the

245. **Berthe Morisot,**
Self-Portrait with Julie, 1885

latter's book *L'Art moderne*, Zola took the younger writer to task for knocking down Courbet in order to present Degas as the 'greatest modern artist. The longer I go on, the more I become disenchanted with corners of observation that are simply curious, the more I have a love for the great abundant creators who bring a whole world into being.' In 1886 Zola published *The Masterpiece*, the fourteenth novel in the Rougon-Macquart series and an exploration of Paris's artistic milieu. Antoine Guillemet, the old comrade of Cézanne and Pissarro who now regularly exhibited realist landscapes at the Salon, was his main source for inside information. Zola created in his central character, Claude Lantier, an experimental painter impotent to realize his potential or his dream; this was interpreted by some of his old friends as a direct slur on Impressionism, and by Cézanne as the ultimate betrayal.

It was a betrayal as much as anything of the memory of Manet, who had died in 1883. In an emotional funeral oration, Manet was warmly praised by his lifelong friend Antonin Proust, a former Minister of Fine Arts, for having played the thankless role of precursor; for having profoundly influenced contemporary art; but also for having had the generosity to applaud 'the successes, almost always greater than his own, carried off by those who followed him and were inspired by his example'. Was Manet's death a reason why that impetus to seize modernity in all its variety – which had been such a powerful motivation among his Impressionist friends in the 1870s – seems to have waned? Within only a few years, Renoir would turn from subjects inspired by the well-known dance halls and restaurants to monumental bather subjects which deliberately deny specificity of time or place. It is curious, too, that Degas progressively abandoned his most modern motifs, the cafés and cabarets, after Manet's demise. Without the friendly rivalry of Manet to spur him on, did Degas perhaps lose his appetite for an art so tied to the present and the instant? Or was this a discreet mark of respect for his old friend's achievements? Or did he abandon this approach because it had been so travestied by illustrative artists such as Béraud? 222

The idea of reviving the Impressionist dinners previously held on a monthly basis was mooted at a get-together to mark the first anniversary of Manet's death, as a way of perpetuating his memory. They were an effective networking device, since supportive critics and collectors were invited along too. It was greatly to the disadvantage of an artist like Sisley that he attended so rarely. As women, Berthe Morisot and Mary Cassatt were not included, but instead organized social events of their own.

246. **Edgar Degas**, Photograph of Renoir (seated) and Mallarmé (standing), 16 December 1895 Renoir and Mallarmé were both guardians to Morisot's daughter, Julie. In the mirror in the background, we see the reflection of Degas taking the photograph and the out-of-focus heads of Mallarmé's wife and daughter.

Given the ever more marked disparities in the working practices of its main protagonists, where did the concept of Impressionism stand in the 1880s? By 1882 it was becoming clearer, for an experienced art commentator like Ernest Chesneau, whose knowledge extended beyond France's borders (his informed study of English painting came out that same year), that although nature was the universal guiding principle of late nineteenth-century artists, Impressionism constituted a very particular and French approach to nature. It was as different as could be from that taken by the English Pre-Raphaelites. If the latter, in Chesneau's view, took as their perfectly legitimate objective the translation of 'nature *as she is*, as the scholar's intelligence understands her, in her most minute details', the Impressionists were attached, with an equal passion, to 'nature *as she appears to us*, nature the way the phenomena of atmosphere and light recreate her for our eyes if only we know how to see'. This was as close to a defining aesthetic tenet of Impressionism as one was ever likely to get. Paul Adam refined it in 1886 when he wrote: 'Impressionism seeks to reproduce the pure phenomenon, the subjective appearance of things.' But such statements remained astonishingly open-ended in terms of actual practice.

As we saw at the end of Chapter Five, critics at the Eighth Impressionist Exhibition were struck by the signs of change demonstrated by the Neo-Impressionists. They were perplexed by how few exhibitors seemed to be practising a form of Impressionism that accorded with what they had originally understood by the term, with one critic narrowing it down to just Gauguin, Guillaumin and Morisot. Despite Pissarro and Degas's resolve to 'purify' the movement, it was an acute embarrassment that a relatively unknown artist, Émile Schuffenecker (1851–1934), had succeeded in manipulating his 'terrible' still lifes into the show, less on the grounds of self-evident talent than by special pleading to Eugène Manet and Berthe Morisot. It would be harsh, Schuffenecker argued, bruising to his pride, and prejudicial to his interests to be excluded by the very artistic group whose doctrines he had adopted and for whose triumph he was 'working and struggling'.

Although within the group there was stylistic disunity and a continuing problem of extraneous elements (with Schuffenecker, in a sense the new Raffaëlli), paradoxically, in the wider artistic world, a broadly conceived idea of 'Impressionism' was increasingly spreading its influence. It penetrated other private exhibitions, the official Salon and art schools both in France and abroad.

The existence of a new generation of French artists signing up to what could already be seen as an Impressionist tradition and claiming to have suffered for the cause seems to have led the originators of the movement to fear that they would be brought down to the level of their weaker adherents. By 1890, Monet was arguing, in no uncertain terms, to Durand-Ruel that any future attempt to revive the group shows would meet his total opposition. It was this concern, I would suggest, more than anything else, that was responsible for sounding the death knell of the united Impressionist movement and for impelling the older generation to pursue individual career paths. Durand-Ruel himself from the 1890s onwards was encouraging a new string of runners – among them, Gustave Loiseau (1865–1935), Henry Moret (1856–1913), Maxime Maufra (1861–1918), Georges d'Espagnat (1870–1950) and Albert André (1869–1954) – artists who would perpetuate Impressionist tendencies but add little that was genuinely innovative.

In the wake of Huysmans there were other new writers, including Octave Mirbeau and Gustave Geffroy, both formerly attached to Zola's naturalist school, who stepped in to defend Impressionism in the mid-1880s. Mirbeau was one of the most passionate and influential, writing columns in papers that covered a wide spectrum of political opinion. Mirbeau approached his subject matter with the probing techniques of modern investigative journalism; his articles were highly readable and he knew how to bring out the distinctive qualities of an artistic personality, but was not always scrupulous about checking his facts. Monet complied with and undoubtedly benefited from this kind of press coverage, as did the sculptor Auguste Rodin (1840–1917) with whom Monet stood shoulder to shoulder in age and stature. By 1889, when they shared an exhibition at Georges Petit's gallery, they were unquestionably for Mirbeau the two masters of the era in painting and sculpture. On the other hand, Pissarro, characteristically, showed himself to be more wary of publicity and reticent about granting interviews. However he was deeply moved in January 1891 when he read the appreciative article Mirbeau had written for Durand-Ruel's short-lived promotional journal *L'Art dans les deux mondes*. 'Did I really deserve such eulogies?' he asked.

In 1889 Mirbeau wrote an article in *Le Figaro* which presented a grandiose image of Monet's tireless quest to persuade nature to yield up her magical secrets: 'He expresses the inexpressible. He gives us the total illusion of life.' It was a heroic image of an obstinate, obsessive painter, doing daily battle with the sun and the elements. In fact Mirbeau hinted that Monet's methods represented a

kind of madness. Certainly he was as much in thrall to the vagaries of the weather as ever. As his letters constantly remind one, if nature called, he dropped everything; as soon as a fall of snow, for instance, transformed his surroundings, he was outside working furiously to capture the effects. In this respect Monet's attitude resembles that of the nature photographer, waiting and watching for advantageous light conditions. But what he was now attempting, as he tried to explain in a letter of 1890 to the critic Geffroy, was exceedingly difficult to accomplish. It involved the subjective appearance of things: 'I am becoming a very slow worker, which depresses me, but the further I go, the more I see that a great deal of work is needed to achieve what I seek – "instantaneity", above all the "envelope", the same light spread everywhere. And more than ever, the things that come easily in a single stroke disgust me. In short, I am keener than ever on the need to render what *I feel*'. And he was heard to explain to a visitor looking at his *Haystacks* in 247 1891, the first of his series exhibition: 'For me a landscape does not exist in its own right, since its appearance changes at every moment. But its surroundings bring it to life – the air and the light, which vary continually…. For me, it is only the surrounding atmosphere which gives objects their real value.'

247. **Claude Monet**,
Haystack, 1891

248. Photograph of Monet (right) in the garden at Giverny, with (from left) Germaine Hoschedé, Lily Butler, Madame Joseph Durand-Ruel and Georges Durand-Ruel, September 1900

Certainly Monet's series exhibitions, held at intervals between 1891 and 1912, represented a new concept in exhibition making which proved to be an enormous success. Both Monet and Durand-Ruel understood the importance of good press coverage and writers such as Geffroy and Mirbeau were not just supportive but showed an exemplary ability to pen explanatory prose at the right level of complexity. Once the public became accustomed to a room full of canvases of the same scale representing the same motif, news of the next show – whether the theme be Rouen 152, 153 Cathedral in 1895, London and the Thames in 1904, Venice in 249 1912, or more familiar scenes of the Seine in 1898 – began to provoke the same kind of anticipation and response among the smart set as a new season's designs from a leading fashion house. Indeed, by the later 1890s, the Claude Monet signature had achieved the bankable status of a designer label.

These explorations of the most subtle shifts in lighting, time of day, weather and atmosphere were a logical extension, but also a kind of *reductio ad absurdum*, of the Impressionist aesthetic. Fénéon, for one, felt the artist should be less prompt to dance attendance upon nature's caprices and should seek instead to coordinate her disparate aspects, to re-create an image of greater stability and permanence. Although no other contemporary artist was able to follow the same path, Monet's achievements, on an ever vaster scale towards the end of his life, can be compared with the 250 music of France's most revolutionary early twentieth-century

249. **Claude Monet,**
The Grand Canal, Venice, 1908

250. **Claude Monet**,
Waterlily Pond at Giverny, 1917

composer, Claude Debussy. In the same way that Monet combined exquisite distillations of harmony and tonal colour with fluid vaporous plays on the arabesque in a manner which overturned conventional notions of linear structure, so the impact of Debussy was revolutionary. The suffused edges of the latter's musical forms signalled his abandonment of conventional progressive structures; he adopted meandering arabesque lines, emphasized tone colour and, above all perhaps, revealed his responsiveness to nature's moods and rhythms. In part, at least, Debussy's harmonies were inspired by Richard Wagner's virtually unprecedented chromaticism.

For Rémy de Gourmont and André Mellério writing at the time of the 1900 Universal Exhibition, the only Impressionist was Monet. But if for some, the essential, authoritative Impressionist manner would remain Monet's, for others, from the mid-1880s on, the term Impressionist had all but lost its specific stylistic connotations and assumed a purely token status. Alfred Paulet, in a review of the 1886 exhibition, quoted the derisory definition of 'Impressionist' given by the Larousse dictionary: 'A category of painters mostly lacking originality and talent who, not being able to gain acceptance at the annual exhibitions of fine arts, put their works on show in a private locale and thus submit them to the appreciation of the public.' Their innovations of style are not mentioned. For latecomers to the movement, such as Gauguin and Vincent van Gogh (1853–90), stylistic issues certainly seem to have mattered less than carrying the name Impressionist as a badge of honour. It was important to associate themselves with a movement which had once taken a courageous independent, revolutionary stand against hidebound tradition. Thus, in 1888, when his practice was already moving away from what he had learned from Pissarro and Degas, Gauguin was still proud to be known as an Impressionist and considered it a cause worth fighting for. Notably, he defended the movement when it came under attack from a group of artists he met in Brittany – artists who were being trained in the naturalist *plein-air* methods then prevalent in the Paris art studios. And one finds van Gogh stretching the term to suit a very different set of ends when he spoke about the 'Impressionist' colours he had used in *La Berceuse* (1889), a portrait whose bold flat colours are subjective, arbitrary and, if anything, anti-naturalistic.

One of the charges made by those now commonly bracketed as Post-Impressionists was that Impressionism lacked intellectual substance. Traditional history painting required academic and imaginative effort, but it was argued that neither of these qualities

was required to produce an Impressionist picture; the artist merely needed sensitivity, special nerves, the ability to deliver a rapid response. Monet was deemed to be brilliant but just blessed with an excellent eye. Among the symbolist generation who were coming to the fore in the late 1880s, this reductive view of Impressionism was increasingly current. It was vehemently rejected by Pissarro, who had always sought to imbue his paintings with deeper social and, occasionally, political meanings but for whom art was also, and above all, about feeling. Pissarro argued that for him rendering his 'sensation' involved memory and synthesis, not just fidelity to the subject; only that way could he convey the truth that had been glimpsed and experienced. In 1890 Monet, too, was effectively retaliating against the same complaint by emphasizing the importance of feeling in his work. It was a view which paid scant respect to the more intellectual approach of Degas, who, through the complexity of his working methods, had always sought to imbue modern and realist subjects with the nobility of history painting. In the 1880s, however, a desire to reinvest Impressionism with the more intellectual content associated with traditional art lay behind the monumental compositions and scientific colour programme undertaken by Georges Seurat, as it did behind the somewhat more faltering efforts of Paul Gauguin.

Although he had joined the Impressionists in 1879 under the tutelage of Pissarro, Gauguin seems quickly to have become aware of the danger of monotony inherent in Pissarro's restricted subject matter and choppy, somewhat laboured, style. He was also wary of the examples set by Monet and Renoir, whose haphazard and highly subjective techniques he felt to be increasingly self-indulgent and idiosyncratic and who were anything but amenable to teaching or encouraging such an opinionated newcomer. He recognized and admired Cézanne's uniqueness and took care to cultivate the powerful draughtsmanship advocated by Degas. But he struggled, as his pictures reveal, to bring his own unschooled methods in line with the contradictory achievements of such mentors.

Throughout the 1880s Gauguin was a constantly dissenting voice within the Impressionist group. His critique had first manifested itself in his dissatisfaction with Monet and Sisley's trite and trademark boating subjects, what he would later call 'Parisianist' motifs. One can see tell-tale signs of his own preoccupation with intense colour and pattern in *For Making a Bouquet*. Ostensibly this is a typical Impressionist subject, a still life of summer flowers waiting to be arranged, with a glimpse of a sunny garden path

251

through an open door. Yet Gauguin is dissatisfied with these ingredients; he elaborates his theme by introducing a counterpoint of busily patterned fabrics, as we see in the tartan strewn over the boldly painted chairback.

In 1886 the contrast between Gauguin's approach and Monet's is instructive. That year Monet worked for several weeks on the island of Belle-Île off the coast of Brittany, where he studied the drama of the elements, the conflict between sea and rocks and their endlessly fascinating rhythms. Gauguin meanwhile, staying on mainland Brittany, was alert to these same effects of nature, but already had an eye on the folkloric aspect of Breton women too, with their quaint costumes and mute rapport with the animal kingdom. This fascination with cultural difference eventually won out over his Impressionist love of nature. His restless search for novel motifs would eventually lead him to take his palette further and further from Paris, discovering not only in Brittany, but also in the Caribbean in 1887 and finally in the South Seas in 1891, new sources of inspiration, an exoticism that he sensed the public craved. After all, the patriotic celebration of the French countryside, which typified and linked Barbizon and Impressionist approaches to landscape, was a recent development.

Colourful exoticism had a proven record of popularity with nineteenth-century audiences, attested by the immense success of orientalists such as Gérôme. Orientalism was again a talking point in 1885 when Delacroix was belatedly honoured with a major retrospective at the École des Beaux-Arts. As we saw, the fiery exaggeration of his North African colourism had been ahead of its time and, at his death in 1863, his supporters were small in number. However, after more than a decade of Impressionism, the public was now more tolerant of Delacroix's vibrancy of colour and touch, more prepared to appreciate intense, highly charged hues. By extension, Gauguin believed it would also be ready to accept these same artistic attributes, seasoned with imagination, served up in a new context. It was this conviction, surely, which underlay Gauguin's calculations in the mid-1880s as he strove to imbue Impressionism with deeper colouristic resonance. Degas, to whom Gauguin was close at the time, held Delacroix's draughtsmanship and colour in equal veneration and, in his own major art collection, gave the earlier artist's work pride of place alongside Ingres's drawings. Delacroix's importance was also confirmed for Gauguin by the object lesson of Cézanne and by van Gogh's passionate enthusiasm for the idea of an art based on intense Mediterranean colour.

251. **Paul Gauguin**, *For Making a Bouquet*, 1880

252. **Paul Gauguin**, *Breton Woman Herding Her Cows on the Beach at Le Pouldu*, 1886

252

253

Eventually, having fallen out with almost everybody associated with old-style Impressionism, Gauguin reinvented himself late in the decade as leader of one of the key breakaway movements to emerge from Impressionism. When Gauguin gathered around him the splinter group of younger artists – van Gogh's friends from Paris – to organize their own marginal group exhibition in 1889, they called themselves the Impressionist and Synthetist Group. Gauguin, perhaps guided by the critic Albert Aurier, saw how inappropriate it was to go on calling their bold, flat, unvariegated, anti-naturalistic experiments 'Impressionist'. But synthetic art was still far from gaining widespread acceptance and at the auction of his works in 1891, just prior to his departure for Tahiti, the prices were as modest as the Impressionists' had been sixteen years before. The main buyers daring to take a chance on his work were mostly other artists like Degas or collectors with avant-garde tastes. But Gauguin, the former stocktrader, had an eye on the longer term future and took heart from the recent rally in the market success of his older confrères.

When Georges Lecomte's book *L'Art impressionniste* was published in 1892, Monet, Degas, Renoir – the central subjects – were described by one of his reviewers as 'universally recognized masters'. By that year, the Impressionist tendencies were judged to have already left their historical mark, to have 'already made their way in the world and [honoured their] country, despite the reservations to which they once gave rise'. The Impressionists' increasing worldly success had a discernible impact on their daily lives. In

254. **Alfred Sisley**, *The Church at Moret, Freezing Weather*, 1893

December 1891, for instance, we know that Pissarro's anarchist beliefs did not prevent him taking pride when his wife came up to Paris in a smart new outfit and spectacles, possibly the first she had been able to afford. Monet meanwhile could afford to indulge his *bon viveur* instincts, to stay in the best hotels when he travelled abroad and to become an early enthusiast for the pleasures of motoring.

More significant was the impact that the Impressionists' improved financial status had on their paintings. It would be fair to say that only when they had achieved a measure of public recognition and were earning comfortable incomes could the Impressionists afford to seek out – through more extensive travel, funded by dealers – or recreate around them their ideal environment for *plein-air* painting. Sisley, whose earning power had not kept pace with his colleagues', had to take Moret-sur-Loing as he found it, as indeed Pissarro did Éragny-sur-Epte. But both had taken care to seek out these congenial locales – offering the appropriate combination of water and barge traffic in Sisley's case, or streams and meadows with intense agricultural activity in Pissarro's – to furnish them with subjects for painting. Éragny's proximity to the historic and picturesque market town of Gisors with a rail service to Paris was also an important factor. A hankering after an earlier age of elegance was something both Berthe Morisot and Mary Cassatt were able to indulge, albeit briefly, at the end of their careers, when they respectively rented and bought châteaux in the Île de France, at Mézy and Beaufresne.

Conspicuous consumption was more the order of the day for Caillebotte and Monet. Caillebotte had been the first to stamp his mark on his environment in 1881, buying property at Petit

254

255

255. Photograph (from left to right) of Madame Joseph Durand-Ruel, Mary Cassatt, an unidentified woman and Marie-Louise Durand-Ruel at Beaufresne, September 1910

256. Photograph of Monet in his studio at Giverny, 1920 Monet and the Duc de Trévise examine the artist's canvases, among them his *Déjeuner sur l'herbe* (see the cover) and paintings executed in the Japanese-inspired water garden at Giverny.

Gennevilliers and cultivating rare blooms in his extensive gardens there. His example was undoubtedly a spur to Monet who, in 1890, was able to buy the property at Giverny and give free rein to his gardening ambitions. In developing his Japanese-inspired water garden there, Monet was essentially creating his own motifs and his remarkable pictorial experimentation in the twentieth century was increasingly concentrated upon this private idyllic world. To a lesser extent, Renoir also created his own motifs at the house and studio he built at Les Collettes near Cagnes in the 1900s. As we have already seen, working under the intense glare of the Mediterranean sun encouraged a particular, heightened and anti-naturalist use of colour – as Guillaumin's late work from Aget shows – and a reassessment – in Renoir's case – of the classical and the decorative. Over the long years of his physical decline, during which rheumatism gradually crippled his hands, Renoir never stopped painting. Les Collettes became a lure for his younger admirers, André, d'Espagnat and the most important of them all, Bonnard.

However when dealing with the phenomenon of artists choosing to work in the Mediterranean, the debate passes quickly to various forms of Post-Impressionism rather than Impressionism. An important strand of van Gogh's legacy was his unrealized dream of founding a communal studio in the south, a dream which bore fruit immediately after his death. It inspired both the colouristic world of tropical harmony Gauguin conjured up in Tahiti and caused a concentration of Neo-Impressionists – Paul Signac, Henri Edmond Cross (1856–1910) and Théo van Rysselberghe (1862–1926) – to gather around Saint-Tropez on the Mediterranean coast. In this drift southwards, they were soon followed by the future fauves, Louis Valtat (1869–1952), Henri Matisse (1869–1954), André Derain (1880–1954) and Charles Camoin (1879–1965). For such innovative artists, eager to learn from Cézanne and ambitious to make their own mark in Paris at the dawn of the new century, it was definitely time to close the book on Impressionism.

248
256

Postscript

In 1895 Lucien Pissarro warned his father that Germany, Holland and Belgium were beginning to show more interest in the new symbolist and decorative art of Britain than in Impressionism, and he predicted that it might take a generation or two before Impressionism's lofty and noble artistic tendencies would be recognized once more. In 1905, Camille Mauclair published an article provocatively entitled 'The End of Impressionism'. And yet, by this date, there was scarcely an art school anywhere in the Western world where the baleful influence of Impressionism was not being decried by a reactionary teacher, or where more open-minded artists were not actively contesting academic rules and demanding the right to work directly from nature. The Impressionist concept, in its simplest form, had taken flight. Such was its global impact, with offshoots of the original movement taking root throughout northern and southern Europe, in Great Britain, in Russia, in America and in Australia, that it was commonplace, right up to the First World War, to find débutant artists adopting Impressionist *plein-airist* ideals as an act of defiance and independence almost as a rite of passage.

Viewed in its broadest dimensions, the multifaceted legacy of Impressionism is difficult to delineate. In France, during the economically depressed inter-war period, Impressionism was excoriated by the leaders of the cubist and surrealist avant-gardes, together with the bourgeois values it was felt to embody. However, coinciding with the post-war economic recovery in the 1950s, Impressionism gradually picked up its following, a rise matched by the steadily increasing prices fetched at auction by Monets, Renoirs and Cézannes. Indeed such are these artists' kudos that the general label 'Impressionist' has long been used by auction houses as a convenient historical bracket for any art deemed to be neither academic and conventional in a nineteenth-century sense nor particularly modern in a twentieth-century sense. It is an ironic fate for an art movement in which edgy notions of modernity played such a central role. Yet we can scarcely be surprised, at a time when art seems bent on denying validity to the aesthetic sensibility, that the very concept of Impressionism should have evolved into something so safe, reassuring and gilt-edged.

Chronology

1830 Birth of Pissarro.

1832 Birth of Manet.

1834 Birth of Degas.

1839 Birth of Cézanne and Sisley.

1840 Birth of Monet.

1841 Birth of Renoir, Bazille and Morisot.

1844 Birth of Cassatt.

1848 Birth of Caillebotte and Gauguin.

1855 Universal Exhibition in Paris. Pissarro arrives in Paris.

1856 Monet meets Boudin. Degas begins three-year stay in Italy.

1859 Monet meets Pissarro at the Académie Suisse.

1861 Cézanne and Guillaumin meet Pissarro at the Académie Suisse.

1862 Manet meets Degas. Renoir enters Gleyre's studio at the same time as Sisley and Bazille.

1863 The Salon des Refusés is dominated by Manet's *Déjeuner sur l'herbe* (ill. 46) and shows work by Cézanne, Fantin-Latour, Guillaumin and Pissarro.

1864 Morisot, Pissarro and Renoir show at the Salon. Monet and Bazille work together in Honfleur.

1865 Monet, Degas, Morisot, Pissarro and Renoir exhibit at the Salon. Manet's *Olympia* (ill. 48) is criticized at the Salon, but defended by Zola.

1866 Manet meets Cézanne. Zola publishes articles on the future Impressionists in *L'Événement.* Monet (*Camille in a Green Dress*, ill. 54), Bazille, Degas, Morisot, Pissarro and Sisley exhibit at the Salon; Manet, Renoir and Cézanne are rejected. Cassatt arrives in Paris.

1867 Universal Exhibition in Paris. Bazille's petition, protesting at the severity of the Salon jury, is signed by Pissarro, Monet, Renoir, Manet and Sisley, all of whom have work rejected.

Manet and Courbet hold their own exhibitions.

1868 Manet meets Morisot. Monet, Renoir and Sisley join Manet in frequenting the Café Guerbois. A more lenient Salon jury accepts work by Bazille, Degas, Manet (*Portrait of Émile Zola*, ill. 55), Morisot, Pissarro, Renoir and Sisley. Monet has one work accepted, but *Women in the Garden* (ill. 83) is rejected.

1869 Manet (*The Balcony*, ill. 88), Bazille, Degas and Morisot are accepted at the Salon, but Manet's *Execution of Emperor Maximilian* (ill. 110), Monet, Sisley and Cézanne are rejected.

1870 Bazille, Degas, Fantin-Latour (*A Studio in the Batignolles*, ill. 37), Manet, Morisot, Pissarro, Renoir and Sisley are shown at the Salon; Monet and Cézanne are refused. Franco-Prussian War. Bazille is killed in action. Manet, Renoir and Degas enlist. Monet and Pissarro flee to England, where they meet Durand-Ruel.

1871 Commune takes power in Paris, but is defeated by government forces after two months. After visiting Holland, Monet settles in Argenteuil.

1872 Durand-Ruel buys paintings by Degas, Manet, Renoir and Sisley and shows work by Degas, Monet, Pissarro and Sisley in London. Renoir has a painting rejected at the Salon. Degas goes to New Orleans for six months.

1873 Monet meets Caillebotte. The Anonymous Society of Painters, Sculptors, Engravers, etc. is formed. Morisot and Cassatt exhibit at the Salon.

1874 First Impressionist Exhibition held at 35 Boulevard des Capucines (Nadar's old studio) from 15 April to 15 May. Works shown include ills. 8, 15, 22, 32, 117, 118, 119, 120 and 180.

1875 Auction of Impressionist pictures at the Hôtel Drouot. Manet's view of *Argenteuil* (ill. 203) is poorly received at the Salon, where Renoir is rejected.

1876 Second Impressionist Exhibition held at 11 Rue Le Peletier (Durand-Ruel Gallery) in April. Works shown include ills. 62, 102, 126?, 127, 150, 161, 192, 195 and 196. Duranty publishes *La Nouvelle peinture*.

1877 Third Impressionist Exhibition at 6 Rue Le Peletier in April. Works shown include ills. 1, 21, 123, 125, 126?, 129, 130, 132, 134, 147, 183, 211 and 218. Second Impressionist auction. Manet's *Nana* (ill. 170) is rejected by the Salon jury on grounds of impropriety, together with Cassatt's submissions.

1878 Universal Exhibition in Paris. Renoir shows (*Madame Charpentier and Her Children*, ill. 179) at the Salon; Cézanne is rejected. Monet moves to Vétheuil.

1879 Fourth Impressionist Exhibition held at 28 Avenue de l'Opéra from 10 April to 11 May. Works shown include ills. 17, 113, 119, 137, 148, 197, 231 and 233. The first issue of *La Vie moderne* is published. Renoir exhibits full-length portrait at the Salon.

1880 Fifth Impressionist Exhibition held at 10 Rue des Pyramides from 1 to 30 April. Works shown include ills. 104, 133, 138, 165, 167?, 176, 181, 200, 219 and 239. Renoir and Monet show at the Salon. Sisley moves to Moret-sur-Loing.

1881 Sixth Impressionist Exhibition held at 35 Boulevard des Capucines from 2 April to 1 May. Works shown include 139, 140, 151, 175 and 251. Manet wins a medal at the Salon. State control of the Salon abandoned.

1882 Seventh Impressionist Exhibition held at 251 Rue Saint-Honoré in March, organized by Durand-Ruel. Works shown include ills. 18, 77, 135, 198, 207 and 234. Renoir exhibits twenty-five works; it is his first showing with the group since 1877. Manet awarded Légion d'Honneur and his *Bar at the Folies-Bergères* (ill. 209) is exhibited at the Salon.

1883 Manet dies. Impressionist exhibitions in Berlin and Boston. Huysmans publishes

L'Art moderne. Monet, Renoir, Pissarro and Sisley all have one-man shows at Durand-Ruel's gallery. Monet settles in Giverny with Alice Hoschedé and also works in the South of France.

1884 Société des Artistes Indépendants founded. Memorial exhibition to Manet at the École des Beaux-Arts. Pissarro settles in Éragny-sur-Epte. Monet shows at Georges Petit's third *Exposition internationale*.

1886 Eighth (and final) Impressionist Exhibition held at 1 Rue Lafitte from 15 May to 15 June. Works shown include ills. 144, 145, 146, 168, 190 and 191. Durand-Ruel shows the Impressionists in New York.

1888 Durand-Ruel opens a gallery in New York. Theo van Gogh exhibits Monet's *Antibes* paintings.

1889 Universal Exhibition in Paris. Monet and Rodin exhibit together at Georges Petit's gallery.

1890 Monet's campaign to buy Manet's *Olympia* (ill. 48) results in it being offered to the state.

1891 Monet's *Haystacks* (ill. 247) series shown in Durand-Ruel's gallery. Gauguin travels to Tahiti.

1892 Monet's *Poplars* series, Degas's landscapes and a Pissarro retrospective are shown in Durand-Ruel's gallery. Morisot exhibits at Boussod & Valadon's gallery.

1893 Degas's *Absinthe* (ill. 183) shocks London. Gauguin, back in Paris, shows Tahitian works and Mary Cassatt has an exhibition at Durand-Ruel's gallery. Monet starts to build his water garden at Giverny.

1894 Caillebotte dies; his Impressionist paintings are left to the state.

1895 Morisot dies. Monet's *Rouen Cathedral* series (ills. 152, 153) shown in Durand-Ruel's gallery. Cézanne exhibits at Vollard's gallery. Monet visits Norway. Gauguin returns to Tahiti.

1896 A Morisot retrospective is shown at Durand-Ruel's gallery.

1897 Sisley has a one-man show at Georges Petit's gallery. A reduced version of the Caillebotte bequest goes on display at the Musée du Luxembourg.

1898 Monet's *Mornings on the Seine*, *Views of Norway* and *Normandy Cliffs* series are shown at Georges Petit's gallery. Paintings by Degas, Manet, Monet, Renoir and Sisley are shown at an exhibition of the International Society of Artists in London. Renoir's first visit to Cagnes-sur-Mer in the South of France, which will later become his home.

1899 Sisley dies. The Chocquet collection goes on sale; high prices are paid for Impressionist works.

1900 Monet's *Water Garden at Giverny* series shown at Durand-Ruel's gallery.

1903 Pissarro and Gauguin die.

1904 Monet's *Views of the Thames in London* series shown at Durand-Ruel's gallery.

1906 Cézanne dies.

1907 Manet's *Olympia* (ill. 48) is exhibited at the Louvre.

1909 Monet's *Waterlilies* series shown at Durand-Ruel's gallery.

1912 Monet's *Venice* (ill. 249) series shown at the Bernheim-Jeune Gallery.

1917 Degas dies.

1919 Renoir dies.

1926 Monet and Cassatt die.

Select Bibliography

This list is by no means exhaustive and concentrates on more recent publications. The reader will find more comprehensive bibliographies in those titles marked with an asterisk.

General

Berson, Ruth (ed.), *The New Painting: Impressionism, 1874–1886. Documentation.* 2 vols., vol. I reviews, vol. II exhibited works, San Francisco, 1996

Broude, Norma, *Impressionism: A Feminist Reading, The Gendering of Art, Science, and Nature in the Nineteenth Century.* New York, 1991

Champa, Kermit, *Studies in Early Impressionism.* New Haven and London, 1973

*Clark, Timothy J., *The Painting of Modern Life. Paris in the Art of Manet and His Followers.* London and New York, 1985

Frascina, Francis *et al.*, *Modernity and Modernism: French Painting in the Nineteenth Century.* New Haven and London, 1993

Garb, Tamar, *Women Impressionists.* Oxford, 1986

*Herbert, Robert L., *Impressionism. Art, Leisure, and Parisian Society.* New Haven and London, 1988

—'Impressionists on Stage', *New York Review of Books*, 2 November 1995, pp. 44–47

Hobbs, Richard (ed.), *Impressions of French Modernity. Art and Literature in France, 1850–1900.* Manchester, 1998

Isaacson, Joel, 'Impressionism and Journalistic Illustration', *Arts Magazine*, June 1982, pp. 95–115

Kinney, Leila, 'Genre: A Social Contract?', *Art Journal*, Winter 1987, pp. 267–77

Nord, Philip, *Impressionists and Politics: Art and Democracy in the Nineteenth Century.* London and New York, 2000

*Rewald, John, *The History of Impressionism.* London and New York, 1973

—*Studies in Impressionism.* London, 1985

Roskill, Mark, 'Early Impressionism and the Fashion Print', *Burlington Magazine*, June 1970, pp. 390–95

Rubin, James H., *Impressionism.* London, 1999

Smith, Paul, *Impressionism: Beneath the Surface.* London, 1995

White, Barbara Ehrlich, *Impressionists Side by Side. Their Friendships, Rivalries, and Artistic Exchanges.* New York, 1996

Selected Exhibition Catalogues

Bowness, Alan and Anthea Callen, *The Impressionists in London.* Exh. cat., Hayward Gallery, London, 1973

Clarke, Michael, *Lighting up the Landscape: French Impressionism and its Origins.* Exh. cat., National Gallery of Scotland, Edinburgh, 1986

Isaacson, Joel, *The Crisis of Impressionism. 1878–1882.* Exh. cat., Museum of Art, University of Michigan, 1979

Moffett, Charles S., *The New Painting: Impressionism, 1874–1886.* Exh. cat., The Fine Arts Museum of San Francisco/National Gallery of Art, Washington, D.C., 1986

*Tinterow, Gary and Henri Loyrette, *Origins of Impressionism.* Exh. cat., Grand Palais, Paris/Metropolitan Museum of Art, New York, 1994

* Wilson-Bareau, Juliet, *Manet, Monet, and the Gare Saint-Lazare.* Exh. cat., Musée d'Orsay, Paris/National Gallery of Art, Washington, D.C., 1998

Collecting, the Art Market and Art Institutions

Bodelsen, Merete, 'Early Impressionist Sales, 1874–94, in the Light of Some Unpublished "Procès Verbaux"', *Burlington Magazine*, June 1968, pp. 331–49

Boime, Albert, *The Academy and French Painting in the Nineteenth Century.* London and New York, 1971

—*Art and the French Commune. Imagining Paris after War and Revolution.* Princeton, 1995

*Distel, Anne, *Impressionism: The First Collectors.* New York, 1990

*Dumas, Ann and Michael E. Shapiro, *Impressionism: Paintings Collected by European Museums.* Exh. cat., High Museum of Art, Atlanta/ Seattle Art Museum/Denver Art Museum, 1999

Haskell, Francis, *Rediscoveries in Art: Some Aspects of Taste, Fashion and Collecting in England and France.* London, 1976

House, John, *Impressionism for England: Samuel Courtauld as Patron and Collector.* Exh. cat., Courtauld Institute Galleries, London, 1994

Mainardi, Patricia, *Art and Politics of the Second Empire: The Universal Expositions of 1855 and 1867.* New Haven and London, 1987

—*The End of the Salon: Art and the State in the Early Third Republic.* New York and Cambridge, 1993

Roos, Jane Mayo, *Early Impressionism and the French State, 1866–1874.* Cambridge, 1996

Stolwijk, Chris and Richard Thomson, *Theo Van Gogh.* Exh. cat., Van Gogh Museum, Amsterdam/Musée d'Orsay, Paris, 1999

Vaisse, Pierre, *La Troisième République et les peintres.* Paris, 1995

Weitzenhoffer, Frances, *The Havemeyers: Impressionism comes to America.* New York, 1986

White, Harrison C. and Cynthia A., *Canvases and Careers: Institutional Change in the French Painting World.* New York, 1965

Criticism

Baudelaire, Charles, *Oeuvres complètes.* Edited by Claude Pichois, 2 vols., Paris, 1975/6

Bouillon, Jean-Paul *et al.*, *La Promenade du Critique Influent: Anthologie de la critique d'art en France, 1850–1900.* Paris, 1990

Brookner, Anita, *The Genius of the Future.* London, 1971

Flint, Kate (ed.), *Impressionists in England. The Critical Reception.* London and Boston, 1984

Neiss, Robert J., *Zola, Cézanne and Manet.* Ann Arbor, 1968

Nochlin, Linda (ed.), *Impressionism and Post-Impressionism 1874–1904, Sources and Documents.* New Jersey, 1966

Drawing and Printmaking

Leymarie, Jean and Michel Melot, *Impressionist Prints.* London, 1971

*Lloyd, Christopher and Richard Thomson, *Impressionist Drawings from British Collections.* Oxford, 1986

Melot, Michel, *The Impressionist Print.* New Haven and London, 1996

*Wadley, Nicholas, *Impressionist and Post-Impressionist Drawing.* London, 1991

Imagery, Representation and Issues of Gender

Clayson, Hollis, *Painted Love. Prostitution in French Art of the Impressionist Era.* New Haven and London, 1992

Garb, Tamar, *Bodies of Modernity.* London and New York, 1998

Nochlin, Linda, *Women, Art and Power and other Essays.* London and New York, 1989

Pollock, Griselda, *Vision and Difference: Femininity, Feminism and the Histories of Art.* London, 1988

Landscape
*Belloli, Andrea P., Richard Brettell and Scott Schaeffer (eds.), *A Day in the Country: Impressionism and the French Landscape*. Exh. cat., Los Angeles County Museum of Art/ Art Institute of Chicago, 1984

*House, John *et al.*, *Landscapes of France: Impressionism and its Rivals*. Exh. cat., Hayward Gallery, London/Museum of Fine Arts, Boston, 1995

*Thomson, Richard, *Monet to Matisse. Landscape Painting in France, 1874–1914*. Exh. cat., National Gallery of Scotland, Edinburgh, 1994

—(ed.), *Framing France: the Representation of Landscape in France, 1874–1914*. Manchester, 1998

Paris Architecture
Anthony Sutcliffe. *Paris: An Architectural Study*. New Haven and London, 1993

—'The Impressionists and Haussmann's Paris', *French Cultural Studies*, 1995, pp. 197–219

Techniques
*Bomford, David *et al.*, *Art in the Making. Impressionism*. Exh. cat., National Gallery, London, 1990

Callen, Anthea, *Techniques of the Impressionists*. London, 1982

ARTISTS
Bazille
Jourdan, Aleth *et al.*, *Frédéric Bazille: Prophet of Impressionism*. Exh. cat., Musée Fabre, Montpellier/ Brooklyn Museum of Art/ Dixon Gallery and Gardens, Memphis, 1992

Marandel, Patrice, *Fréderic Bazille and Early Impressionism*. Exh. cat., Art Institute of Chicago, 1978

Schulman, Michel, *Fréderic Bazille. Catalogue Raisonné*. Paris, 1995

Caillebotte
Berhaut, Marie, *Caillebotte. Sa Vie et son oeuvre*. Paris, 1978

*Groom, Gloria *et al.*, *Gustave Caillebotte: Urban Impressionist*. Exh. cat., Grand Palais, Paris/Art Institute of Chicago/Los Angeles County Museum of Art, 1996

Varnedoe, Kirk, *Gustave Caillebotte*. London and New Haven, 1987

—*et al.*, *Gustave Caillebotte: A Retrospective Exhibition*. Exh. cat., Houston Museum of Fine Arts/Brooklyn Museum of Art, 1976

Cassatt
*Barter, Judith A. and Erica Hirshler, *Mary Cassatt: Modern Woman*. Exh. cat., Art Institute of Chicago/Museum of Fine Arts, Boston/National Gallery of Art, Washington, D.C., 1998

Mathews, Nancy Mowll (ed.), *Cassatt and her Circle. Selected Letters*. New York, 1984

—*Mary Cassatt: A Retrospective*. New York, 1996

Pollock, Griselda, *Mary Cassatt*. London and New York, 1980

Cézanne
*Cachin, Françoise and Joseph Rishel, *Cézanne*. Exh. cat., Grand Palais, Paris/Tate Gallery, London/ Philadelphia Museum of Art, 1996

Cézanne, Paul, *Letters*. Edited by John Rewald, Oxford, 1976

Gowing, Lawrence, *Cézanne. The Early Years, 1859–1872*. Exh. cat., Royal Academy, London/Musée d'Orsay, Paris/National Gallery of Art, Washington, D.C., 1988

Kendall, Richard (ed.), *Cézanne by Himself*. London, 1988

Rewald, John and Walter Feilchenfeldt, *The Paintings of Paul Cézanne: A Catalogue Raisonné*. 2 vols., New York and London, 1996

Rubin, William (ed.), *Cézanne: The Late Work*. Exh. cat., Museum of Modern Art, New York, and London, 1977

*Shiff, Richard, *Cézanne and the End of Impressionism*. Chicago and London, 1984

Smith, Paul, *Interpreting Cézanne*. London, 1996

Degas
Armstrong, Carol, *Odd Man Out. Readings of the Work and Reputation of Edgar Degas*. London and Chicago, 1991

*Boggs, Jean Sutherland, *Degas*. Exh. cat., Grand Palais, Paris/National Gallery of Canada, Ottawa/ Metropolitan Museum of Art, New York, 1988

Brame, Philippe and Theodore Reff, *Degas et son oeuvre. A Supplement*. New York and London, 1984

Callen, Anthea, *The Spectacular Body: Science, Method and Meaning in the Work of Degas*. New Haven and London, 1995

Dumas, Ann *et al.*, *The Private Collection of Edgar Degas*. Exh. cat., Metropolitan Museum of Art, New York, 1997

Kendall, Richard (ed.), *Degas by Himself*. London, 1987

—and Griselda Pollock (eds.), *Dealings with Degas: Representations of Women and the Politics of Vision*. London, 1992

Lemoisne, Paul-André, *Degas et son oeuvre*. 4 vols., Paris, 1954

Lipton, Eunice, *Looking into Degas. Uneasy Images of Women and Modern Life*. California, 1986

Loyrette, Henri, *Degas*. Paris, 1991

Reff, Theodore, *Degas: The Artist's Mind*. London and New York, 1976

Guillaumin
Gray, Christopher, *Armand Guillaumin*. Chester, Conn., 1974

Serret, Gabriel and Dominique Fabiani, *Armand Guillaumin. Catalogue raisonné de l'oeuvre peint*. Vol. 1, Paris, 1971

Manet
Adler, Kathleen, *Manet*. Oxford, 1986

Brombert, Beth Archer, *Édouard Manet: Rebel in a Frock Coat*. Boston and London, 1996

*Cachin, Françoise *et al.*, *Manet, 1832–1883*. Exh. cat., Grand Palais, Paris/Metropolitan Museum of Art, New York, 1983

Hamilton, George Heard, *Manet and his Critics*. 2nd edn, New Haven and London, 1986

Reff, Theodore, *Manet and Modern Paris*. Exh. cat., National Gallery of Art, Washington, D.C., and London, 1982

Rouart, Denis and Daniel Wildenstein, *Édouard Manet: Catalogue Raisonné*. 2 vols., Lausanne and Paris, 1975

Wilson-Bareau, Juliet, *The Hidden Face of Manet: An Investigation of the Artist's Working Processes*. Exh. cat., Courtauld Institute Galleries, London, 1986

—(ed.), *Manet by Himself*. London, 1991

Monet
Adhémar, Hélène *et al.*, *Hommage à Claude Monet (1840–1926)*. Exh. cat., Grand Palais, Paris, 1980

Brenneman, David (ed.), *Monet and Bazille: A Collaboration*. Exh. cat., High Museum of Art, Atlanta, 1999

Forge, Andrew, *Monet*. Art Institute of Chicago, 1995

Hamilton, George Heard, *Claude Monet's Paintings of Rouen Cathedral*. London, 1960

Herbert, Robert L., *Monet on the Normandy Coast. Tourism and Painting, 1867–1886*. New Haven and London, 1994

—'Monet our Contemporary', *New York Review of Books*, 19 November 1998, pp. 18–22

*House, John, *Monet: Nature into Art.* London and New Haven, 1986

Isaacson, Joel, *Monet: Le Déjeuner sur l'herbe.* London and New York, 1972

—*Claude Monet: Observation and Reflection.* Oxford and New York, 1978

Kendall, Richard (ed.), *Monet by Himself.* London, 1989

Levine, Stephen, *Monet, Narcissus and Self-Reflection. The Modernist Myth of the Self.* Chicago, 1994

Claude Monet. Auguste Rodin. Centenaire de l'exposition de 1889. Exh. cat., Musée Rodin, Paris, 1989

Pickvance, Ronald *et al.*, *Monet in Holland.* Exh. cat., Rijksmuseum Vincent Van Gogh, Amsterdam, 1986

Pissarro, Joachim, *Monet and the Mediterranean.* Exh. cat., Kimbell Art Museum, Fort Worth/Brooklyn Museum of Art, 1997

Rouen, les Cathédrales de Monet. Exh. cat., Musée des Beaux-Arts, Rouen, 1994

*Spate, Virginia, *The Colour of Time.* Claude Monet.* London and New York, 1992

Stuckey, Charles, *Claude Monet, 1840–1926.* London and New York, 1995

Tucker, Paul, *Monet at Argenteuil.* New Haven and London, 1982

—*Monet in the '90s. The Series Paintings.* Exh. cat., Museum of Fine Arts, Boston/Royal Academy, London, 1989

—*Claude Monet. Life and Art.* New Haven and London, 1995

—*et al.*, *Monet in the Twentieth Century.* Exh. cat., Museum of Fine Arts, Boston/Royal Academy, London, 1998

Wildenstein, Daniel, *Claude Monet. Catalogue Raisonné.* Lausanne and Paris, vol. I (1974), vols. II and III (1979), vols. IV and V (1991). For correspondence, see vol. V. Reprinted in four vols. by Taschen, 1996

Morisot

Adler, Kathleen and Tamar Garb (eds.), *Correspondence of Berthe Morisot,* London, 1986

—*Berthe Morisot.* Oxford, 1987

Clairet, Alain *et al.*, *Berthe Morisot. Catalogue raisonné de l'oeuvre peint.* Paris, 1997

Delafond, Marianne and Caroline Genet-Bondeville, *Berthe Morisot ou l'audace raisonnée: Fondation Denis et Annie Rouart.* Paris, 1997

Edelstein, Terry J. (ed.), *Perspectives on Morisot.* New York, 1990

Higonnet, Anne, *Berthe Morisot. A Biography.* Berkeley and London, 1990

—*Berthe Morisot's Images of Women.* Cambridge, Mass., and London, 1992

*Stuckey, Charles and William Scott, *Berthe Morisot, Impressionist.* Exh. cat., National Gallery, Washington, D.C./Mount Holyoke College Art Museum, 1987

Pissarro

Bailly-Herzberg, Janine (ed.), *Correspondance de Camille Pissarro.* 5 vols., Paris, 1980–91

Brettell, Richard and Christopher Lloyd, *A Catalogue of the Drawings by Camille Pissarro in the Ashmolean Museum.* Oxford, 1980

*Brettell, Richard, *Pissarro and Pontoise. The Painter in a Landscape.* London and New Haven, 1990

—and Joachim Pissarro, *The Impressionist and the City. Pissarro's Series Paintings.* Exh. cat., Dallas Museum of Art/Philadelphia Museum of Art/Royal Academy, London, 1992

Lloyd, Christopher, *Camille Pissarro.* Oxford, 1979

—(ed.), *Studies on Camille Pissarro.* London, 1986

Camille Pissarro, 1830–1903. Exh. cat., Arts Council, London, 1980

Pissarro, Joachim, *Camille Pissarro.* London, 1993

Rewald, John (ed.), *Camille Pissarro: Letters to His Son Lucien.* New York and London, 1943

Shapiro, Barbara Stern, *Camille Pissarro: Impressionist Printmaker.* Exh. cat., Museum of Fine Arts, Boston, 1973

Shikes, Ralph and Paula Harper, *Pissarro. His Life and Work.* London and New York, 1980

Thomson, Richard, *Camille Pissarro: Impressionism, Landscape and Rural Labour.* Exh. cat., South Bank Centre, London, and New York, 1990

Thorold, Anne, *Artists, Writers, Politics: Camille Pissarro and His Friends.* Exh. cat., Ashmolean Museum, Oxford, 1980

—(ed.), *The Letters of Lucien to Camille Pissarro, 1883–1903.* Cambridge, 1993

Renoir

*Bailey, Colin B. *et al.*, *Renoir's Portraits. Impressions of an Age.* Exh. cat., National Gallery of Canada, Ottawa/Art Institute of Chicago/Kimbell Art Museum, Fort Worth, 1997

Callen, Anthea, *Renoir.* London, 1978

Cooper, Douglas, 'Renoir, Lise and the Le Coeur Family', *Burlington Magazine*, May 1959, pp. 163–71; September and October 1959, pp. 322–28

Daulte, François, *Auguste Renoir. Catalogue Raisonné. I. Figures, 1860–90.* Lausanne and Paris, 1971

Druick, Douglas W., *Renoir.* Art Institute of Chicago, 1997

House, John *et al.*, *Renoir. Master Impressionist.* Exh. cat., Queensland Art Gallery, Brisbane/National Gallery of Victoria, Melbourne/Art Gallery of New South Wales, Sydney, 1994

Kern, Stephen *et al.*, *A Passion for Renoir. Sterling and Francine Clark Collect, 1916–1951.* Exh. cat., Clark Art Institute, Williamstown, 1996

Rathbone, Eliza E., *Impressionists on the Seine: A Celebration of Renoir's 'Luncheon of the Boating Party'.* Exh. cat., The Phillips Collection, Washington, D.C., 1996

Renoir. Exh. cat., Hayward Gallery, London/Grand Palais, Paris/Museum of Fine Arts, Boston, 1985

White, Barbara Ehrlich, *Renoir. His Life, Art and Letters.* New York, 1984

Sisley

Daulte, François, *Alfred Sisley. Catalogue Raisonné.* Lausanne and Paris, 1959

Shone, Richard, *Alfred Sisley.* London, 1992

*Stevens, MaryAnne (ed.), *Alfred Sisley.* Exh. cat., Royal Academy, London/Musée d'Orsay, Paris/Walters Art Gallery, Baltimore, 1992

List of Illustrations

71. **Pissarro,** *The Road to Louveciennes at the Outskirts of the Forest,* 1871, oil on canvas, 110 x 160 cm (43⅜ x 63 in.) Private collection.

72. **Cézanne,** *View of Louveciennes,* 1872, oil on canvas, 73 x 92.1 (28¾ x 36¼ in.) Private collection.

73. **Renoir,** *The Engaged Couple, c.* 1868, oil on canvas, 106 x 74 cm (41½ x 29 in.) Wallraf-Richartz-Museum, Cologne.

74. **Gauguin,** *Mette Gauguin in Evening Dress,* 1884, oil on canvas, 65 x 54.3 cm (25⅝ x 21⅜ in.) Nasjonalgalleriet, Oslo.

75. **Pissarro,** *Madame Pissarro Sewing, c.* 1885, oil on canvas, 54 x 45 cm (21¼ x 17¾ in.) Ashmolean Museum, University of Oxford.

76. Photograph of Eugène Manet, Berthe Morisot and their daughter, 1880. Musée Marmottan – Claude Monet, Paris. Photo Giraudon.

77. **Morisot,** *Eugène Manet and His Daughter in the Garden at Bougival,* 1881, oil on canvas, 73 x 92 cm (28¾ x 36¼ in.) Private collection, Paris.

78. **Manet,** *Portrait of Victorine Meurent,* 1862, oil on canvas, 43 x 43 cm (16⅞ x 16⅞ in.) Museum of Fine Arts, Boston.

79. **Jongkind,** *View of the Schie,* 9 September 1867, watercolour, 17.7 x 29.5 cm (7 x 11⅝ in.) Museum Boijmans van Beuningen, Rotterdam.

80. **Monet,** *A Mill near Zaandam,* 1871, oil on canvas, 43 x 73 cm (16⅞ x 28¾ in.) Ashmolean Museum, University of Oxford.

81. **Monet,** *Headland of the River Hève at Low Tide,* 1865, oil on canvas, 90.2 x 150.5 cm (35½ x 59¼ in.) Kimbell Art Museum, Fort Worth, Texas.

82. Fashion plate from *La Mode de Paris,* 1 September 1864, coloured engraving. Courtesy of Belinda Thomson.

83. **Claude Monet,** *Women in the Garden,* 1866, oil on canvas, 256 x 208 cm (100⅞ x 82 in.) Musée d'Orsay, Paris.

84. **Perin,** *Group on the Steps of the Villa Stéphanie at Baden, c.* 1865, photograph Musée d'Art Moderne et Contemporain de Strasbourg – Collections photographiques.

85. **Bazille,** *Family Reunion,* 1867, oil on canvas, 152 x 230 cm (59¾ x 90½ in.) Musée d'Orsay, Paris. Photo Giraudon.

86. **Bazille,** *View of the Village,* 1868, oil on canvas, 130 x 89 cm (51¼ x 35 in.) Musée Fabre, Montpellier.

87. **Bazille,** *View of the Village,* 1868, black chalk on paper, 30 x 20.7 cm (11¾ x 8⅛ in.) Cabinet des Dessins du Louvre, Paris

88. **Édouard Manet,** *The Balcony,* 1868–69, oil on canvas, 170 x 124 cm (66⅞ x 48⅞ in.) Musée d'Orsay, Paris.

89. **Pons,** caricature of Manet's *The Balcony,* from *La Parodie,* no. 1, 1869. Photo Bibliothèque national de France, Paris.

90. **Monet,** *On the Banks of the Seine at Bennecourt,* 1868, oil on canvas, 81.5 x 100.7 cm (32⅛ x 39⅝ in.) Mr and Mrs Potter Palmer Collection 1922.427. Photograph © 2000, The Art Institute of Chicago, All Rights Reserved.

91. **Boudin,** *Jetty at Trouville,* 1865, panel, 34 x 58 cm (13¾ x 22⅞ in.) Collection of Mr and Mrs Paul Mellon

92. **Monet,** *The Beach at Sainte-Adresse,* 1867, oil on canvas, 75.8 x 102.5 cm (29⅞ x 40⅜ in.) Mr and Mrs Lewis Larned Coburn Memorial Collection, 1933.439. Photograph © 2000, The Art Institute of Chicago, All Rights Reserved.

93. **Renoir,** *La Grenouillère,* 1868, oil on canvas, 65 x 92 cm (25⅝ x 36¼ in.) Oskar Reinhart Collection, Am Römerholz, Winterthur.

94. **Monet,** *Bathers at La Grenouillère,* 1869, oil on canvas, 73 x 92 cm (28¾ x 36¼ in.) © National Gallery, London.

95. **Monet,** *The Thames below Westminster,* 1871, oil on canvas, 47 x 72.5 cm (18½ x 28½ in.) © National Gallery, London.

96. **Monet,** *Beach at Trouville,* 1870, oil on canvas, 55.9 x 57.5 cm (22 x 22⅝ in.) The Ella Gallup Sumner and Mary Catlin Sumner Collection Fund. Wadsworth Atheneum, Hartford.

97. **Pissarro,** *L'Hermitage at Pontoise,* 1867, oil on canvas, 90 x 150 cm (35⅜ x 59 in.) Wallraf-Richartz-Museum, Cologne. Photo Rheinisches Bildarchiv Cologne.

98. **Pissarro,** *Lordship Lane Station, Upper Norwood, London,* 1871, oil on canvas, 45 x 74 cm (17¾ x 29 in.) Courtauld Institute Galleries, London.

99. **Pissarro,** *Kitchen Gardens at L'Hermitage, Pontoise,* 1874, oil on canvas, 54 x 65.1 cm (21¼ x 25⅝ in.) National Gallery of Scotland.

100. **Renoir,** *Portrait of Madame Pierre-Henri Renoir,* 1870, oil on canvas, 81.3 x 64.8 cm (32 x 25½ in.) Courtesy of the Fogg Art Museum, Harvard University Art Museums, Bequest of Grenville L. Winthrop. © President and Fellows of Harvard College, Harvard University Art Museums. Photo Photographic Services

101. **Renoir,** *At the Inn of Mother Anthony,* 1866, oil on canvas, 195 x 130 cm (76½ x 51 in.) Nationalmuseum, Stockholm.

102. **Renoir,** *Portrait of Claude Monet,* 1875, oil on canvas, 85 x 60.5 cm (33½ x 23⅝ in.) Musée d'Orsay, Paris.

103. **Monet,** *The Museum at Le Havre,* 1873, oil on canvas, 100 x 75 cm (39⅜ x 29½ in.) © National Gallery, London.

104. **Degas,** *Young Spartans Exercising,* 1860, oil on canvas, 109.2 x 154.3 cm (43 x 60¾ in.) © National Gallery, London.

105. **Degas,** *The Triumph of Flora, c.* 1860, pen and ink and wash on off-white laid paper, 23.5 x 32 cm (9¼ x 12⅝ in.) Private collection, Zurich.

106. **Degas,** *Orchestra Musicians, c.* 1870, oil on canvas, 56.5 x 46.2 cm (22¼ x 18¼ in.) Musée d'Orsay, Paris.

107. **Degas,** *The Bellelli Family,* 1858–67, oil on canvas, 200 x 250 cm (78¾ x 98⅜ in.) Musée d'Orsay, Paris.

108. **Degas,** *Giulia Bellelli,* 1858–59, essence on buff wove paper mounted on panel, 38.5 x 26.7 cm (15⅛ x 10½ in.) Dumbarton Oaks Research Library and Collection, Washington, D.C.

109. **Degas,** *A Gentleman Amateurs' Race: Before the Start,* 1862, reworked *c.* 1882, oil on canvas, 48 x 61 cm (19 x 24 in.) Musée d'Orsay, Paris.

110. **Manet,** *The Execution of Emperor Maximilian,* 1868–69, but dated 19 June 1867, oil on canvas, 252 x 305 cm (99¼ x 120 in.) Kunsthalle, Mannheim.

111. **Degas,** *The Pedicure,* 1873, essence on paper mounted on canvas, 61 x 46 cm (24 x 18⅛ in.) Musée d'Orsay, Paris.

112. **Tissot,** *Lady on a Couch,* 1873/6, gouache over black chalk on green/blue paper, 22 x 28.8 cm (8⅝ x 11⅜ in.) Ashmolean Museum, University of Oxford.

113. **Monet,** *Rue Saint-Denis Decked out with Flags,* 1878, oil on canvas, 62 x 34 cm (21¼ x 13 in.) Musée des beaux-arts, Rouen. © Photo RMN – Gérard Blot.

114. **Sisley,** *Early Snow at Louveciennes, c.* 1871–72, oil on canvas, 54.8 x 73.8 cm (21⅝ x 29 in.) Museum of Fine Arts, Boston. Bequest of John T. Spaulding.

115. **Manet,** *Civil War,* 1873, lithograph, 39.9 x 50.8 cm (15¾ x 20 in.) Photo Bibliothèque nationale de France, Cabinet des Estampes, Paris.

116. Title page of the catalogue to the first exhibition of the Anonymous Society of Painters, Sculptors, Engravers, etc., 1874. Photo Bibliothèque nationale de France, Paris.

117. **Cézanne,** *A Modern Olympia,* 1872–73, oil on canvas, 47 x 55.9 cm (18½ x 22 in.) Musée d'Orsay, Paris.

118. **Morisot,** *The Cradle,* 1872, oil on canvas, 56 x 46 cm (22 x 18⅛ in.) Musée d'Orsay, Paris.

119. **Monet,** *Impression, Sunrise,* 1873, postdated 1872, oil on canvas, 48 x 63 cm (18⅞ x 24⅞ in.) Musée Marmottan, Paris. Photo Studio Lourmel.

120. **Pissarro,** *Hoar Frost,* 1873, oil on canvas, 65 x 93 cm (25⅝ x 36⅝ in.) Musée d'Orsay, Paris. Eduardo Mollard Bequest, 1972.

121. **Monet,** *Hyde Park,* 1871, oil on canvas, 40 x 73.3 cm (15¾ x 28⅞ in.) Museum of Art, Rhode Island School of Design, Providence. Gift of Mrs Murray S. Danforth.

122. **Pissarro,** *Piette's House at Montfoucault,* 1874, oil on canvas, 45.9 x 67.6 cm (18 x 26⅝ in.) © Sterling and Francine Clark Art Institute, Williamstown, Massachusetts.

123. **Piette,** *The Marketplace in front of the Town Hall at Pontoise,* 1876, oil on canvas, 111 x 186 cm (43¾ x 73¼ in.) Musées de Pontoise, Pontoise.

124. **Degas,** *The Dance Class,* 1874–75, oil on canvas, 85 x 75 cm (33½ x 29½ in.) Musée d'Orsay, Paris.

125. **Caillebotte,** *The Pont de l'Europe,* 1876, oil on canvas, 125 x 180 cm (49¼ x 70⅞ in.) Musée du Petit Palais, Geneva.

126. **Sisley,** *Flood at Port-Marly,* 1876, oil on canvas, 50 x 61 cm (19⅝ x 24 in.) Musée des beaux-arts, Rouen.

127. **Renoir,** *Nude in Sunlight,* 1876, oil on canvas, 81 x 64.8 cm (31⅞ x 25½ in.) Musée d'Orsay, Paris.

128. Title page of *L'Impressionniste,* in *Journal d'art,* 21 April 1877. Photo Bibliothèque nationale de France, Paris.

129. **Renoir,** *The Ball at the Moulin de la Galette,* 1876, oil on canvas, 131 x 175 cm (51½ x 68¾ in.) Musée d'Orsay, Paris. © Photo RMN – Hervé Lewandowski.

130. **Cézanne,** *Head of a Man, Study,* 1876–77, oil on canvas, 45.7 x 36.8 cm (18 x 14½ in.) Private collection, New York.

131. **Cham,** *Madame! That Wouldn't be Wise. Keep Away!* from *Le Charivari,* 16 April 1877. Photo Bibliothèque nationale de France, Paris.

132. **Renoir,** *Portrait of Madame Alphonse Daudet,* 1876, oil on canvas, 46 x 38 cm (18⅛ x 15 in.) Musée d'Orsay, Paris. © Photo RMN – Bellot/Ojeda.

133. **Morisot,** *Lady at Her Toilet, c.* 1875, oil on canvas, 60.3 x 80.4 cm (23¾ x 31⅝ in.) Stickney Fund, 1924.127. Photograph © 2000, The Art Institute of Chicago, All Rights Reserved.

134. **Guillaumin,** *The Arcueil Aqueduct at Sceaux Railroad Crossing, c.* 1874, oil on canvas, 51.4 x 65 cm (20¼ x 25⅝ in.) Restricted gift of Mrs Clive Runnells, 1970.95. Photograph © 2000, The Art Institute of Chicago, All Rights Reserved.

135. **Monet,** *Floating Ice,* 1880,
oil on canvas, 97 x 151 cm (38¼ x 59½ in.)
Shelburne Museum, Shelburne,
Vermont.

136. **Monet,** Poster for the Fifth Impressionist
Exhibition, 1880.

137. **Cassatt,** *Woman in a Loge,* 1878–79,
oil on canvas, 80.2 x 58.2 cm (31⅝ x 22⅞ in.)
Philadelphia Museum of Art, Philadelphia.

138. **Caillebotte,** *In a Café,* 1880, oil on canvas,
153 x 114 cm (60¼ x 44⅞ in.) Musée des
beaux-arts, Rouen.

139. **Raffaëlli,** *The Absinthe Drinkers,* 1881, oil
on canvas, 110.2 x 110.2 cm (43⅜ x 43⅜ in.)
Private collection, Philadelphia.

140. **Forain,** *The Encounter in the Foyer,*
1877, gouache on paper, 34.3 x 21.6 cm
(13½ x 8½ in.) Private collection, London.
© ADAGP, Paris and DACS,
London 2000.

141. **Morisot,** *Nice Harbour,* 1882, marouflage
oil on canvas, 53 x 43 cm (20⅞ x 16⅞ in.)
Musée Marmottan – Claude Monet, Paris.
Photo – Giraudon.

142. **Draner,** *Visiting the Impressionists,*
from *Le Charivari,* 9 March 1882.

143. Poster for the Eighth Impressionist
Exhibition, 1886.

144. **Cassatt,** *Children on the Shore,* 1884,
oil on canvas, 97.6 x 74 cm (38⅜ x 29⅛ in.)
National Gallery of Art, Washington, D.C.

145. **Gauguin,** *Near the Farm,* 1885, oil on
canvas, 55.9 x 100.3 cm (22 x 39½ in.)
The Joan Whitney Payson Gallery of
Art, Westbrook College, Portland,
Maine. The Joan Whitney Payson
Collection.

146. **Guillaumin,** *Twilight at Damiette,* 1885,
oil on canvas, 72 x 139 cm (24⅜ x 54¾ in.)
Musée du Petit Palais, Geneva.

147. **Cézanne,** *Impression from Nature,*
c. 1877, pencil, watercolour and gouache
on paper, 23 x 34.5 cm (9 x 13⅝ in.)
Städelsches Kunstinstitut, Frankfurt
am Main. Photograph © Ursula
Edelmann, Frankfurt am Main.

148. **Degas,** *Miss La La at the Cirque
Fernando,* 1879, oil on canvas,
116.8 x 77.5 cm (46 x 30½ in.)
© National Gallery, London.

149. **Sisley,** *Barges on the Canal Saint-Martin,*
1870, oil on canvas, 55 x 74 cm (21⅝ x 29 in.)
Am Römerholz, Oskar Reinhardt Collection,
Winterthur.

150. **Morisot,** *Boats under Construction,* 1874,
oil on canvas, 32 x 41 cm (12⅝ x 16⅛ in.)
Musée Marmottan – Claude Monet, Paris.
Photo – Giraudon.

151. **Cassatt,** *Mrs Cassatt Reading to
Her Grandchildren,* 1880, oil on canvas,
55.9 x 100.3 cm (22 x 39½ in.) Private
collection.

152. **Monet,** *Rouen Cathedral,* 1894, oil on
canvas, 107 x 73 cm (42⅛ x 28¾ in.) Musée
d'Orsay, Paris. © Photo RMN – Hervé
Lewandowski.

153. **Monet,** *Rouen Cathedral,* 1894, oil on
canvas, 100 x 73 cm (39⅜ x 28¾ in.) Musée
des beaux-arts, Rouen.

154. Photograph of Pissarro at Éragny, late
1890s. Ashmolean Pissarro Collection,
Oxford, Bensusan-Butt Gift.

155. **Pissarro,** *Factory near Pontoise,* 1873,
oil on canvas, 39 x 47 cm (15⅜ x 18½ in.)
Earl of Jersey Collection, Jersey, Channel
Islands.

156. **Pissarro,** *Justice Path at Pontoise,*
c. 1872, oil on canvas, 52.4 x 81.6 cm
(20⅝ x 32⅛ in.) Memphis Brooks Museum
of Art, Memphis. Gift of Mr and Mrs Hugo
N. Dixon 53.60.

157. **Monet,** *The Railroad Bridge at
Argenteuil,* 1874, oil on canvas, 54 x 71.4 cm
(21¼ x 28⅛ in.) The John G. Johnson
Collection at the Philadelphia Museum
of Art, Philadelphia.

158. **Monet,** *Boulevard Saint-Denis, Argenteuil,
in Winter,* 1875, oil on canvas, 60.9 x 81.5 cm
(24 x 32⅛ in.) Courtesy, Museum of Fine Arts,
Boston. Gift of Richard Saltonstall.

159. **Renoir,** *Woman with a Parasol in a
Garden,* c. 1874, oil on canvas, 54.5 x 65 cm
(21½ x 25¾ in.) Fundación Colección
Thyssen-Bornemisza, Madrid.

160. **Morisot,** *Eugène Manet on the Isle of Wight,*
1875, oil on canvas, 38 x 46 cm (15 x 18⅛ in.)
Musée Marmottan, Paris.

161. **Degas,** *A Woman Ironing,* 1873, oil
on canvas, 54.3 x 39.4 cm (21⅜ x 15½ in.)
The Metropolitan Museum of Art, New York.
Bequest of Mrs H. O. Havemeyer, 1929. H. O.
Havemeyer Collection (29.100.46).

162. **Caillebotte,** *Still Life with Oysters,* 1880–82,
oil on canvas, 38 x 55 cm (15 x 21⅝ in.) Private
collection.

163. **Hadol,** *La Semaine comique,* from *L'Éclipse*
26 April 1874. Photo Bibliothèque nationale
de France, Paris.

164. **Morisot,** *In a Villa by the Seaside,* 1874,
oil on canvas, 51 x 61 cm (20⅛ x 24 in.)
Pasadena Museum of Art, Norton Simon
Foundation.

165. **Morisot,** *Summer's Day,* 1879, oil on
canvas, 45.7 x 75.2 cm (18 x 29⅝ in.) ©
National Gallery, London.

166. Fashion plate from *L'Illustrateur des dames,*
c. 1872, coloured engraving. Courtesy of
Belinda Thomson.

167. **Bracquemond,** *Teatime,* 1880, oil on
canvas, 81.5 x 61.5 cm (32 x 24½ in.) Musées
de la ville de Paris, Petit Palais, Paris.

168. **Cassatt,** *Susan on a Balcony Holding a
Dog,* c. 1883, oil on canvas, 100.3 x 64.7 cm
(39½ x 25½ in.) Corcoran Gallery of Art,
Museum Purchase, Gallery Fund,
Washington, D.C.

169. **Cabanel,** *Birth of Venus,* 1863, oil
on canvas, 130 x 225 (51⅝ x 88½ in.)
Musée d'Orsay, Paris.

170. **Manet,** *Nana,* 1877, oil on canvas,
154 x 115 cm (60⅝ x 45¼ in.) Kunsthalle,
Hamburg.

171. **Renoir,** *Blonde Bather,* 1881, oil on canvas,
81.8 x 65.7 cm (32¼ x 25⅞ in.) © Sterling and
Francine Clark Art Institute, Williamstown,
Massachusetts.

172. **Cézanne,** *Three Bathers,* 1879–82, oil on
canvas, 53 x 55 cm (20¾ x 21⅝ in.) Musée du
Petit Palais, Paris.

173. **Degas,** *Breakfast after the Bath,* c. 1895–98,
pastel, 121 x 92 cm (47⅝ x 36¼ in.) Private
collection.

174. **Pissarro,** *Bather in the Woods,* 1895,
oil on canvas, 60.3 x 73 cm (23¾ x 28¾ in.)
The Metropolitan Museum of Art, New York.
Bequest of Mrs H. O. Havemeyer, 1929.
The H. O. Havemeyer Collection.

175. **Gauguin,** *Suzanne Sewing,* 1880, oil
on canvas, 115 x 80 cm (45¼ x 31½ in.)
Ny Carlsberg Glyptotek, Copenhagen.

176. **Bracquemond,** *Portrait of Monsieur
Edmond de Goncourt,* 1880, charcoal on canvas,
55 x 37.9 cm (215/8 x 147/8 in.) Cabinet des
Dessins, Musée du Louvre, Paris.

177. **Renoir,** *Man on a Staircase,* c. 1876, oil
on canvas, 167.5 x 65.3 cm (65⅞ x 25¾ in.)
The State Hermitage Museum,
St Petersburg.

178. **Renoir,** *Woman on a Staircase,* c. 1876,
oil on canvas, 167.5 x 65.3 cm (65⅞ x 25¾ in.)
The State Hermitage Museum,
St Petersburg.

179. **Renoir,** *Madame Charpentier and
Her Children,* 1878, oil on canvas,
153 x 189 cm (60½ x 74½ in.) The
Metropolitan Museum of Art, New York.
The Wolfe Fund, 1907, Catherine Lorillard
Wolfe Collection.

180. **Renoir,** *The Loge,* 1874, oil on canvas,
80 x 63.5 cm (31½ x 25 in.) Courtauld
Institute Galleries, London.

181. **Caillebotte,** *Woman at the Window,* 1880,
oil on canvas, 116 x 89 cm (45⅝ x 35 in.)
Private collection, Paris.

182. **Degas,** *Interior,* 1868–69, oil on canvas,
81 x 116 cm (31⅞ x 45⅝ in.) Philadelphia
Museum of Art. The Henry P. McIlhenny
Collection. In memory of Frances
P. McIlhenny (1986-26-10)

183. **Degas,** *Absinthe,* 1875–76, oil on canvas,
92 x 68 cm (36¼ x 26¾ in.) Musée d'Orsay,
Paris. © Photo RMN.

184. **Degas,** *Dancer (Adjusting Her Shoulder
Strap),* late 1895 or 1896, modern gelatin
silver paint from the original negative,
17.9 x 12.9 cm (7 x 5⅛ in.) Photo
Bibliothèque nationale de France, Paris.

185. **Degas,** *Café-Concert Singers,* 1877–78,
pencil, 16.2 x 12.2 cm (6⅜ x 4¾ in.) Private
collection.

186. **Degas,** *The Song of the Dog,* c. 1876–77,
oil on canvas, gouache and pastel over
monotype on three pieces of paper joined,
57.5 x 45.4 cm (22⅝ x 17⅞ in.) Private
collection, Los Angeles (on loan to the
J. Paul Getty Museum).

187. **Degas,** *Three Prostitutes Seated,* c. 1879,
pastel over monotype, 16 x 21.5 cm (6¼ x 8½ in.)
Rijksmuseum, Amsterdam.

188. **Degas,** *The Dance Class,* c. 1880, oil on
canvas, 81.4 x 76.3 cm (32⅛ x 30¼ in.)
Philadelphia Museum of Art, W. P. Wilstach
Collection.

189. **Degas,** *The Famous Good Friday
Dinner,* 1876–77, black ink on china paper,
mounted, 21.1 x 15.7 cm (8½ x 6¼ in.)
Graphische Sammlung der Staatsgalerie
Stuttgart.

190. **Degas,** *At the Milliner's,* 1882, pastel
on pale grey wove paper, 75.6 x 85.7 cm
(29¾ x 33¾ in.) The Metropolitan Museum
of Art, New York. Bequest of Mrs H. O.
Havemeyer, 1929. The H. O. Havemeyer
Collection.

191. **Degas,** *Woman Bathing in a Shallow
Tub,* 1885, charcoal and pastel on pale green
wove paper now discoloured to warm grey,
81.5 x 56 cm (32 x 22 in.) The Metropolitan
Museum of Art, New York. Bequest of Mrs H.
O. Havemeyer, 1929. The H. O. Havemeyer
Collection.

192. **Monet,** *The Seine at Argenteuil,* 1875, oil on
canvas, 59.7 x 81.3 cm (23¾ x 31¾ in.) Present
whereabouts unknown.

193. **Béraud,** *Avenue des Champs-Élysées,* c. 1885,
oil on canvas, 147.6 x 106.4 cm (58⅛ x 41⅞ in.)
Private collection. © ADAGP, Paris and
DACS, London 2000.

194. **Gérôme,** *Phryne before the Areopagus,* 1861,
oil on canvas, 80 x 128 cm (31½ x 50⅜ in.)
Photo © Elke Walford, Hamburg. Courtesy
of the Hamburger Kunsthalle, Hamburg.

195. **Degas,** *The Cotton Office, New Orleans,*
1873, oil on canvas, 73 x 92 cm (28¾ x 36¼ in.)
Musée des beaux-arts, Pau.

196. **Degas,** *Yellow Dancers (In the Wings),*
1974–76, oil on canvas, 73.5 x 59.5 cm
(28⅞ x 23⅜ in.) Gift of Mr and Mrs
Gordon Palmer, Mr and Mrs Arthur
M. Wood and Mrs Bertha P. Thorne,
1963.923. Photograph © 2000, The
Art Institute of Chicago, All Rights
Reserved.

197. Degas, *Portrait of Edmond Duranty,* 1879, tempera and pastel on canvas, 100 x 100 cm (39½ x 39½ in.) Glasgow Museums. The Burrell Collection.

198. Caillebotte, *Man at a Window,* 1880, oil on canvas, 117 x 90 cm (46⅛ x 35⅜ in.) Private collection.

199. Degas, *Place de la Concorde,* 1875, oil on canvas, 79 x 118 cm (31⅛ x 46½ in.) The State Hermitage Museum, St Petersburg.

200. Degas, *The Dance Exam, c.* 1879, pastel and charcoal on heavy grey wove paper, 63.4 x 48.2 cm (25 x 19 in.) Denver Art Museum, Denver. Anonymous gift, 1941.

201. Busson, *The Village of Lavardin, c.* 1877, oil on canvas, 17.5 x 22 cm (6⅞ x 8⅝ in.) Photo Musées d'Angers, Angers.

202. Cézanne, *Small Houses at Auvers, c.* 1873–74, oil on canvas, 39.4 x 53.3 cm (15½ x 21 in.) Courtesy of the Fogg Art Museum, Harvard University Art Museums, Bequest of Annie Swan Coburn. Photo Rick Stafford. © President and Fellows of Harvard College, Harvard University Art Museums.

203. Manet, *Argenteuil,* 1874, oil on canvas, 149 x 115 cm (58⅝ x 45¼ in.) Musée des beaux-arts, Tournai.

204. Manet, *Monet in His Studio Boat,* 1874, oil on canvas, 81.3 x 99.7 cm (32 x 39¼ in.) Neue Pinakothek, Bayerische Staatsgemäldesammlungen, Munich.

205. Manet, *The Seine at Argenteuil,* 1874, oil on canvas, 61 x 101 cm (24 x 39¾ in.) Courtauld Institute Galleries, London.

206. Mars, *An Impressionist about to Begin a Painting,* from *Le Journal amusant,* 30 April 1881. Photo Bibliothèque nationale de France, Paris.

207. Renoir, *Two Sisters (On the Terrace),* 1881, oil on canvas, 100.5 x 81 cm (39⅝ x 31⅞ in.) Mr and Mrs Lewis Larned Coburn Memorial Collection, 1933.455. Photograph © 2000, The Art Institute of Chicago, All Rights Reserved.

208. Manet, *Skating,* 1877, oil on canvas, 88.3 x 69.9 cm (34⅞ x 27½) Courtesy of the Fogg Art Museum, Harvard University Art Museums, Bequest from the Collection of Maurice Wertheim, Class of 1906. Photo Rick Stafford. © President and Fellows of Harvard College, Harvard University Art Museums.

209. Manet, *A Bar at the Folies-Bergère,* 1882, oil on canvas, 96 x 130 cm (37¾ x 51⅛ in.) Courtauld Institute Galleries, London.

210. Chéret, *At the Folies-Bergère,* 1875, colour lithograph, 54.5 x 44 cm (21½ x 17⅜ in.) Photo Musée de la Publicité, Paris. All Rights Reserved. © ADAGP, Paris and DACS, London 2000.

211. Monet, *The Gare Saint-Lazare,* 1877, oil on canvas, 80.3 x 98.1 cm (31⅝ x 38⅝ in.) Courtesy of the Fogg Art Museum, Harvard University Art Museums, Bequest from the Collection of Maurice Wertheim, Class of 1906. Photo David Mathews. © President and Fellows of Harvard College, Harvard University Art Museums.

212. Monet, *Rough Sea, Étretat,* 1883, oil on canvas, 81 x 100 cm (31⅞ x 39⅜ in.) Musée des beaux-arts, Lyon.

213. Monet, *Lavacourt under Snow,* 1881, oil on canvas, 59.7 x 80.6 cm (23½ x 31¾ in.) © National Gallery, London.

214. Sisley, *Molesey Weir, Hampton Court,* 1874, oil on canvas, 51.1 x 68.8 cm (20⅛ x 27⅛ in.) National Gallery of Scotland.

215. Sisley, *Boatyard at Saint-Mammès,* 1885, oil on canvas, 54.9 x 73.3 cm (21⅝ x 28⅞ in.) Columbus Museum of Art, Ohio.

216. Degas, *Mary Cassatt at the Louvre,* 6th and final state, 1879/80, etching, aquatint and crayon, 26.7 x 23.2 cm (10½ x 9⅛ in.) Staatliche Museen zu Berlin – Preussischer Kulturbesitz Nationalgalerie.

217. Cassatt, *Interior Scene,* 1879–80, softground etching, aquatint and drypoint on cream laid paper, 39.7 x 31 cm (15⅝ x 12¼ in.) National Gallery of Art, Washington, D.C.

218. Pissarro, *The Côte des Boeufs at L'Hermitage,* 1877, oil on canvas, 114.9 x 87.6 cm (45¼ x 34½ in.) © National Gallery, London.

219. Pissarro, *Wooded Landscape at L'Hermitage,* 5th state of five, 1879, softground etching, aquatint, and drypoint on ivory laid paper, 22 x 27 cm (8⅝ x 10⅝ in.) Museum of Fine Arts, Boston.

220. Pissarro, *Landscape at Chaponval,* 1880, oil on canvas, 54 x 65 cm (21¼ x 25½ in.) Musée d'Orsay, Paris.

221. Morisot, *Copy of Detail from Boucher's 'Venus at Vulcan's Forge',* 1884, oil on canvas, 114 x 138 cm (44⅞ x 54⅜ in.) Courtesy of the Galerie Hopkins-Thomas-Custot, Paris. Private collection, USA.

222. Renoir, *The Bathers, c.* 1887, oil on canvas, 117.7 x 170.8 cm (46⅜ x 67¼ in.) Philadelphia Museum of Art, Philadelphia.

223. Renoir, *Portrait of Paul Durand-Ruel,* 1910, oil on canvas, 65 x 54 cm (25⅝ x 21¼ in.) Photo courtesy Archives Durand-Ruel, Paris.

224. Manet, *Departure of the Folkestone Boat,* 1869, oil on canvas, 59 x 71 cm (23¼ x 28 in.) Philadelphia Museum of Art. Mr and Mrs Carrroll S. Tyson Collection (63.116.10)

225. Sisley, *The Bridge at Hampton Court,* 1874, oil on canvas, 46 x 61 cm (18⅛ x 24 in.) Wallraf-Richartz-Museum, Cologne.

226. Pissarro, *Factories and Barrage at Pontoise,* 1872, oil on canvas, 55 x 91 cm (21⅝ x 35⅞ in.) Lucille Ellis Simon Collection, Los Angeles. Photo Rheinisches Bildarchiv.

227. Renoir, *Portrait of Madame Victor Chocquet,* 1875, oil on canvas, 75 x 60 cm (29½ x 23⅝ in) Staatsgalerie, Stuttgart.

228. Renoir, *A Girl with a Fan,* 1881, oil on canvas, 65 x 54 cm (25½ x 21¼ in.) © Sterling and Francine Clark Art Institute, Williamstown, Massachusetts.

229. Merle, *Portrait of Paul Durand-Ruel,* 1866, oil on canvas, 113 x 81.5 cm (44½ x 32⅛ in.) Photo courtesy Archives Durand-Ruel, Paris.

230. Renoir, *Alice and Elisabeth Cahen d'Anvers,* 1881, oil on canvas, 120 x 75 cm (47¼ x 29½ in.) Museu de Arte de São Paulo Assis Chateaubriand.

231. Cassatt, *At the Theatre, c.* 1879, pastel and gouache with metallic paint on tan wove paper, 64.6 x 54.5 cm (25⅜ x 21½ in.) Private collection.

232. Guillaumin, *View of the Panthéon from a Window on the Île Saint-Louis, c.* 1881, oil on canvas, 79.5 x 45 cm (31¼ x 17¾ in.) Ny Carlsberg Glyptotek, Copenhagen. Photo Ole Haupt.

233. Pissarro, *Slopes at Chaponval,* 1878–79, gouache and watercolour on silk. © Photo RMN – C. Jean. Cabinet des Dessins, Musée du Louvre, Paris.

234. Renoir, *The Luncheon of the Boating Party, c.* 1881, oil on canvas, 129.5 x 172.7 cm (51 x 68 in.) Phillips Collection, Washington, D.C.

235. Renoir, *The Umbrellas, c.* 1881 and *c.* 1885, oil on canvas, 180.3 x 114.9 cm (71 x 45¼ in.) © National Gallery, London.

236. Renoir, *Young Girls at the Piano,* 1892, oil on canvas, 116 x 90 cm (45⅝ x 35⅜ in.) Musée d'Orsay, Paris.

237. Interior of Durand-Ruel Gallery, New York, 1894, photograph. Photo courtesy Archives Durand-Ruel, Paris.

238. Sahib, *La Belle Olympia au Louvre,* from *La Vie parisienne,* 22 February 1890. Photo Bibliothèque nationale de France, Paris.

239. Pissarro, *Man Sawing Wood,* 1879, oil on canvas, 89 x 117 cm (35 x 46⅛ in.) Private collection.

240. Pissarro, *The Gleaners,* 1889, oil on canvas, 65.5 x 81 cm (25⅝ x 32 in.) Öffentliche Kunstsammlung, Kunstmuseum, Basel.

241. Cézanne, *The Battle of Love, c.* 1880, oil on canvas, 37 x 46 cm (14⅝ x 18⅛ in.) Gift of the W. Averell Harriman Foundation in Memory of Marie N. Harriman. National Gallery of Art, Washington, D.C.

242. Renoir, *La Roche-Guyon,* 1885–86, oil on canvas, 48 x 55.5 cm (18⅞ x 21⅞ in.) Aberdeen Art Gallery and Museum, Aberdeen.

243. Degas, *Jockeys in the Rain, c.* 1883–86, pastel, 47 x 65 cm (18½ x 25⅝ in.) Glasgow Museums. The Burrell Collection.

244. Degas, *The Morning Bath, c.* 1892–95, pastel on tan wove paper, 70.6 x 43.3 cm (27¾ x 17 in.) Mr and Mrs Potter Palmer Collection, 1922.422. Photograph © 2000, The Art Institute of Chicago, All Rights Reserved.

245. Morisot, *Self-Portrait with Julie,* 1885, oil on canvas, 72 x 91 cm (28⅜ x 33⅞ in.) Private collection.

246. Degas, Photograph of Renoir and Mallarmé, 16 December 1895, gelatin silver print, 39.1 x 28.4 cm (15⅜ x 11⅛ in.) Gift of Paul F. Walter. 207.89. The Museum of Modern Art, New York.

247. Monet, *Haystack,* 1891, oil on canvas, 65 x 92 cm (25⅝ x 36¼) Gift of Misses Aimée and Rosamond Lamb. Museum of Fine Arts, Boston.

248. Photograph of Monet in the garden at Giverny, September 1900. Photo courtesy Archives Durand-Ruel, Paris.

249. Monet, *The Grand Canal, Venice,* 1908, oil on canvas, 73 x 92 cm (28⅝ x 36¼ in.) Private collection. Photo Sotheby's, London.

250. Monet, *Waterlily Pond at Giverny,* 1917, oil on canvas, 117 x 83 cm (46⅛ x 32⅝ in.) Musée de Grenoble, Grenoble.

251. Gauguin, *For Making a Bouquet,* 1880, oil on canvas, 54 x 65.1 cm (21¼ x 25⅝ in.) © Christie's Images Ltd, 1999.

252. Gauguin, *Breton Woman Herding Her Cows on the Beach at Le Pouldu,* 1886, oil on canvas, 75 x 112 cm (29½ x 44 in.) Private collection, Pennsylvania.

253. Gauguin, *The First Flowers,* 1888, oil on canvas, 73 x 92.5 cm (28¾ x 36⅜ in.) Private collection. © 2000 Kunsthaus Zürich. All Rights Reserved.

254. Sisley, *The Church at Moret, Freezing Weather,* 1893, 102 x 125 cm (40⅛ x 49¼ in.) Musée des beaux-arts, Rouen.

255. Photograph at Beaufresne, September 1910. Photo courtesy Archives Durand-Ruel, Paris.

256. Photograph of Monet in his studio at Giverny, 1920. Photo Roger-Viollet, Paris.

Index

Numerals in *italics* refer to captions
to illustrations